CHARLESTON
REBORN

D1088535

CHARLESTON REBORN

A SOUTHERN CITY, ITS NAVY YARD AND WORLD WAR II

FRITZ P. HAMER

the
History
CHARLESTON PRESS LONDON

Published by The History Press
18 Percy Street
Charleston, SC 29403
866.223.5778
www.historypress.net

Copyright © 2005 by Fritz P. Hamer
All rights reserved

First published 2005

Front cover: Several transport ships in a navy yard dry dock getting an overhaul in April 1943. These vessels were coastal transports used by the United States Navy to haul cargo and men from one port to another, usually along the U.S. coast. *South Carolina State Museum.*

Back cover: Laying the keel for the largest vessel built at the Charleston Navy Yard, the destroyer *Tidewater*, a large ship used to supply the destroyer fleet at sea or away from home. November 27, 1944. The welders appear to be females whom male instructors are assisting. The ship was launched in late June 1945. *Courtesy of Palmer Olliff, North Charleston, SC.*

Manufactured in the United Kingdom

1-59629-020-X

Library of Congress Cataloging-in-Publication Data

Hamer, Fritz P.
 Charleston reborn : a southern city, its navy yard, and World War II /
Fritz P. Hamer.
 p. cm.
 Includes bibliographical references and index.
 ISBN 1-59629-020-X (alk. paper)
 1. Charleston (S.C.)--History--20th century. 2. World War,
1939-1945--South Carolina--Charleston. 3. Charleston Naval Shipyard. I.
Title.
 F279.C457H36 2005
 975.7'915'043--dc22
 2005011714

Notice: The information in this book is true and complete to the best of our knowledge. It is offered without guarantee on the part of the author or The History Press. The author and The History Press disclaim all liability in connection with the use of this book.

All rights reserved. No part of this book may be reproduced or transmitted in any form whatsoever without prior written permission from the publisher except in the case of brief quotations embodied in critical articles and reviews.

Contents

Preface

Ever since I was a youngster, I remember a fascination with stories my parents and grandparents told of their life during World War II. It was an era that seemed so different from the time and places where I grew up. Like most memories of this world event, the one my relatives had was of a nation united in its fight against Fascism. Perhaps because I grew up during the 1960s, when the nation seemed so divided over the Vietnam War, I, like many others, wanted to go back to that era when Americans "united" in the massive struggle to defeat Hitler, Mussolini and Tojo.

As I grew older, this rosy picture of national unity changed. As I read more on my own and then in graduate school, the unity of purpose turned into a more complex, discordant reality where national unity was at best only partially achieved. An American society where African Americans were segregated and women achieved only temporary equality in the workplace with men contradicted the president's proclamation that we were fighting to give everyone in the world self-determination. Nonetheless, despite these and other unsettling, sometimes reprehensible, episodes throughout the war, the period remains intriguing.

Two things sparked my interest in World War II Charleston. The first was my experience as the curator of an exhibition that examined the part South Carolina played during World War II. The show that opened at the South Carolina State Museum on December 7, 1991, included a component on Charleston and its navy yard.

Like most of the exhibition, this component was based almost exclusively on original documents and oral interviews. Later, as I focused my attention on Charleston, I continued to be intrigued by the lack of research on South Carolina's World War II era. Historians of the state have remained captivated with earlier periods, especially the nineteenth century through the Civil War, but it seemed to me that much of what Charleston has become today originated not in these earlier eras but in the 1940s. Spurred by this lack of analysis, I was inspired to study the "Holy City" during a seminar on World War II Americans. Although my paper for that course did not examine Charleston, I continued to think about making this subject my dissertation at

the University of South Carolina. This I did. Now, with the support of Kirsten Sutton and her editorial staff at The History Press, especially Amanda Lidderdale and Julie Hiester, it has become a published work.

Acknowledgements

I am indebted to many people for the success of this study. First, I would like to thank the many generous South Carolinians who agreed to tell me the stories of their lives during the war years. Even though few knew me, many responded to my letters and nearly all allowed me into their homes to spend hours answering endless questions—many that may have seemed redundant—and reflecting on their experiences. I owe every one of them a great deal of gratitude.

For making this entire academic process feasible, both from a financial and a moral perspective, I owe my parents, John H. Hamer, PhD, and Irene J. Hamer, MA, a tremendous debt and thanks. Without their backing, and an occasional prod, I might never have reached this moment. Having provided me with the discipline and interest to learn throughout my youth, their continuing encouragement helped me to reach this point in my writing life.

No one knows more about the writing process than my dissertation advisor, Edward H. Beardsley, PhD. Despite his own extensive duties as teacher and confidant to dozens of students, he was always able to find time to go over chapters of this study after already having spent many hours reading and editing earlier drafts. It even led to some unexpected insights—as on the spring day in 1997 when two African American gentlemen spent more than an hour with us debating the merits of the historical profession and the study of race relations in a Church's Fried Chicken restaurant, where Ed and I had planned to go over a chapter draft. The lively debate we engaged in diverted us from our original purpose but gave us another new, if sobering, insight on the current state of race relations. This was the most unexpected part of the mentor-student process, but was only one episode that gave me new insights into how history is written and debated by not only historians but also the public at large. I can never thank Ed enough for his encouragement and sense of humor when dealing with problems I had in completing this work.

I also want to express my appreciation to my other advisors, who provided encouragement and thoughtful criticisms that helped to make this study better. I especially want to acknowledge Lacey Ford, PhD, Connie Schulz, PhD, and Stanley South, one of this country's renowned historical archaeologists who read the original drafts of this

manuscript and provided thoughtful suggestions. Although he has devoted years of research on colonial life ways of South Carolina, he did not hesitate when I asked him to be a reader for a twentieth-century topic. Despite the requirements of another season of supervising fieldwork at Santa Elena on Parris Island, he found the time to read my manuscript and to send me useful suggestions and valid criticisms.

Another group of people who have been very supportive in this process over several years have been my colleagues and friends at the South Carolina State Museum. I was working full time while researching and writing this manuscript, and it would not have been possible without the permission and support of Rodger Stroup, PhD, my previous supervisor for more than eleven years, and our museum's former director, Overton G. Ganong, PhD. On more than one occasion they permitted me to combine museum business with research for this study. I also want to thank James L. Knight, a close colleague and friend and current supervisor, who provided encouragement (and commiseration) about the writing process and the importance of scholarship. Another close colleague and friend has been Sherry B. LeTempt, who not only has encouraged me but has helped type my original manuscript and spent even more time producing the important table for this study. There are many others at the State Museum who have also provided encouragement and support. I am especially indebted to Ashley Lowrimore and Dan Dowdey, who took time from their busy days to scan and transfer most of the photographs to a sufficient quality so they could be used for this publication.

I also want to thank my sister, Linnea Hamer, MA, and her husband, Darren Lisse, MD, for opening their home in Northern Virginia to me during my several research trips to the Washington, D.C., area. They provided a free haven for me to rest and energize during the evenings after many long hours in the archives. I appreciate their help and patience.

Last, but most important, I want to thank my three favorite ladies. My two daughters, Madeleine and Anna, who put up with their "Daddy" spending many evenings and weekends "hiding" upstairs writing his "book." They rarely complained but provided needed diversions that I appreciated more than I showed. But, it was their mother who has had to endure the most. Jane Patrick Britton's encouragement and help with household duties as well as her reading of portions of this manuscript—all while working full time—were invaluable. Her exhaustive knowledge of historical and literary works gave me access to studies I might never have discovered. I thank her for the love and patience she has shown through this long process.

Introduction

"Do you realize that there is no definitive (I hate the word) short history of any of our past wars?...We ought...to capture or recapture the public pulse as it throbs from day to day; the effect on the lives of different types of citizens; the processes of propaganda; the parts played by the newspaper emperors...It is war work of most decided value. It is not dry history...It is trying to capture a great dream before it dies."

Franklin D. Roosevelt to Archibald MacLeish, June 9, 1943[1]

When Franklin Roosevelt made this statement, the nation was in the midst of its greatest crisis since the Civil War. Roosevelt realized that while he must keep close attention on the war raging abroad, he also had to consider the smaller, more mundane, domestic issues of wartime society. Support from husbands, wives and children on the homefront, he believed, was as much a necessity for victory as the efforts of men and women in overseas combat. Thus, as he commanded the country through World War II, issues affecting homefront communities remained as important as the bigger, bloodier events occurring in North Africa, Italy, Russia, Western Europe and the South Pacific.

Since 1945 much has been written about the battles and strategy of World War II. Important works range from Winston Churchill's monumental five-volume work that included *Their Finest Hour* (1949) and *Triumph and Tragedy* (1953) to more recent studies such as John Keegan's *The Second World War* (1990) and Stephen Ambrose's *D-Day, June 6, 1944: The Climactic Battle* (1994). These, and others like them, focus on the military and foreign affairs aspects of the conflict and give only passing mention to the issues faced on the various homefronts. Gradually, however, and particularly since the 1970s, historians have turned their attention to the role civilians played in the war, as they struggled with problems of housing, rationing, childcare and a multitude of other dilemmas. Some of the earliest examinations of the topic were Richard R. Lingeman's *Don't You Know There's A War On?* (1970), Richard Polenberg's *War and Society: The United States, 1941–1945* (1972) and Geoffrey Perrett's *Days of Sadness, Years of Triumph: The American People, 1939–1945* (1973). More recent studies have added a focus on the parts

that women, specifically, played in the war effort. Susan Hartmann's *The Home Front and Beyond: American Women in the 1940s* (1982) led the way in an examination of changing gender roles. While some work has been done on African Americans' contributions and experiences, much more is needed.

There are also works that examine specific regions and communities during the war. They include Alan Clive's *State of War: Michigan in World War II* (1979), Marc Scott Miller's *The Irony of Victory: World War II and Lowell, Massachusetts* (1988) and Roger W. Lotchin's *The Way We Really Were: The Golden State in the Second Great War* (2000). While these studies have amply delineated local problems and triumphs brought by the war, they have mainly addressed Northern homefronts. The role of Southern communities has received academic attention, with pioneering works that include Mary Martha Thomas's *Riveting and Rationing in Dixie: Alabama Women and the Second World War* (1987), Louis Fairchild's *They Called it the War Effort: Oral Histories From World War II, Orange, Texas* (1993) and Alan Cronenberg's *Forth to the Mighty Conflict: Alabama and World War II* (1995). The latter three studies show that World War II, more than anything else, brought the South out of its economic doldrums and planted the seeds for the civil rights movement. Like no other event or change, government spending on armed forces, training facilities and new war industrial plants gave the South a shot in the arm that thrust it into the twentieth century.

In Charleston, South Carolina, one of the South's oldest communities, the effects of the World War II spending boom are particularly apparent. In 1940, Charleston was rich in history but economically still recovering from the Civil War's devastation. From 1865 until World War I the city had tried various economic schemes to rejuvenate its agriculturally based economy, but failed. It would not be until World War II that the city would begin to develop an economy that had lasting prosperity. In the meantime the city's social structure changed little: a white elite dictated the direction of the city, women played no role of consequence outside the home and racial segregation was law.

The economic and social demands of World War II challenged the South's old status quo. Though it brought new economic and social vitality, the war also carried new problems—some equal in extremity to those faced during the Civil War. This study examines the ways in which the South's oldest city adjusted to its new prosperity and coped with problems and challenges of a wartime nation.

The war emergency forced city and military officials and federal war agencies to work together to resolve many pressing problems to keep the economy and war production running smoothly. In Charleston, the navy yard attracted thousands of new workers and their dependents to the city. While the navy's needs heralded job prospects unheard of before, the rapid expansion of a yard and a large labor force led to huge housing shortages, rationing problems and dilemmas over gender and race.

As labor needs continued to grow, society was forced to accept both minorities and women in roles it never had before. Though both women and African Americans would

break through initial boundaries during the war, long-term societal acceptance would be slow. Charleston industries began to hire women in production jobs as early as the summer of 1942. Most performed superbly, and as long as the emergency lasted, women were largely accepted by male counterparts. But once the war ended, both men and women seemed to accept, if not expect, that it was the duty of female war workers to return to traditional domestic duties.

While men and women seemed to accept "Rosie the Riveter" on the production line, if only temporarily, whites did not accept African Americans as readily. After generations of second-class status, the national black leadership understandably demanded that minorities have an equal share in all phases of wartime industrial employment. But Charleston, and indeed the rest of the South, resisted. Despite the need for more skilled labor at the navy yard and in other local industries, management and white workers opposed the inclusion of blacks in skilled positions. Out of necessity, some skilled African Americans were brought on the production lines, but as the war wound down, whites expected a return to the prewar racial status quo.

As John Blum has argued in *V Was for Victory* (1976), Americans of this era expected society to return to prewar norms after the defeat of the Axis. Women would return to the home and minorities would go back to second-class status. Blum's argument has been refined and extended by other historians, specifically in one later study by John W. Jeffries. In *Wartime America: The World War II Home Front* (1996), Jeffries agrees that the war brought significant economic changes to the nation but argues that many ideas held by prewar society—ideas of race, gender, individualism, consumerism and security—continued after 1945. In short, "the nation was different after the war but not transformed; fundamental dynamics and patterns of life persisted."[2]

However, the return to prewar social structures was never complete for either group. Minorities were forced out of skilled positions, but they began to fight back. Economic and political change was in the air, even though white Charlestonians, with a few exceptions, were unwilling to concede this until the 1960s. Nevertheless, Charleston's black activists began laying the groundwork after World War II for the attainment of equal rights through citizenship workshops, civil lawsuits and the like. Much of their hope grew out of the new outlooks and ideas that the war years brought to Charlestonians of all races and backgrounds.

Just as World War II brought long-lasting economic prosperity to the South, it would introduce permanent changes in the South's racial mores—even if ideas and opportunities born out of the war experience took much longer to take hold.

Chapter I
Setting the Stage:
Charleston Before the War

All communities have their scandals, but all too few have retained the aroma of by-gone days
in this changing world as has Charleston.

Elizabeth O'Neill Verner, Charleston artist, 1941 [3]

Until the end of the 1930s, Charleston had a bleak economy and a society that drew its pride solely from its past. Efforts to revitalize the once bustling port city of pre-Civil War years had never succeeded. Its isolated location on the coast and the competing ports in North Carolina and Georgia often left the commercial hopes of Charleston businessmen and politicians thwarted—a fact that may explain some of the city's extreme reverence for its past.

In 1937 William Boyce, a young marine design engineer from the Brooklyn Navy Yard, accepted a position at Charleston's naval facility. Looking back nearly sixty years later, the New York City transplant remembered the South Carolina port city as rather strange, a place where people were still fighting the Civil War, and "some of the natives went as far back as Pocahontas."[4] Yet, Boyce recalled ironically, in the locals' midst, the Charleston Navy Yard was developing a modern shipyard for building and repairing war vessels. To the locals' credit, when Boyce arrived in 1937, no one could have imagined the extent of the shipyard's growth over the next few years or the remarkable changes that would take place (many of them products of the navy yard expansion) in the host city.

City business leaders had tried since 1865 to bring the coastal port out of its economic depression, but the Civil War's disastrous end seemed to condemn the city to perpetual poverty. Moreover, though many of the ravages of war had been repaired by the mid-1880s, a second, natural, disaster—the earthquake of 1886—forced the city to once again rebuild itself. In 1901, efforts to rejuvenate the city began anew with the South Carolina Interstate and West Indian Exposition. Hopes were that the extravaganza of the exposition would attract new business investments. But in the end, the optimism proved unfounded. The exposition's biggest legacy, when it closed in 1902 after only a six-month run, was a huge debt.[5]

Though the exposition proved to be a failure, another event that took place in the same year would prove to be of paramount importance—the re-location of the navy yard from its original, too-isolated home seventy miles south in Port Royal, to Charleston's northern outskirts. The decision had been a sensible one. The new location had better access to inland transportation and a larger population base from which to recruit a workforce. But, in truth, the decision was based as much on political pork barrel politics and the political maneuverings of Senator Benjamin Tillman as naval strategy.

Unfortunately, the move was hardly an answer to the city's prayers for immediate assistance. While providing modest economic stimulation to the area and about four hundred new jobs during its first years of operation, the navy yard's impact would not be felt for nearly a decade and a half, when the demands of World War I would boost the yard's production.[6] And the major financial benefits would not be seen until the late 1930s, when the nation began to rearm its naval forces in earnest as the threat of Fascist Germany and Imperial Japan grew more alarming with their aggressive foreign policies seeking more land and resources.

Thus, from World War I until the latter stages of the Depression, the local shipyard served as only a sporadic stimulus to Charleston's economy—an economy that continuously grappled with unemployment and financial difficulties. Although the city saw a moderate 14.5 percent population increase in the ten years following 1929, its general condition remained problematic: most improvements to the city and county economies were traceable, directly or indirectly, to federal relief, grants or loans. The navy yard grew because of navy expenditures, supplemented by New Deal grants. Improvements to the city's infrastructure, ranging from road surfacing and historic reconstructions to additions to colleges and recreation facilities were based, again, on New Deal loans and outright grants. Even private investments seemed to exploit Charleston's weaknesses, rather than build on its strengths. In 1937, when a pulp and paper mill agreed to move into the county north of the city, the lures were cheap labor and the city's promise to finance a new water line to the mill location.[7]

One hindrance to Charleston's economic prosperity was geography; the old city was confined to a peninsula and this meant that major expansion could only take place beyond the northern bounds of the city, where there lay plenty of rural land for the development of the navy yard and other enterprises.

A perhaps more powerful hindrance was Charlestonian resistance to change. In the midst of economic crisis, most of Charleston's elite seemed largely unconcerned. Their deep appreciation of the colonial and antebellum past had always been reinforced with the daily physical reminders of the city's architecture. Many city residents valued its antiquity as much as, if not more than, the possibility of the modern business and industrial center desired by Charleston's political and business leaders. A look at the old city center, an area that had witnessed surprisingly little alteration in its near three-hundred-year history, illustrates. By 1940, it still had the same street system and several structures created in the eighteenth and early nineteenth centuries, including the Old Exchange Building (1772), the Charleston Orphan House (1790) and the Joseph Manigault House (c. 1803)

Proud of their genealogies, many old families claimed to trace their ancestry back to the colonial period, or as far back as "Pocahontas," as William Boyce half-jokingly recalled.

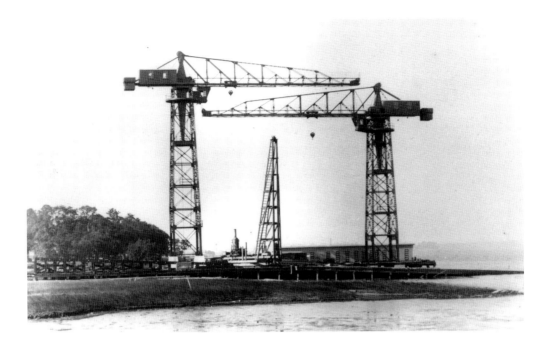

Some of the first cranes installed at the navy yard less than a year before United States' entry into World War I, October 14, 1916. *South Carolina State Museum.*

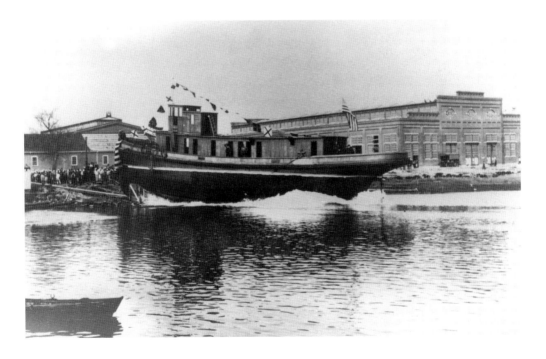

Launching of the U.S. Navy tug *Wando* from the Charleston Navy Yard, March 7, 1916. This was the first vessel built at the Lowcountry facility. *South Carolina State Museum.*

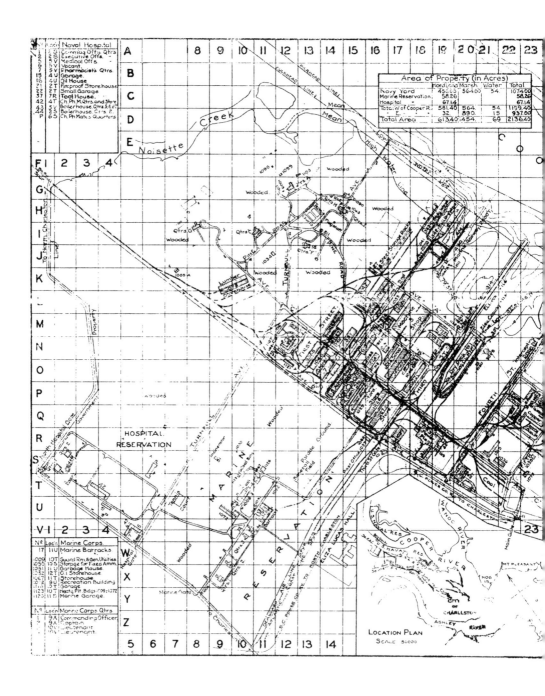

This map shows the small extent of the facility in the midst of the Depression, when it employed just a few hundred men. (1934) *Courtesy of the Navy Base Redevelopment Office Map Room.*

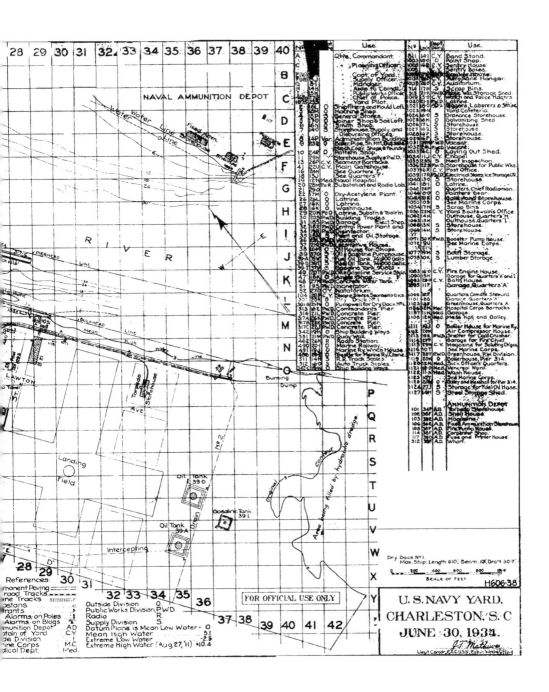

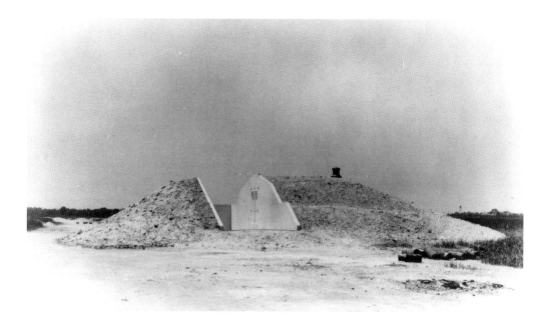

Navy yard magazine for explosives, building #150, May 7, 1940. *South Carolina State Museum.*

Most of these families had more capital in significant ancestors than in large fortunes to invest in economic redevelopment and modernization. It is possible that if Charleston's old families had had more assets they would have changed both the economics of the city and the old neighborhoods they seemed to cherish. But, as it was, most clung to past glories (or myths) and the historic environment. Consequently, change and newcomers were only reluctantly accepted by the old elites who still controlled many aspects of the city. Even as most Charlestonians appreciated and joined in the economic bonanza that the growing navy yard and its tributary industries and services brought to the city, there was an ambivalence, if not outright resistance, to new establishments entering the old city center, regardless of potential economic benefit.[8]

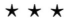

World War I gave Charleston a temporary financial boost. Employment at the young Charleston Navy Yard grew to ten thousand workers, military training and logistical support for the navy brought prosperity and jobs to city business and commerce and the economic future for the city appeared more promising than ever. During America's participation in the war, the Charleston base built eighteen vessels and two new building ways while repairing and refitting numerous other ships.

But American participation in the Great War lasted less than two years, so the economic impact for Charleston, as well as for the state, was short-lived. By the early twenties Charleston found itself faced with unemployment, failed businesses and its most important

industry, the Charleston Navy Yard, subject to closure.[9] In 1922, the navy announced plans to close the base. Fortunately, the political intervention of South Carolina's congressional delegation persuaded the navy to rescind its proposal and keep the yard open—if only on a modest scale—with no prospects to make it truly viable.[10]

For the rest of the decade Charleston leaders had to continue lobbying the navy to keep its shipyard in their city. Along with political pressure on the navy by state congressional representatives, city fathers resorted to public celebrations to honor and show appreciation for the U.S. Navy. In October 1923, with the help of the state branch of the Navy League, the city instituted its first Navy Day. The Navy League, a national organization, wanted the national fleet kept strong and up-to-date. They promoted the fact that the United States Navy was the "nation's first line of defense." The state chapter naturally played an important role in doing whatever it could to support the city's efforts to keep the navy yard in Charleston. It was instrumental in organizing the first and subsequent Navy Days, publicizing the events beforehand and lobbying the navy to support them with sufficient pomp and ceremony.

However, while both the league and the city's efforts built goodwill and seemed to encourage a few more repair and maintenance jobs, they did not make the Charleston Navy Yard a substantial shipbuilding center. The yard survived, but barely. Although its work earned praise from other navy yards, the labor force stood at little more than four hundred in 1930. Despite the city's best efforts, in 1931 the Department of the Navy informed Charleston that the yard had again been earmarked for closure. But again, after loud protests from South Carolina's congressional delegation, led by Senator Ellison "Cotton Ed" Smith and newly elected Junior Senator James F. "Jimmy" Byrnes, the Hoover administration canceled the recommendation.[11]

Two years later, in 1933, with the insufficient availability of work now a critical consideration, navy officials again threatened to close the yard. Their evaluation was understandable. Periodic layoffs had occurred in the yard since the start of the decade. Only by asking workers to take unpaid leave could the navy yard avoid laying off veteran workers. During one eight-month period in the shipfitter shop, workers averaged 3.4 days per month of unpaid leave.[12]

However, by this stage of the Depression, the future of the Charleston Navy Yard was no longer solely dependent upon navy officials' application of standard economic principles, but rather a set of new principles being devised by a desperate government trying to reinvigorate a collapsed economy. The new president, Franklin D. Roosevelt, had priorities other than efficiency. With a pledge to bring hope and new jobs to a prostrate economy, the resourceful chief executive probably saw in the South Carolina facility a way to fulfill his promise and make key political allies. Charleston Mayor Burnet Maybank and U.S. Senator Jimmy Byrnes had vigorously supported Roosevelt's 1932 campaign. Furthermore, FDR had favored the navy since his days as assistant secretary during the Wilson administration. In May 1933, Byrnes sat down with Assistant Navy Secretary Henry Roosevelt to discuss ways of making the Charleston Navy Yard more useful. Out of the meeting came a promise of a $3.2 million gunboat contract requiring the employment

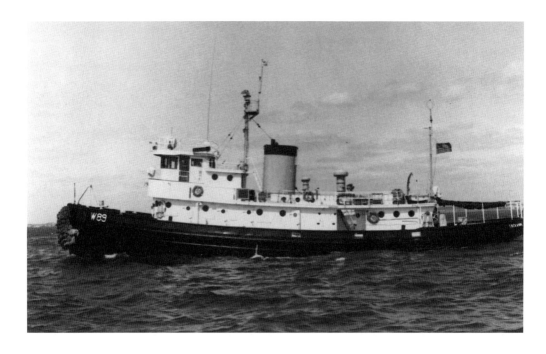

One of three coast guard cutters built by the Charleston Navy Yard in 1934. These were some of the first vessels built at the facility since the end of World War I. This small vessel began the yard's slow refurbishment as an important part of the U.S. Navy's rebuilding program before World War II. *Courtesy of the U.S. Coast Guard Historian Office.*

of five hundred workers through 1936 at the under-used facility. The contract gave the navy yard a small but significant shot in the arm, and when the contract was fulfilled, two more would be awarded to build a coastguard cutter and a destroyer.[13]

In addition, the navy tapped into New Deal programs to fund new construction. Owing again, in part, to Byrnes's and Maybank's vocal support for the New Deal, between 1935 and 1939 Works Progress Administration (WPA) funds put seventeen hundred workers on the Charleston Navy Yard payroll. The yard was able to build new officers' quarters, a galvanizing plant, an addition to the base hospital and another dry dock.[14]

In August 1939 William Bendt, recently graduated from high school in his native Charleston, eagerly accepted a labor position at the navy facility. Assigned to help build racks for sheets of metal used for the evolving ship construction program then underway, Bendt recalled that the work was hard but pay was good—nearly $3.50 per day with a five-day work week. Previous to that he had worked in a local laundry where he only earned $1.00 per day and had a six-day work week. For his new job at the navy yard he could thank the facility's Public Works Department for the funds.[15]

Though the employment growth in Charleston was modest compared to that experienced at other yards, by 1936, following another contract to build five new destroyers, Charleston Navy Yard activity was obviously expanding. This is evident in the

Above and Below: By the late 1930s new construction at the navy yard had increased extensively. During this period significant funding came from the PWA or the WPA, providing jobs to the large number of unemployed in the Charleston area. This view is looking southwest on Third Street. *South Carolina State Museum.*

yard's increased utilization of a federal apprenticeship program to aid accelerated naval construction.[16] As new contracts were awarded, the Charleston base needed trained foremen and competent mechanics in the various shipbuilding trades. Former Brooklyn Navy Yard Engineer William Boyce recalled the upsurge of Charleston's labor force after his 1937 arrival at the Charleston Navy Yard. Statistics confirm his observation. With 1,288 workers in 1936, the workforce continued its expansion even as the Depression lingered, reaching 1,629 in November 1938, and rising almost 50 percent more over the next seven months.[17]

Regardless of whether it was the growing navy yard or the various New Deal grants and loans that helped ease the city through the depth of the Depression, throughout the 1930s the coastal city was heavily dependent on federal funds to remain fiscally afloat.

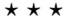

Problems other than unemployment also plagued political leaders and businessmen as a result of the poor economy of the Depression. By the early thirties the "looting" of the historic city for the benefit of homes and museums in New York, Boston and Philadelphia over the past two decades had reached a critical juncture. This removal of important, historic façades, ironwork and ornamentation, together with new construction that had taken place since before World War I, threatened to seriously compromise the integrity of Charleston's historic center. This center, which included the peninsula roughly from the Battery at the south end to Calhoun Street on the north, traced its roots to the seventeenth century.[18]

In the early twenties, the nation's first preservation society—something that few communities in the nation then had—was formed by elite Charlestonians imbued with a sense of place and nostalgia. In 1931, in large part because of the society's efforts, the city council passed the nation's first historic municipal ordinance in spite of the economic woes surrounding them. This law established a Board of Architectural Review (BAR) empowered to review all plans before the start of any exterior construction to buildings lying in the "Old and Historic Charleston District." The BAR continues to review all exterior construction and renovation projects in an expanded historic downtown Charleston.[19]

Because the Preservation Society was made up of old and politically powerful Charleston families, the ordinance succeeded. One local politician with a long, distinguished Charleston paternity was Mayor Thomas P. Stoney. Although he was out of office by the time the ordinance was passed, he was instrumental in putting it before the council agenda during his tenure and continued to use his influence for its passage after he left office. His successor, Burnet Maybank, another descendant of old Charleston families, supported the ordinance's passage. A protégé of Stoney, Maybank had run his father's successful cotton brokerage business before he entered politics. Although ultimately remembered as a champion of new economic initiatives relying heavily on federal funding, Maybank's first important legacy was the preservation and re-creation of some of Charleston's historic buildings.[20]

Yet even as this historic ordinance was taking effect, for most of the first half of his inaugural term and more than a year before Franklin Roosevelt's election, Maybank could only tighten the city's belt. In 1930, with a city population of 62,263 (101,050 in Charleston County), the new mayor was forced to reduce the city budget further, regardless of the difficult financial times experienced the previous decade. He started by cutting wages for city workers and reducing all other spending to a minimum. When the city's bank collapsed on the first day of January 1932, the municipal debt quickly rose to eleven million dollars, forcing the city to earmark its dwindling revenue for debt service and for salaries paid to a reduced city administration. Until Roosevelt's inauguration in March 1933, austerity kept the city going, but barely.[21]

With his public support of Roosevelt's candidacy, Maybank was able to tap into fledgling New Deal programs begun soon after FDR took office. As early as the summer of 1933, WPA funds began to reach Charleston, bringing work to thousands of unemployed in and around the city. While some of the funds were earmarked for the navy yard, by the middle of the decade money was being received for civilian construction projects. More than $200,000 went to the renovation of buildings and the construction of a new gymnasium at the College of Charleston, the city's oldest institution of higher learning. In addition, tuition for fifty students was provided through federal and local funds. Uncle Sam provided a half a million dollars in the mid-1930s to The Citadel, South Carolina's military college, to build a mess hall, quarters for the faculty and a chapel. Within the city itself, the most publicized WPA project concerned the rebuilding of the Dock Street Theater. The location had gone through many changes since the building of the nation's first theater in 1734. The WPA rebuilding replaced a derelict structure and an old hotel on an adjacent site. When finished in 1937, the theater became a new symbol of the city's determination to rebuild its distinguished past.[22]

Despite the obvious economic benefits of New Deal spending in Charleston, there were voices opposed to virtually all public relief programs. William Watts Ball, conservative editor of the *Charleston News and Courier*, never liked any aspect of the New Deal. Throughout the early months of the federal relief program, Ball denounced the public funds as money wasted on useless administrators. As if recalling the ghosts of South Carolina's independent, destructive past, he wrote: "We stand on the ancient and honorable ground that South Carolina can take care of itself…[and it] will never be dependent and a beggar state."[23]

Maybank countered that without federal support eight thousand families would suffer severely, but Ball remained adamant in his opposition. Thankfully, Ball's references to historic ancestors such as John C. Calhoun and John Rutledge did not win him much support for his belief that South Carolina should remain independent from federal purse strings, and Ball and his few allies failed to have a significant impact on Maybank's relief strategies. To most Charlestonians, Maybank's links to the Roosevelt administration and its largesse were what kept Charleston in business.[24]

While Maybank's direction gave renewed hope to many citizens, some Charlestonians remained destitute and struggled to survive. By 1932, an estimated sixty-five hundred people in the city (or 20 percent) were unemployed. Dorothea Spitzer and her family were

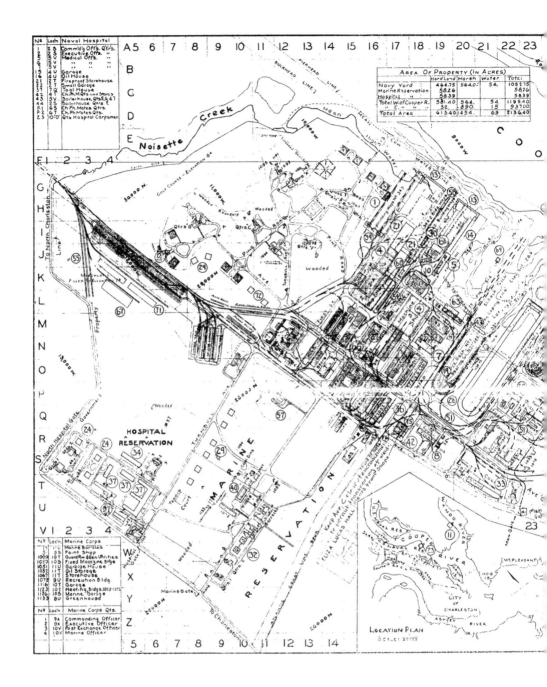

By the end of the thirties, the facility had begun to expand and add workers as its destroyer construction phase got underway in 1936. By this time it employed less than two thousand people. (*c.* 1939) *Courtesy of the Navy Base Redevelopment Office Map Room.*

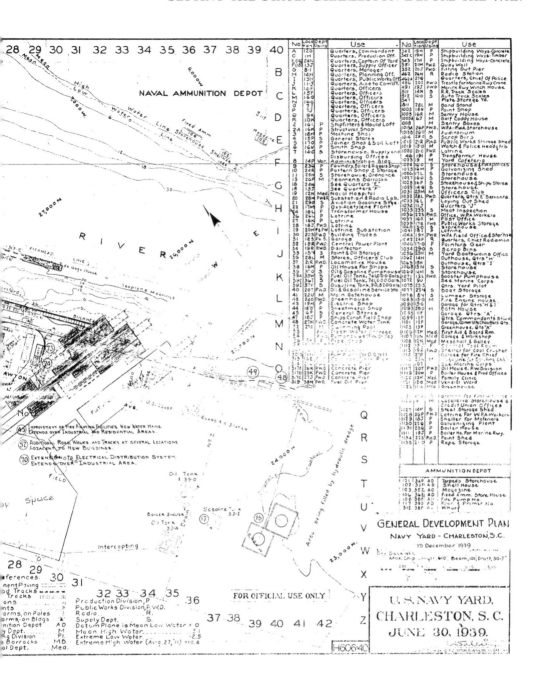

GENERAL DEVELOPMENT PLAN
NAVY YARD - CHARLESTON, S.C.
15 December 1939

U.S. NAVY YARD,
CHARLESTON, S.C.
JUNE 30, 1939.

forced to leave Charleston in the early thirties to try farming in the sandy soil of Berkeley County, twenty miles north of the city. Her father, a grocer, found his business could not survive in the city following the 1929 stock market crash. Johnnie Dodds, born on State Street, grew up in the twenties and thirties near many relatives and friends. But even so the Depression was tough for everyone, he recalled. After working as an electrician's apprentice for nearly a year on a private job, he soon faced a tough decision. Work was so scarce, his boss informed him, that someone had to go. Even though Dodds was senior to the newest man hired, he quit so that the new person, with a wife and child, could be assured of a steady income for his young family. Single at the time, Dodds felt better able to survive unemployment until he could find a new job. Many other young couples were not so fortunate.[25]

Of all who faced bad times, the black community faced the greatest hardships in the Lowcountry city. Even when New Deal money began to reach Charleston, black citizens were usually the last to get any of the federal relief. Before the New Deal the city provided what relief it could, but there was an obvious discrepancy between white and black welfare. In 1932 blacks made up approximately half the city's sixty-five thousand residents. Between March and September 1932, limited work was available to both races. While more than three thousand whites received work relief, only about eight hundred blacks were helped. Again, Ball of the *News and Courier* spoke out against the relief, even before the federal government began providing it. He contended that the thousands of "able bodied Negroes" of Charleston who were out of work should be removed to the rural areas where they could live on farms more cheaply.[26]

Although Maybank effectively countered this argument by noting that there was nothing in the country for these people to live on, the mayor and his council still did not adequately support the blacks in greatest need. One of the most desperate African American organizations during this period was the Jenkins Orphanage. Founded in 1891 by the Reverend Daniel Jenkins, the orphanage provided food, shelter and an education for hundreds of orphaned black children in and around the city. Despite its important service to the community, the institution was always in financial difficulty. When the Depression hit, its very survival was threatened. Appealing to Maybank in 1931, Jenkins pleaded for enough support to allow the orphanage to feed its charges properly. But his appeal was ignored. Nonetheless the reverend persisted and, nearly eighteen months later, he finally persuaded the council to earmark the paltry sum of fifty dollars per month for groceries. Money was not Jenkins's only trouble. Fire severely damaged the main building in 1933, and the black institution would spend five years seeking funds for its reconstruction. In 1938 the city agreed to fund the project on the condition that the orphanage move to another location far from its original downtown site. The prime lot was coveted by white leaders for other prospects.[27]

Other portions of the black community experienced similar difficulties. Ever since the 1920s, city leaders had lobbied "prominent citizens" of the city to contribute ideas and money to clean up the "unsightly, overcrowded, and filthy surrounding[s]" of black tenement housing.[28] Yet by the mid-thirties, housing conditions in Charleston had not

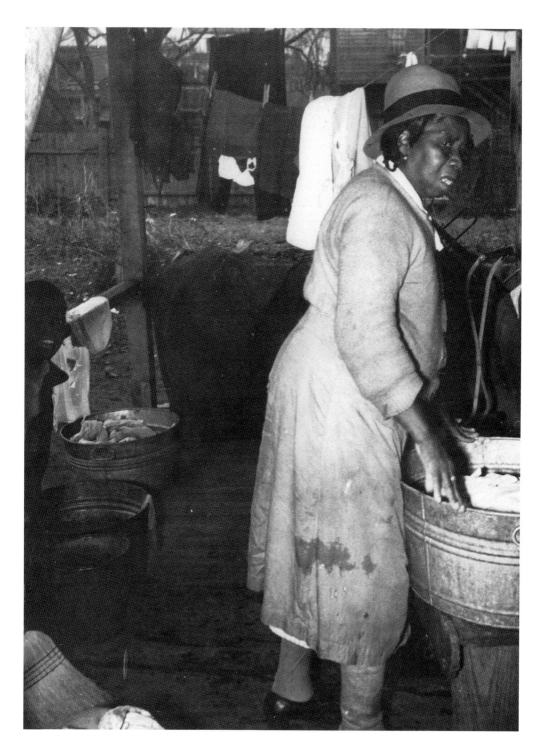

African American women, like this washerwoman on Cromwell Alley in Charleston, had few options prior to World War II except domestic service. This washing was done by hand, a backbreaking task. (*c.* 1940) *South Carolina State Museum.*

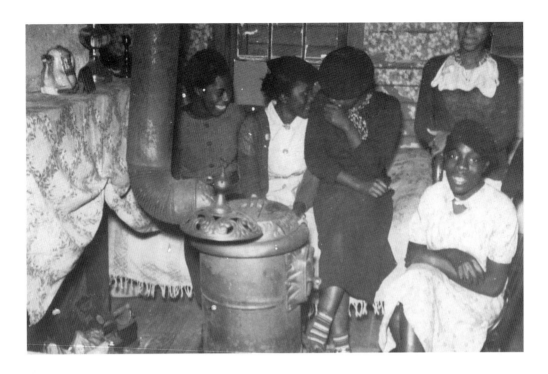

Neighbors of a Charleston community on Cromwell Alley gather in one of eight apartments. This interior view provides insight into the run-down conditions of many working-class residents, especially among African Americans. (*c.* 1940) *South Carolina State Museum.*

changed. Of the 22,369 African American housing units examined, 21.7 percent had no running water and 48.9 percent had no indoor toilets—compared to a national average of 5 percent and 17.9 percent, respectively.

Mamie Fields, a leader of the Charleston chapter of the South Carolina Federation of Colored Women's Clubs, who assisted in the survey, recalled that "the condition inside of Charleston's slums were worse than they looked from the outside." Although advised not to enter the worst slum areas along the Cooper River, Fields and her colleagues did. Years later she remembered finding several black families living in abandoned warehouses, nothing having been done to make them livable except for what the impoverished residents devised. Privacy consisted of burlap sacks sewed together and hung to form three "rooms," one for each family.[29]

Clearly the city needed new housing. With Maybank's support, WPA funds became available to build the first of three public housing units in the second half of the decade. When the first was completed in 1936 it was intended for black residents. The Cooper River Project produced such good housing, however, that before the first tenant moved in, white authorities decided that half of the development should be earmarked for white residents. Fields recalled that, though frustrating to the black community, this setback was minor compared to subsequent efforts to undermine African American endeavors. In one

example, a respected black mechanical arts teacher was hired to manage the new housing units. He not only managed the units well, but also created a shop to teach skills to boys. His program was so successful that white authorities grew jealous, and when his contract was up for renewal he was demoted to the position of janitor. Though the city had not fired him, the demotion was so humiliating that he resigned altogether. According to Fields, many in the black community throughout Charleston felt the white establishment did all it could to wear them down by placing obstacles in their way. In response, many blacks left.[30]

The black exodus had begun before World War I and continued throughout the twenties as African Americans sought better economic and social prospects in the North. Washington, D.C., and New York City were favorite destinations for those leaving the Lowcountry. Although the trend slowed during the Depression years, it did not stop. Vivienne Anderson left her native city in the mid-1930s for better job prospects in the national capital. Relatives and friends who had left before her helped her find a job and a place to stay. After working as a domestic for a time, she found a job in the United States Treasury Building where she stayed until 1941. Nonetheless, many African Americans remained in Charleston and those who did, as Fields observed, felt that there were always small victories to bolster blacks' spirits and help them to feel that they had not completely surrendered to white opposition.[31]

For many black Charlestonians, age-old trades were still mainstays of their livelihoods. Black street hucksters sold fish, vegetables and other foods around the city. Others went out in their small fishing boats every morning to harvest the treasures of the sea. Another common job, particularly for women, was domestic service to white families. While there were black professional trades, particularly school teaching, there were few black businesses. According to Gunnar Myrdal's comprehensive 1944 study on the African American society in the South, Charleston's black community was too scattered to develop its own significant business district like that which existed in Savannah and Atlanta.[32]

In spite of hardships and white-imposed obstacles, the black leadership, along with the aid of paternalistic whites, tried to find ways to improve their community. During the early period of the New Deal the city matched federal funds to build a swimming pool for blacks that opened in 1934, a proposal that had been floated in the city since the 1920s. Some blacks found jobs on new city projects such as the construction of the Municipal Yacht Basin along the Ashley River, completed in 1935, as well as general city paving projects.[33]

Outside of the urban area, regardless of one's race, there were fewer employment prospects except for truck farming and timber jobs. In spite of Charleston County's agricultural past, cotton and rice were no longer significant cash crops. Many former plantations were turned into timber farms where, by the 1920s, large stands of pine grew for regular harvesting. In the 1930s timber companies had bought much of this land. By 1941, Charleston County was 81 percent forest land with sweet gum and pine the predominant species. In 1936 this forest resource would help to attract the West Virginia Pulp and Paper Company, which

established a paper mill and timber yard several miles north of the city along the Cooper River. By 1941 it was employing more than six hundred workers.[34]

Even though the timber industry was just becoming a viable economic resource for the county, many rural inhabitants still depended on farming for at least part of their livelihood. Most of the agriculture in the 1930s was in truck farming. While the majority of farmland was still owned by upper-class families whose ancestors had owned the land for generations, most farms were rented and managed by black and a small number of white tenants (there were five times as many African Americans living in rural areas as whites). To make enough to live, tenants often worked on the farm and harvested timber, depending on the season. In the spring and summer, vegetables and fruits were commonly grown. One Charlestonian recalled years later that during the thirties her father made his living by driving fruits and vegetables in his truck to New York on a regular schedule. However, most of the produce was sold locally, since the need in the city was constant and the transportation cost for shipping items to the Northeast was high.[35]

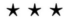

One problem the Lowcountry faced in its attempts to attract industry was supplying sufficient power at rates cheap enough to lure new industries. Yet as the Charleston Navy Yard began to grow and Mayor Maybank looked for ways to diversify the economy, an ambitious plan resurfaced that many local business and political leaders thought would generate vast amounts of cheap power. This plan, originally proposed in the twenties, would harness the extensive 538-mile-long Santee River system in a huge dam, 40 miles north of the port city. In 1926 the Federal Power Commission awarded a license to the International Paper Company to begin construction of a reservoir at the end of the year. However, several extensions were needed for funding reasons. When things seemed ready to go at last in 1930, the Depression hit with such force that the project seemed finished for good.

The advent of the Roosevelt administration gave the reservoir idea new life. Before construction could commence, several obstacles remained. The first was bureaucratic: a private firm still held the construction license and it soon became clear that extensive federal funding could only go to a government entity. Consequently the state had to negotiate the revocation of the private firm's license and form a public service corporation to supervise the project. This alone took time and negotiations. Second, and just as difficult, was the acquisition of the land that would be needed for the huge reservoir from private owners and local government entities. This took more negotiations and money, partly because many powerful landowners and politicians opposed the project. Fearing the loss of farm and hunting land to the extensive flooding the dam would cause, conservationists supported the landowners' cause.

A key supporter of the project was Charleston native Senator Jimmy Byrnes. Determined to see the project succeed despite local and federal opposition, Byrnes used his political

One of the many steam engines of the navy yard, seen here moving a large piece of machinery across the facility to an unspecified destination. Rail lines that crisscrossed the facility provided the best method in the 1940s of moving all kinds of heavy equipment and supplies from supply depots to dry docks and building ways. *South Carolina State Museum.*

influence with Roosevelt and personal persistence to see construction begin in 1938. Although the project would be hampered by cost overruns and accusations of fraud, the sixty-two-million-dollar project provided construction jobs to more than seven thousand men in one of the state's most economically depressed regions. Although the anticipated economic boost from the Santee Cooper Project was not realized on its completion in 1942, the project did help attract some industry to the Lowcountry.[36]

By the second half of the decade, partly because of the prospects of cheap power in the near future, new industries were attracted to the area. In 1936 Mayor Maybank convinced the West Virginia Pulp and Paper Company to choose his city over a Virginia location for its new plant. To clinch the West Virginia deal, the city had to upgrade a primitive water system with twenty-three miles of tunnels, bringing Edisto River water to Charleston for processing needs. Situated on the Cooper River site of a World War I army base, the new plant began operations by the end of 1937.[37]

An electro-magnetic sweeper collecting scrap for recycling at the navy yard, January 5, 1940. This helped the yard to reuse scrap metals such as discarded bolts and other pieces of metal to save on scarce resources. *South Carolina State Museum.*

Though it cost the city a significant sum, this new industry would add jobs to the Charleston area and give the growing forest industry a valuable local processor for more forest products. But this immediately raised the question of how to ship these products to market. Transportation had always been a problem for South Carolina, as it sought ways to send agricultural products out of state. High and discriminatory freight rates on Southern goods since the end of the Civil War hindered the use of rail traffic. The ocean–going trade that had made Charleston so prosperous during the eighteenth and early nineteenth centuries had declined, following the Civil War's destruction of its harbor facilities. By trying to sell the port facilities to rail interests before the end of the century, the city had hoped to challenge its more prosperous rivals in Wilmington, North Carolina, and Savannah, Georgia. However, the rail interests already had good facilities in these two cities and proved unwilling to invest significantly in Charleston's port. Although World War I finally brought renewed prosperity to the city and its port, those gains, tied as they were to military and naval needs, proved temporary.[38]

Convinced that private enterprise was unwilling to restore ocean commerce to its harbor, Charleston's then mayor, Thomas P. Stoney, followed through on his 1920 election

promise to make the seaport a local government agency. Backed by a public referendum in November 1921, the city purchased the port facilities from the railroad interests for $1.5 million and organized the Port Utilities Commission the following year. With an energetic board and some city funding, the port docks were repaired and upgraded. For the next four years the efforts of the administration had positive results, with a steady increase in cargo and ship traffic—between 1922 and 1926 cargo volume increased from 1.5 million tons to 3.03 million tons. Unfortunately, the growing instability of the market began to show during the remainder of the decade as volume steadily declined. In the wake of the 1929 stock market crash the Port Utilities virtually collapsed. One longtime employee remembered those early years when "no ships would come in for six months" as a period when many port workers nearly starved to death. Although some traffic trickled into Charleston Harbor later in the thirties, it was only enough to provide minimal employment to a reduced workforce.[39]

Attempts to rebuild the facility during the late thirties were hindered by many of the same problems that confronted the port before 1921. The South Carolina coastal city could not compete with its rivals to the north and south and it had insufficient funds to maintain and add new equipment and update facilities. Furthermore, by the end of 1939, with war in Europe, shipping was considerably curtailed. Even before the submarine menace threatened the eastern seaboard in January 1942, only "some few foreign vessels" came to Charleston.[40]

Jobs were scarce and pay, when work could be found, was low. But for many Charlestonians the thirties were not much different from the twenties. The economic boom of World War I disappeared soon after Germany surrendered, and although positive efforts were made to re-establish the port's trade during the 1920s, by the end of the decade this optimism changed to gloom. Even the navy yard barely survived the Great War, and while it avoided closure, it was at best a minor naval facility until the middle of the Depression. But, as the thirties came to an end, another war was about to bring new life (and problems) to the Lowcountry city.

At the beginning of a new decade Charleston was on the verge of an economic upsurge that would bring an unprecedented number of jobs, salaries and newcomers, but also new dilemmas. Labor shortages, housing problems and racial tensions would test the mettle of Charlestonians in a way never seen before in the city's long, turbulent history.

Chapter II

An Influx of Newcomers

"The old Charleston is one of the casualties of the war and there is no time now for mourning over it."

Editorial, Charleston News and Courier, *January 8, 1943*

In 1939, as war broke out in Poland, the United States began a concerted effort to rebuild its military forces, which had languished since the end of World War I. Even before Nazi forces had marched across the eastern border of Germany, the Nazis and their Italian allies had given Roosevelt and his advisors reason to grow concerned for the future of world peace, and after 1933, the administration had begun some plans for preparing the nation for a possible war. However, the president had been cautious in instituting the plans so as not to inflame isolationists who were against taking the nation into a conflict. Nevertheless, when Nazi armies invaded Poland, Roosevelt forged ahead with rebuilding America's armed forces (albeit not to the degree that he desired). Orders for military hardware, planes and ships increased, and industry in the South Carolina Lowcountry reaped the benefits.[41]

In Charleston, the main result of FDR's increased spending was the accelerated expansion of its naval base. Located about ten miles northwest of the old city, the Charleston Navy Yard sat on the west branch of the Cooper River. In 1940 its landholdings of nearly 2,000 acres on both sides of the river had changed little since its establishment in 1901. The main area of production, repair and auxiliary operations covered a total of 728 acres, and included workshops, two dry docks, shipbuilding ways, storage facilities, a naval hospital and marine barracks. There was also a separate reservation on the north side of the yard that included several large homes and smaller residences for the navy yard commandant and his senior staff. To keep the shipbuilding operation supplied, several railway lines and roads connected the facility to the outside world.[42]

By June 1941, six months before Pearl Harbor, the new spending had begun to change the face of the yard both physically and otherwise. The labor force and new ship construction was increasing rapidly, as was the number of newly built structures to

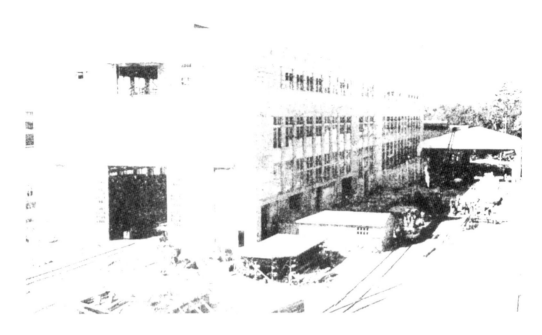

One of the many new structures built for the expanding navy yard prior to the attack on Pearl Harbor was this building, the structural shop, building 62. *CNY Annual.*

This shipfitter's layout shed, building 59, was another new building completed prior to the United States' entrance into the war. *CNY Annual.*

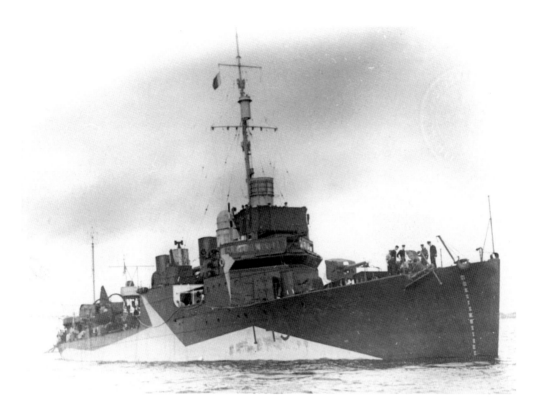

WR 258 was probably one of the many British warships that the Charleston Navy Yard repaired or refitted during the war for our ally. Note the British ensign flying above the bridge. (December 1, 1942) *South Carolina State Museum.*

accommodate the growth. (In early 1941, for example, navy demands on the Lowcountry base had become so heavy that a third dry dock had been built for the accelerated production of destroyers.) In the machine shop, floor space increased by twenty-four thousand square feet in 1941, and in the same year a two-story office building to manage the new activity neared completion.[43] The most dramatic of the early changes was the expansion of the navy yard's labor force, which doubled between 1940 and 1941, standing at more than ten thousand by September 1941. The growth of industrial shops illustrates the dramatic increase in activity and personnel at the once sleepy naval facility. From 1934 the shipfitter and welding shops' staffs had increased from a total of twenty-nine men to a staff of twenty-five hundred—an expansion which was continual over the seven-year period, but most concentrated in the period after September 1939. Also dramatic, was the growth of the labor for the sheet metal and boiler shops, which doubled between 1940 and 1941.

By this time, the Charleston Navy Yard's stature had also increased; it had been designated to serve as headquarters for the Sixth Naval District. (One of twelve naval districts in the nation, the Sixth was to include South Carolina, Georgia and most of North Carolina.)

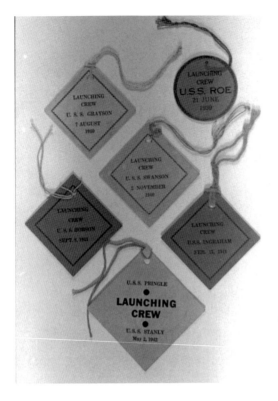

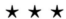

Launching tags had to be worn by the members of the launching crew for identification. These tags are examples of those worn by the launching crews for Charleston-built destroyers. *Courtesy of S.F. Fennessy and Palmer Olliff, North Charleston, SC.*

By the early part of the war, to accommodate the expanded staff of the Sixth Naval District's headquarters and to facilitate coordination of naval operations for all the states of the district, the admiral and his staff moved from the small quarters at the navy yard into wartime offices in downtown Charleston, taking over the Fort Sumter Hotel for the duration. Also, in the first year of the war, nearly two hundred additional acres were purchased to increase equipment storage.[44]

★ ★ ★

The types of work and production done at the yard also changed with the needs of the war. Years before the attack on Pearl Harbor, the Charleston Navy Yard had become a center for building new destroyers to defend against German U-boats. Having finished its first in 1937, by 1941 the yard had already produced five, and when construction of these vessels finally stopped in 1943, a total of nineteen had come off the building ways of the Charleston base. Since the U-boat menace in the North Atlantic had already accounted for the sinking of hundreds of thousands of tons of British shipping in the first two years of the war in Europe, American naval planners realized that modern destroyers, with the latest anti-submarine detection devices, were essential. The Charleston Navy Yard became a major facility for producing these destroyers for two key reasons: the lobbying efforts of South

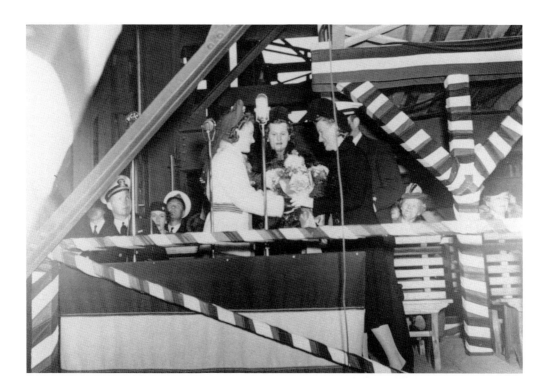

Before the launching of LST 356, Miss Sue Drury presents a bouquet of flowers to Mrs. Harold R. Parker and Miss Marion Marker, maid of honor, for the launching ceremony, November 16, 1942. Such activity was repeated for each of the more than two hundred vessels built at the navy yard during World War II. *South Carolina State Museum.*

Carolina's congressional delegation (especially Mendel Rivers and Jimmy Byrnes) to the navy department, and, more important, the other eight major national navy yards were already operating at full capacity with ship construction of all kinds.[45]

But by the middle of 1942, as the Allies had begun to check and then minimize the U-boat threat, the navy began changing the Charleston facility's main production function. As the Allies began to form plans for invasions of Europe and the Pacific Islands, the U.S. Navy foresaw a need for landing craft and supply vessels, and the South Carolina base saw its production shift to Landing Ship Tanks (LSTs) and the smaller Landing Ship Mediums (LSMs). LSTs, large, cavernous 350-foot-long ocean-going vessels, were designed to transport troops, tanks, trucks and other supplies from the United States to invasion beaches around the globe. LSMs were smaller crafts, a little over 200 feet long, that carried troops and military equipment and vehicles to invasion beaches, mostly in the Pacific Theater. The production shift was speedy, and though destroyers continued to be built in Charleston until May 1943, the first LST slid off the ways in the summer of 1942. Before the end of the war, 157 landing crafts of all types (but mostly LSMs) would be built. In addition, the Lowcountry base also built 17 destroyer escorts, 15 seaplane

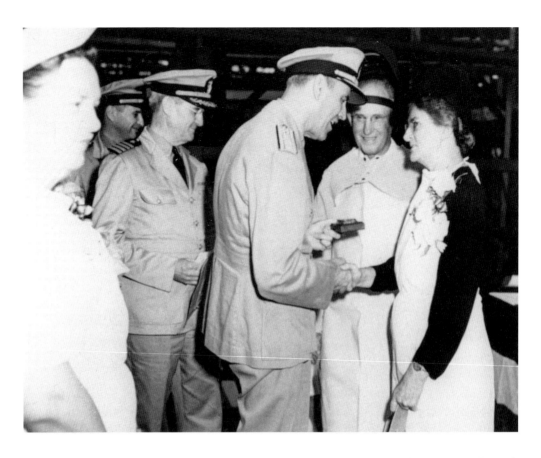

Admiral William Glassford, commandant of the Charleston Navy Yard, June 1942 through spring 1943, presents Mr. and Mrs. Hayes with a plaque commemorating the keel laying of LST 356 on Labor Day, 1942. *South Carolina State Museum.*

derricks, a seaplane-wrecking derrick and a few navy fleet tugboats—all while serving as a repair base for damaged United States and Allied warships.[46]

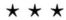

Another shipbuilding facility also existed in Charleston. Although much smaller, the privately owned Charleston Shipbuilding and Dry Dock Company (CSDDC) built fleet tugs, minesweepers and smaller naval vessels. Although its workforce would never go much above three thousand during the peak of the war production (compared to the navy yard's twenty-six thousand), the smaller shipbuilding facility played an important role in the city's economy. Like the navy yard, CSDDC was in constant need of skilled workers and supplies to maintain the production schedule set by naval authorities.[47]

Secondary industries also played an important role in Charleston's economy. The Charleston Port of Embarkation employed a little fewer than seven thousand workers

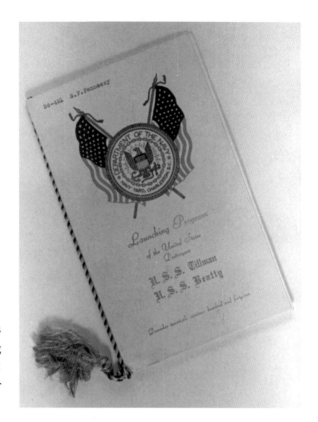

An invitation was sent to dignitaries inviting them to attend the launching of two new destroyers in late 1941 at the navy yard. *Courtesy of Palmer Olliff, North Charleston, SC.*

during its peak of employment in late 1944. From the attack on Pearl Harbor until Germany's surrender, it was responsible for shipping more than two and a half million tons of cargo overseas. While only a small embarkation point (it processed just over thirty thousand troops for overseas duty throughout the war), it was the port of entry for innumerable American wounded. During the last two years of the war, more than one hundred hospital ships were needed to bring them to Charleston, either for treatment at Stark General Army Hospital in North Charleston or for transshipment by hospital train to other army hospitals in the Southeast. By the last year of the war the hospital employed nearly a thousand doctors, nurses and support staff to care for all these wounded.[48]

In order to operate such an extensive and vital set of war industries and service programs successfully, sound planning, thorough management and ample numbers of skilled workers were primary needs. Though officially, federal agencies like the navy, army and the U.S. Maritime Commission were responsible for managing production at these facilities, they hoped to depend on Charleston and other Southern cities to supply a large portion of the labor.[49]

And indeed needs were mammoth because of the production volume demanded by Washington. Knowledge, skill and experience were required in specialties ranging from electricians and sheet metal workers to machinists, pipe fitters and riggers. To enable a modern navy to fight a war successfully against up-to-date enemy ships, the U.S. Navy had to build and equip its vessels with the latest electronic range finders, gunnery, radar

For security reasons, all navy yard employees had to wear an ID badge like this during the war. *Courtesy of Palmer Olliff, North Charleston, SC.*

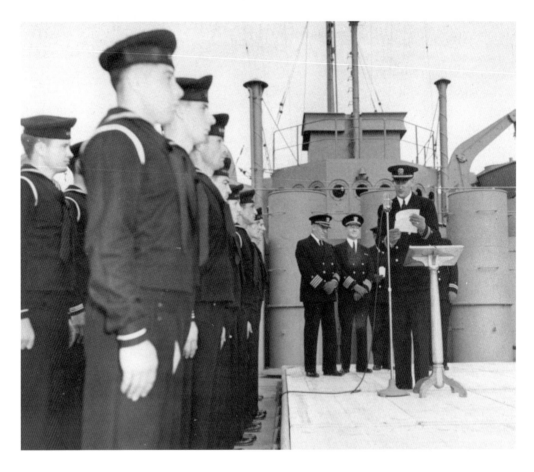

The crew of newly commissioned LST 356 receiving their orders from their commander, Captain Jacquenot, on December 22, 1942, at the Charleston Navy Yard. *South Carolina State Museum.*

Rear Admiral William H. Allen, commandant of the navy yard and the Sixth Naval District. A native of Florence, SC, Allen was a 1901 graduate of the Naval Academy. He assumed command in 1938 to oversee the facility's rapid expansion. Allen was replaced in 1942 and retired from the navy at the end of the war. *CNY Annual.*

and machinery. All of this required craftsmen skilled in ship construction, equipment installation and testing. Electricians wired ships for such basic things as lighting as well as sophisticated fire controls. Sheet metal workers were essential for a range of tasks, from fitting out a vessel's intricate air duct system to building metal furnishings, berths and instrument holders such as compass stands. Machinists had to build the engines needed to power modern ships of war. Pipe fitters were needed to build systems for transferring high pressure steam from the engines to power each vessel's large propellers, or for creating more basic but equally important piping systems for fresh water, flushing and other sanitation needs. Riggers, billed as perhaps the least skilled employees in shipbuilding, were still important and had to know how to lift, carry and place large machines, guns and furniture from the dockside to the ship's decks, both above and below the water line. In 1939 in South Carolina and much of the South, none of these skills were available in enough quantity.[50]

In Charleston, labor needs were especially critical. In October 1939, in fact, Captain Charles W. Fisher, the navy's director of shore establishments in Washington, learned from the Charleston facility that the register for skilled tradesmen at the Charleston Navy Yard was nearly exhausted. Not only were requisite skills hard to come by, but many of the experienced workmen whom the yard did have were seeking transfers to other facilities or resigning for unspecified reasons.[51]

One way to replenish the civil service register was to lower minimum requirements. One official became frustrated that, despite a vital need for more workers, the lowest entry-level position, helper general, required one year's experience. The official suggested that

Captain Albert M. Penn was the industrial manager of the Charleston Navy Yard, 1939–1944. He oversaw some of the yard's greatest expansion and had to deal with many problems including labor shortages, finding more skilled workers and inadequate housing. *CNY Annual.*

examinations be given to prospects with six months' experience instead. A certain level of experience for new workers was needed, he reasoned, but reducing entry requirements and giving more-on-the-job training would be an effective compromise. Allowing current workers who had already had some work experience to earn faster promotions to skilled and foreman positions would also be helpful in opening up entry-level positions. Gradually the official's suggestion became policy. Bolstered by a signed letter from Rear Admiral William H. Allen, Charleston Navy Yard commandant, the Department of the Navy worked with the Civil Service Commission to reform the register with these changes in mind. The requested reforms came about during the next two years, as the necessities of war production grew more acute.[52]

Despite these efforts to broaden the register, by 1941 there still were not enough Lowcountry workers to meet the navy yard's growing needs. The problem was so serious that desperate navy yard job recruiters even enlisted some of their own valuable skilled workers in the hunt for new employees. During that year a young pipe fitter, Robert Sneed, was one of four men from the pipe fitter shop assigned occasional duty over three months to travel up and down the South Carolina coast and as far as Orangeburg, eighty miles inland, to visit farms to recruit workers. Armed with a list of addresses of prospective recruits provided by the War Labor Board, Robert Sneed and a yard colleague went to each home to explain why the Charleston Navy Yard was interested in hiring and to evaluate potential recruits. Though, as part of their enrollment tactics, Sneed and his partner insinuated that failure to join the yard would bring a draft notice, the implication was perhaps unnecessary. Most men that Sneed contacted were eager to drop their farm

Instructors of the apprentice school helped turn out trained workers for the growing force at the navy yard during the last half of the 1930s to 1941. Once the war began, these instructors were unable to keep up with the accelerated demand for skilled workers, forcing the yard to train on the job more while reducing formal instruction, as was standard before the war. *CNY Annual.*

tools and head for Charleston. After the visit and the recruit's signing of an intent form, a letter came later giving the prospective worker a time to report to the yard for a physical and an interview. It is difficult to assess the success of this venture, but surely many farm workers, especially tenants, after nearly two decades of rural poverty, were happy to take the higher pay and steadier work of a job with the Charleston Navy Yard.[53]

Sneed's recruiting duties were part of a larger region- and statewide recruiting effort that began before Pearl Harbor and remained in effect until the summer of 1945. Before the war began, Captain Albert M. Penn, industrial manager of the navy yard, was aware

that the facility was in critical need of both more skilled and unskilled labor even as new workers kept arriving. By May 1940, the navy had instructed the Charleston base to employ as many workers as it could absorb, but the peacetime civil service regulations continued to hinder rapid employment of new workers. Eventually, in March 1942, the rating system and physical requirements were fully relaxed, though the constant need for workers never subsided.[54]

But vastly increased hiring could not alone solve labor needs. The Charleston base still had to give novice employees training before they could be effective workers. The apprentice program implemented during the mid-thirties had been created to develop skilled labor from the local population, but its extended course of instruction could not provide enough craftsmen for a shipyard in 1940 gearing up for rapid wartime construction and repairs. Though this program had expanded tremendously from its Depression days, it was essential to shorten the training time for its rapidly growing workforce.[55]

The apprentice program was revised in 1941, and instructors and novices now went through an intensive training program that included both class instruction and practical work in the various shops to which they were assigned. By March 1941, employment was growing at the rate of three to four hundred workers per month. The six-week apprentice program had four hundred openings, with a planned expansion to six hundred. Apprentices attended classes for one week; the other five weeks were spent in assigned shops, with practical instruction on machines and tools. Shipfitter apprentices who showed special aptitude were assigned loft work and eventually made into loftsmen. Apparently this group of workers learned so quickly that instructors wanted to accelerate their graduation to enable them to be placed immediately in full-time shifts, where they were desperately needed.[56]

Competent instructors were fundamental to the apprentice program. Nearly a year before Pearl Harbor, seven full-time instructors were working forty-eight-hour weeks. To supplement the instructor pool, classes for instructors were held on a regular basis. The navy further advised that new graduates from engineering schools such as The Citadel and other schools in the region, including Clemson and Georgia Tech, be recruited when appropriate. In addition, skilled craftsmen who did not necessarily have shipbuilding knowledge—pipe fitters from oil fields or electricians from building trades—should be designated for supervisory training. This, according to the secretary of the navy, would eliminate the need to take experienced managers from other yards in the nation or, in other words, the "robbing of Peter to pay Paul."[57]

By 1942, the positive results of the apprenticeship program were apparent. The navy yard had a significant number of trainees in many skills. In January almost 3,082 were in instruction and another 4,200 had completed their apprenticeships. Soon a new apprentice and trainee school, located on navy yard grounds, was serving 946 apprentices, 43 mechanic instructors and 51 shop supervisors. In addition, 286 unspecified workers took supplementary classes after normal working hours, while another 1,160 workers enrolled in an "in-service" training program outside of the school, but within the navy yard.[58]

To supplement the navy yard's program, a local program at the Murray Vocational School downtown also trained new workers in Charleston. In March 1941, evening and day classes were held for about 270 boys. Two full-time faculty members and eleven part-time staff members gave instruction in shipfitting, welding, machinist skills and electrician work. The part-time instructors were navy yard employees who taught two evenings per week. This program produced 40 to 50 graduates annually.[59]

The accelerated recruiting and training campaign also offered the prospects of better pay. In the fall of 1942 the lowest unskilled laborer earned a minimum wage of thirty dollars per week. Apprentices earned between thirty-five and fifty-seven dollars weekly, depending on the job category. Semi-skilled workers received a range of thirty-four to fifty-five dollars per week, depending on seniority and experience. Highly skilled workers such as journeymen electricians and machinists could start at nearly forty-one dollars per week and could reach a maximum of one hundred dollars. Despite government wage ceilings, salaries rose somewhat as the war progressed. But even as the yard tried to expand its workforce with constant recruiting and good pay, naval officials could not provide military deferments for most workers. By June 1943, Captain Albert M. Penn advised that the yard would have to focus on hiring new employees who were not eligible for military service, since many experienced employees were expected to be called by Uncle Sam. Usually only the most highly skilled workers or those in upper management positions received deferments.[60]

One novice who joined the navy yard apprentice school before Pearl Harbor was John Moore, a native of Summerville, just a few miles north of the navy yard. He took an entrance exam to qualify as an apprentice mechanic. After passing the eight-hour civil service test he began a yearlong series of comprehensive classes in mechanical drawing, math, physics and English. As he recalled decades later, the apprentices had a week of classes each month and then spent the remainder of the period working in the mechanic shop under direction of an instructor, making basic machine parts on lathes and milling machines. As he and his fellow novices mastered a skill they would move on to more intricate jobs. He also recalled that what he was learning was not easily mastered. Everyone in his class made errors and "many parts they made were not usable and had to be recycled."[61]

Charlestonian Robert Sneed learned the basics of his trade in the 1930s with the local gas company. After a year of training at the Murray Vocational School, he learned pipe fitting by connecting gas appliances in homes to the gas lines under the street. After a few years at this he decided to work at the navy yard because it had better pay. Having passed an exam, he became an apprentice there in January 1940, and later, during the war, trained many other apprentices.[62]

There is no question that as the war went on, most workers the navy yard recruited were sorely deficient in skills. Early in the war, training programs other than the apprentice program were offered through the National Youth Administration, but after mid-1943 most recruits bypassed even this training, going right onto the production line where they were given on-the-job training. Thus, of course, workers were welcomed who had not been part of the apprentice program, but had gained skills elsewhere. Attracted by better

pay and benefits, South Carolinians from the Upstate and Midlands found opportunities at the Lowcountry facility that none would have dreamed of a few years before. In 1939 Chester F. Russell Sr., a Spartanburg electrician, left his own business in the Upstate to join the electrician shop at the navy yard. The navy offered Russell the best prospect he and his family had had since the start of the Depression.[63]

Thomas Pack Jr., also of Spartanburg, took a vocational course in shipfitting in the Upstate city for about two months. Upon completion in September 1942, he became an apprentice helper at the Charleston Navy Yard. His wife and daughter came with him and remained until April 1945.[64] Edna Brown of Anderson also was able to turn an eight-week vocational course into a high-paying navy yard job in the machine shop. (She soon found, however, that her true vocation was not on the production line but in office work. The navy yard accommodated her, giving her work in its offices keeping track of employee time cards and filing maps and other records.)[65]

While in-state recruitment brought labor to the navy yard throughout the war, the huge labor needs made it necessary to recruit non–South Carolinians in growing numbers. Out-of-state recruits came both from Southeastern states such as Alabama and Mississippi as well as from states outside the region, such as Idaho and California. Newspaper ads seeking workers offered enticements of better pay, the opportunity to learn new job skills and, of course, appealed to the reader's sense of patriotism. A young Oxford, Mississippi, native, Sherlock Hutton, was attracted to the navy yard in 1941 to serve as a radiographer analyzing ships' metal parts in the test lab for defects. He was part of a team that included chemists, metallurgists and welding and materials engineers who came from places ranging from Georgia to Pennsylvania.[66]

By early 1942 the labor crisis was not only intensifying but also moving into a new phase, at once both hopeful and troublesome. The potential for tapping the nation's largest unused resource—women—offered hope for a resolution to the labor problem, but obstacles like the prevailing feminine image and male prejudice were troubling. The navy's view was "full steam ahead," and in February 1942, the Department of the Navy instructed Rear Admiral William Allen to "start in on using women."[67] For the rest of the war the Charleston facility, like other industries and businesses throughout the nation, would wrestle with how to handle this issue. Yet even with many men—and women—opposed to female labor, from late 1942 through 1944, during the peak of the war, the government supported an intensive recruiting campaign. Despite government support, a majority of women, in Charleston and elsewhere, would stay out of the workforce. In November 1944, near the peak of wartime employment, of the nearly sixty-five thousand women over age fourteen in Charleston County, less than twenty-three thousand worked (about 40 percent of these worked in war industries). Nonetheless, the navy yard succeeded in making women an important segment of its labor force, reaching one-fifth of its total in July 1944, when employment peaked at nearly twenty-six thousand.[68]

While the navy yard grew significantly prior to Pearl Harbor, new construction accelerated even more after the Japanese attack. Shown here is part of the new work to extend pier 317B, looking west, March 5, 1942. *South Carolina State Museum.*

If the numbers seem impressive upon first glance, a closer inspection reveals that navy yard attitudes toward women were far from what would be considered acceptable today. In 1944, the same year a feminist author claimed that women were able to work all but fifty-six of the nineteen hundred war occupations, the Charleston Navy Yard instructed Southeastern recruiters to hire women only as "mechanic learners." Claiming that the navy yard's other twenty-seven jobs, which ranged from "helper electrician" to "shipwright" or "packer," were suitable only for males, the Southern base's policy belied the fact that thousands of women across the nation were already working in a variety of shipbuilding operations. Perhaps the yard was reluctant to commit training to new women workers, since many skills took weeks, if not months, of training, and there was a fear that women were less likely than men to remain on the job. The position of "mechanic learner" required minimal training, which meant less of a loss if a worker resigned.[69]

Nonetheless, at the peak of the war, when national shipyard employment reached 800,000, only 17 percent of the workforce was women. By the fall of 1944, despite its early misgivings, the Charleston Navy Yard, in keeping with navy yards across the nation, employed nearly 5,000 female workers, many in traditionally male jobs such as welding,

electrical work and pipe fitting. At Charleston's other shipbuilding facility the proportion of women workers was smaller, with only 7 percent, or 181 females out of a total force of 2,558. Although social taboos and management reluctance may have hindered full employment of potential female workers here and at other Charleston facilities, women still made valuable contributions to the port city's war production.[70]

In December 1942, Mrs. Sophie Collom, a sheet metal worker at the Charleston Navy Yard, exclaimed that she was "just crazy about" her job. Collom worked on the 5:30 p.m. to 3:00 a.m. shift, and she claimed that she would not change her job "for any of the usual sort of jobs girls can get."[71]

Robert Sneed, who trained many female apprentices at the navy yard, estimated that he gave instruction to about three hundred women in the pipe fitting shop. In his opinion, at least 70 percent of women he trained worked as well as, sometimes even better than, their male counterparts. Although Sneed admitted that they lacked the physical strength of men, women made up for it through their determination and willingness to learn. He also noted that unlike men, women felt "they had something to prove," so generally took their jobs more seriously than male workers.[72]

Similar compliments were paid to women working in other local war industries. In January 1943, George Burton, superintendent of production at the Ordnance Depot, hired twelve women in their fifties to work on the production line. He claimed more women would soon join these twelve to work in the "pouring room" or chauffeuring officials to "important" meetings, delivering and picking up mail and doing other related tasks.[73]

Although women were not often welcomed with open arms into industry, African American workers were openly rejected from most skilled positions, even though there was a significant labor force of African Americans in the Charleston area well before Pearl Harbor. Prior to the war it was estimated that 2,000 African Americans worked in the Charleston Navy Yard (about 35 percent of the total workforce), and 100 worked at the Charleston Shipbuilding & Drydock Company (out of a total workforce of about 950), mostly in unskilled labor or helper positions. These low numbers can be mostly attributed to racial discrimination. However, other factors also contributed to the problem, such as the decline of Charleston's minority population— between 1940 and 1944 the population of blacks in Charleston County dropped from over 48 percent of the total population to 36.5 percent. Another significant problem for blacks was the historic disability of inadequate education.[74]

Scholars researching the low educational levels of blacks in South Carolina during the 1930s and 1940s agree that lack of education was a large handicap preventing blacks from gaining higher-level employment. In 1942, the War Manpower Commission (WMC) reported that there were fifty-one hundred available workers from Charleston's African American community, but it claimed that few could be referred for training at the Charleston base or its sister facility because of a general lack of basic education. According to the commission, 50 percent were illiterate, while more than 90 percent had less than three to four years of schooling. Indeed, only one in five African Americans who had applied for an apprenticeship at the navy yard had passed the preliminary exam.[75]

Job placement of African American workers corresponded with the low education levels. In October 1942, 3,185 blacks (or 17 percent of the Charleston facility's total labor force) worked at the navy yard. Most were classified as unskilled workers with the rest as semi-skilled.

But lack of education was only one of the obstacles blacks had to overcome.[76] Non-white labor was also singled out for lack of commitment. Throughout the war, job recruiters complained that African Americans were not accustomed to working a regular full week. In April 1942, a WMC researcher claimed that in "boom times, [African Americans] can get along better on three days work and three days leisure than they formerly did on six days work."[77]

Recruiters failed to recognize, or perhaps failed to acknowledge, the responsibility of the white system in helping to form African American attitudes. Many minorities may have avoided steady employment because of poor work conditions that white workers did not have to face—low pay and unfair labor practices of racist white managers. Unlike whites, blacks had few, if any, official ways of redressing unfair workplace activities, so in the 1930s and 1940s, Southern black workers resorted to unconventional forms of protest. Some historians argue that black workers who appeared insolent on the job or were late for work were often doing so out of protest, rather than out of laziness or lack of will, as most contemporary white observers perceived.

In the most overt forms of protest, black workers staged work slow downs or literally sabotaged factory equipment, as was the case in a 1930s textile mill in North Carolina. When the owners tried to speed up production as a way of reducing the workforce, one black worker admitted years later that black employees covertly broke the equipment to control the pace of work. No evidence suggests that such drastic actions were taken at the Charleston Navy Yard, but it is likely that the apparent transience of some black workers was due not to black shiftlessness, but to discontent with race-based working conditions.[78]

While most managers denied that racial discrimination restricted African American attainment of skilled jobs within Charleston war industries, their claims were at best contradictory. In 1942, when denying racial discrimination as a reason for the low number of blacks in skilled jobs at the Charleston Navy Yard, a federal official also conceded, "white workers would not work alongside black workers."[79] And while few cases of discrimination were reported in Charleston during the first two years of the war (no formal reporting mechanism emerged until 1943), there is little doubt that racism kept blacks out of skilled jobs.[80]

During the early months after Pearl Harbor, an experienced black machinist from New Jersey was hired from the register. A white colleague recalled that this new employee received no support from his white co-workers as he adapted to his new surroundings, and that few, if any, of the local workers would help the black recruit or lend him tools when he asked for them. It was apparently the intention of most in the machine shop to force the newcomer out.[81]

Another yard worker, Oliver Perry, recalled that when he applied for work at the navy yard before Pearl Harbor, blacks had few options outside of menial labor positions.

Those who had skills might be able to get on as a helper, giving assistance to skilled whites. Spurred on to apply by a white acquaintance, Perry filed an application that gave him no options for a position other than that of a laborer. To evaluate his abilities, the white supervisors gave him (along with other African American applicants) a manual test: lift and place a fifty-pound bag on his shoulders without falling over. The test was more difficult than one might imagine because the bag was weighted at one end. If an applicant placed the bag on the back of his shoulder he would invariably fall over. Perry discovered that if he put the bag on his chest that he could avoid falling, so he passed—one of the few who passed that day. Perry's new employers put him to work on the yard's rail lines, laying and maintaining track as the yard's expansion accelerated. Perry recalled years later that as far as he could remember, there was virtually no opportunity for minorities to gain journeyman status or higher until after the war.[82]

Another sign of the subtle discrimination toward black workers could be seen in their job training opportunities. While there were a variety of vocational training classes for whites at the Murray Vocational School, as well as within the navy yard itself, there were few openings for blacks. Most training opportunities had to be found in other areas of South Carolina and beyond, including St. Augustine, Florida, and Atlanta, Georgia. But these facilities were segregated and did not match the training schools whites used. The equipment was often either inferior or in too short supply to train all applicants—the result, federal government officials claimed, of foot dragging by state and local administrators. There were also long delays in finding instructors and equipment and tools.

Despite discrimination, a small but valuable number of blacks were trained in the state and other places in the Southeast for war work. In 1943 the WMC found that South Carolina training schools for blacks had 181 males and 42 females taking basic training in shipbuilding skills ranging from shipfitting, machination, welding, radio communications and bricklaying. Another 27 were getting supervisory training in shipfitting, carpentry and electrical work at the navy yard itself. About the same time in St. Augustine, 78 black males and 20 black females were completing thirteen-week courses for similar skills, making them eligible to take jobs wherever positions were available. The number of these newly trained blacks actually hired cannot be determined.[83]

Charleston's blacks objected to their low employment positions, but the community's leadership was fragmented and appeared too weak to push the interests of black workers. Blacks in other Southern cities, however, showed persistence. In Mobile, Alabama, lobbying efforts eventually led to a separate black welding school. When rumors circulated at the Mobile shipyards that blacks would work alongside white workers, a three-day riot ensued. The riot prompted government authorities and owners to establish a separate shipway for blacks. This shipway allowed blacks to earn promotions without antagonizing white workers. Despite efforts by white and black clergymen and others to work at reconciliation and a final solution, tensions remained high in the city for the remainder of the war. There were obvious racial tensions in Charleston as well, but naval authorities, determined to prevent disruption of production to meet the demands of the navy, kept a lid on overt clashes by keeping close watch on potential problems in the shipbuilding facility.

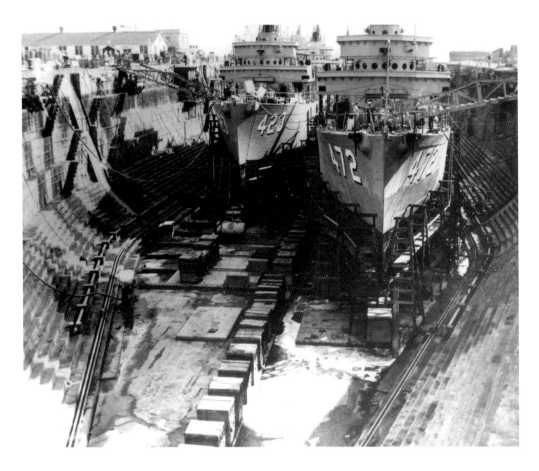

These war ships at a Charleston Navy Yard dry dock appear to be in for repairs and refits some time during World War II. *South Carolina State Museum.*

Additionally, in 1942, out of fear that violence would erupt, Charleston formed a bi-racial committee that helped ease tension in the area through the remainder of the war.[84]

Because discriminatory laws and customs hindered the full use of available black labor for Southern war industries, the need for more labor continued to be strong at the end of the war's second year. While newspaper ads and statewide recruiting lured many, both male and female, numbers continued to fall short of required quotas. By late 1943, new and higher quotas for landing craft production made yard planners realize that a more aggressive recruiting campaign was needed. In January 1944, the United States Employment Service (USES), under the direction of the WMC, selected navy yard workers to visit various Southeastern states to recruit more labor. At WMC offices in cities as small as Yazoo City, Mississippi, and as large as Birmingham, Alabama, Charleston yard workers spoke to potential recruits about the South Carolina facility. Those who enquired were interviewed about their skills and told how they would be used if they came to the Charleston Navy Yard. Again using the enticements of learning a skilled trade, better pay and patriotism,

recruiters tried to lure potential workers from other states, away from family and friends to Charleston, a city few, if any, had ever seen before.[85]

The Charleston Navy Yard did not rely only on the efforts of the personnel, however. Extensive newspaper ad campaigns and federal job placement services were also enlisted to recruit new workers. The WMC campaign, in fact, followed a detailed plan describing when to start labor recruitment, who should work within the various federal labor agencies and what methods should be used to reach the largest potential pool of workers. These methods included radio interviews, films, posters, booklets and public speeches.[86]

One such recruiting project involved Everett A. Gossett, a leading pipe fitter from the Charleston facility who, in January 1944, was sent on a recruiting trip to Alabama. For a radio program he was to appear on, he was given a six-page script written by the WMC with every detail of the program spelled out for both the announcer and Gossett. The program began with a musical fanfare followed by the tune *Anchors Aweigh*. The announcer began by introducing the Charleston man and identifying his military service in World War I and current duties at the Charleston Navy Yard. A story of the war action of a ship Gossett helped construct followed. Near the end of the program, listeners were told that in return for helping "get the fighting men on the Japanese beaches," prospective workers would receive good pay with plenty of overtime and that the navy yard would help each worker find comfortable housing. Those interested were advised to meet with Mr. Gossett at the local labor recruitment center for an interview and an evaluation of qualifications.[87]

As the campaign progressed, the WMC and its local representatives kept the navy regularly informed of its progress. Perhaps because of the extraordinary need for landing craft for the upcoming Normandy invasion and the continuing island-hopping by marines in the Pacific, Charleston had one of the highest claims on workers.[88] (Only the "Clinton Engineer Works"—code name for the Manhattan Project site in east Tennessee—and the tire cord industry—essential to the heavy-duty tires needed by the military—had a higher status than the Charleston Navy Yard.) Despite this priority, the yard still experienced a shortfall. The planned three-month hiring campaign for six thousand new workers at the Charleston Navy Yard began in early January 1944. By the end of March WMC state directors were notified that the campaign needed to continue for several more months. At the end of April the regional WMC chief in Atlanta, Frank Constangy, advised each state director that Charleston still required a minimum of forty-eight hundred additional workers to reach their quota by the middle of the summer.

The obstacles to attracting new workers to the South Carolina city were many. Grover C. Harris, local manager for the USES in Tuscaloosa, Alabama, reported in January 1944 that in ten days his office had interviewed thirty-seven applicants. Of these, seven were already employed and nine others refused jobs. Others were either rejected or did not return to the office with the necessary physical exam data. (It was difficult to find a doctor who would give a physical during this period because a local flu epidemic forced area physicians to devote their time to flu patients.)[89]

A significant number of workers from beyond South Carolina's borders were recruited, and by 1942 Charleston war industries had employees from all parts of the globe. Nevertheless, the navy yard and its sister shipyard, the CSDDC, never seemed able to get enough workers. Late in 1944 they (and other yards) began asking the Department of the Navy to let them tap another labor source—prisoners of war.

Since the summer of 1943, after the surrender of over three hundred thousand German and Italian troops in North Africa, the United States had become a growing center for the internment of Axis POWs. In early 1945 the chief of naval operations sent recommendations to all naval installations with manpower shortages to use POW labor, noting that twenty-five navy installations were already using five thousand prisoners. According to the Geneva Convention, POWs could not be employed in work that contributed directly to the war effort or that could be injurious to their health. The convention did require enlisted POWs to work, and non-commissioned officers could be ordered to serve as supervisors, though not as laborers. For an eight-hour shift, six days per week, a POW laborer was paid eighty cents per day. (POWs who had been officers were exempt from any labor, though they were to receive the same pay while imprisoned as they had before capture.)[90] Exactly when the Charleston Navy Yard began using this labor source is uncertain, but in January 1945, the commandant requested details on employing POWs at the navy yard for maintenance work of various kinds.[91]

The first temporary POW camps in South Carolina were established in late 1943 to help harvest peanuts and cotton in rural counties. By 1944, there was a medium-size base camp at Fort Jackson, in Columbia, and a growing number of satellite camps throughout the state, including the Charleston area. Although the dates of establishment for the latter camps are uncertain, by the fall of 1944 four camps ranging in size from two hundred to six hundred POWs were operating near the city. Some of the POWs were assigned to work at the navy yard to cut grass, provide labor for moving, loading and unloading supplies and to serve in the cafeteria in various capacities.[92]

Former navy yard workers recalled that POWs worked on the grounds or at the cafeteria (but none remembered POWs engaged in war production). One Charleston resident even recalled the prisoners were allowed to come to USO dances in the later stages of the war. After Germany surrendered, POW labor continued at this and other military facilities nearby for several more months.[93]

While POW labor may have been the most novel form of labor used in the Charleston area, others who were enlisted in the war effort were just as unlikely. By the middle of the war, handicapped workers had been assigned to various jobs ranging from gunnery systems installation to welding and painting. Along with some amputees, little people were among the most surprising war workers. Eugene S. David Jr. from Columbia, who stood forty-two inches tall, was assigned to do welding work in tight, shipboard places where an average-size individual could not reach. Normally, welding in cramped bulkhead areas could only be done by cutting openings into the area, but David could easily step into the space to do the work. This experiment was so successful that the navy yard began to recruit more little people to work in tight places that average-size shipfitters, plumbers and painters could not reach.[94]

Charleston's response to all these newcomers—out-of-staters, farmers, former shop girls, African Americans, German prisoners of war and an occasional little person—was mixed. The *News and Courier* for example, began a series of stories in the fall of 1942 that featured the new citizens. Entitled "Among the War-workers," the stories provided thirty fascinating, albeit rosy, pictures of newcomers' adaptation to Lowcountry life. The story of the Green family gives an example of the supportive tone. In 1941, Josephine Green arrived in Charleston with her husband who began work as a shipfitter at the navy yard. After remaining at home for a time, Mrs. Green became interested in doing something for the war effort, too. She soon entered a machinist course at the local vocational school and proved so adept that upon graduation, the yard hired her to turn out bolts and "other metal things." With both spouses working long hours, seven days a week, they had little time to visit their new home city except to take in an occasional movie.[95]

Perhaps the conservative *News and Courier* said it best in a January 1943 editorial. Noting the continued growth of the navy yard, predicted to rise to thirty-five thousand workers by the end of the year, the editor speculated that this good news might enhance the city's prosperity, yet it would place a new burden on taxed facilities already strained to the "uttermost." But even if "old Charleston is one of the casualties of the war," he said, there was no time to mourn the loss. Instead, the editorial advised that people be sensible and look for the best possible solutions.[96]

Solutions to the problems did come, but their implementation was often slow going and inconsistent. An example can be seen in the manner in which shopkeepers in the community approached the issue of adjusting their operating hours to accommodate shoppers with wartime work schedules. Charleston's small-town traditions dictated that shops downtown close at six. For many war workers who did not get off their shifts until that time, early closing posed obvious difficulties. It took city shopkeepers more than a year to become convinced that their hours needed adjustment, but finally in February 1943, shopping hours were extended to nine o'clock. With this change, storekeepers asked that regular shoppers do their purchasing between the hours of ten and four or to complete their shopping on Saturday mornings so that war workers would find less congestion when they came in the late afternoon. However, these concessions were partly reclaimed in 1944 when the closing hour was rolled back to seven o'clock, and not all stores agreed to stay open until then. For those residing near the navy yard the cutback was especially burdensome, since they had to make the seven- to ten-mile commute downtown after their shift using overcrowded, sometimes unpredictable, public transportation.

As for the generosity of native Charlestonians, their response to the newcomers, and the wealth and overcrowding they brought, was ambivalent. Most of those who grew up north of Broad Street, where middle- and working-class Charlestonians lived, welcomed the war's newcomers and did not mind the disruptions brought by their presence. As an Atlanta news reporter wrote in 1943, Charleston was adapting to unprecedented growth. Small businesses and other local entrepreneurs loved the jingle of money in their pockets and even the members of the community's elite, those who lived south of Broad Street, were supportive, albeit in a conservative, lukewarm sort of way. To illustrate upper-class

cooperation, the Atlanta journalist pointed out that the upper class had rented 90 percent of their spare rooms and apartments in their aristocratic homes near the Battery to servicemen, their families and war workers.[97]

But some Charlestonians were less sanguine, fearing that they would have to aid newcomers once the war ended. Certain local officials and businessmen predicted that the war boom would be temporary and that, as soon as the Allies won, Charleston's prosperity would turn into another postwar depression. One local shopkeeper looked askance at the wartime money spent and predicted that all the new people coming to his city would leave as soon as the war ended. He felt it "foolish" to expand his and other businesses to meet a "temporary need," and predicted that not only would the outsiders leave at the war's end but that he and other natives would also have to "fill their gas tanks" so they could get out of town.[98]

Others, like some old establishment members of the community, showed only half-hearted support for wartime changes, no matter what the national emergency might demand. Such was the case with those whose cause was maintaining historic buildings. A visiting wartime journalist noted the central importance of old structures to these preservationists. Describing the whole city as a museum, he observed that eleven hundred city buildings were aesthetically remarkable enough to be on "index cards." To protect this beauty, a community development council had formed to guard the historic areas of the city. During his visit, the journalist was shown a new brick housing project that had been built as an answer to desperately needed housing. Referring to the new buildings, an old dowager told the visiting journalist tersely that she and many had fought "every step of the way" during its construction to prevent it. In his article, the journalist predicted that if the navy tried to cut down another whole section of the historic area, the community would "explode." Fortunately, for both sides, this never happened.[99]

Fear of change, for many Charlestonians, seemed to outweigh even the crisis of war, and this dread was often reinforced by small, seemingly trifling issues. Newcomers did not adhere to many of the traditions that were ingrained in the minds of native residents. For example, many neophyte Charlestonians were not used to the rice and grits staple of the Lowcountry, and did not know how to eat them. One grocer was scandalized that they fixed their grits "all up with sugar and cream."[100] On another level, Charlestonians also expressed shock at the smallest effort at racial integration. In 1942 a Lowcountry native complained to Governor Richard Jeffries that his wounded brother had to share a ward with a black patient in Charleston's Stark General Hospital.[101]

Still, other natives had more positive attitudes about what new things the war introduced. One Charleston resident remembered years later that sour cream on a baked potato was a new delicacy introduced during the war. Before Pearl Harbor she had never seen a potato garnished like that. Another dish introduced by Yankee shipyard workers was lasagna. At first exotic, Charlestonians soon came to prize it.[102]

In addition to foods, the city encountered new ideas on every subject from language to tastes in automobiles, which would have a lasting impact on the future life of the city. Some natives recalled that workers who came from places such as Brooklyn, New

York, introduced new expressions, perhaps influencing the local dialect that had been relatively stagnant since the Civil War. The vernacular expression, "youse' guys do this" became common in many navy yard circles. Although new cars stopped coming off assembly lines in early 1942, the local popularity of traditional Ford and Chevrolet models was soon challenged by other makes of cars that were rarely seen in the prewar city. Plymouths, Studebakers and Hudsons became a common sight as new workers from beyond South Carolina and the Southeast drove to the Lowcountry in search of war work. Even new varieties of cigars appeared. One Charlestonian was introduced to the "White Owl" cigar for the first time after Pearl Harbor, and liked it. Soon it was a common item in Charleston stores.[103]

Reflecting on the changes that occurred in their native Charleston, Robert Sneed and Johnnie Dodds were positive about the war's impact. Having lived through a Depression when jobs were hard or impossible to find, they were pleased with how the nation's war needs had turned Charleston into a boomtown where jobs were plentiful and salaries above average. Not surprisingly, working men saw the war period as one of the best economic times of the century. With the war came plentiful jobs, good wages and better prospects for the future.

But along with economic benefits came extreme overcrowding, too many outsiders and a general and unprecedented sense of social disruption. After decades of isolation from the mainstream of American society, Charleston was not prepared to handle the sudden new problems bequeathed by its bustling, overextended society. The Charleston representative of the Committee for Congested Production Areas summed up the dilemma well: "Charleston," he said, "with its staid, deep rooted Southern traditions has not been an easy area to transform into one of intense activity."[104]

Chapter III
Labor, Gender and Race in War Production

"So if we work a little harder
For our boys across the sea
We won't have the time to grumble
And that goes for you and me."

Excerpt from poem by Mildred D. Barnes
Shipfitter shop, Charleston Navy Yard[105]

As in any large industrial complex there were many individuals and schedules to incorporate into one cohesive production unit at the Charleston Navy Yard. Consequently, disagreements, rivalries and egos swirled as the navy yard brass did its best to keep the workforce focused on producing as many ships as it could to help win the war. Even with such problems, the workforce at the yard made valuable contributions to the war effort that resulted in surpassing production quotas set by Washington. One issue that remained a small but persistent irritant throughout the war was the labor union.

On January 6, 1938, when trying to inquire about an attack earlier in the day on a fellow union man, Charleston Navy Yard Watchman John G. Frain and companion R.L. Bergquist, a seaman and fellow organizer of the Committee for Industrial Organization (CIO) local, were attacked by rival American Federation of Labor (AFL) members who were meeting at the downtown Francis Marion Hotel. The assailants included A.G. Flynn, veteran worker and union leader at the navy yard since 1914, and three associates. They attacked the CIO men because the organization had dared to compete for union membership within the Charleston area. Despite the flagrant nature of the attack, less than two weeks later, the Charleston magistrate dismissed the charges of assault and battery, which Frain had brought against his assailants.[106]

The reason the magistrate gave for his ruling was that Frain and his associate had trespassed on Flynn's property. Even though the confrontation occurred in a hotel, the magistrate stated that the hotel was "the same as a man's home" and that "a man is justified in defending his home." In the official's judgment, the plaintiff had provoked the beatings and, consequently,

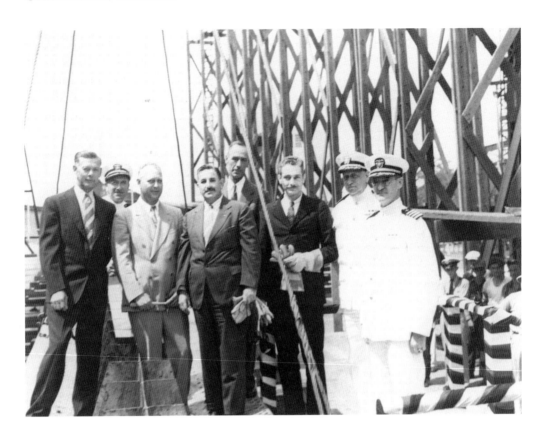

A group of civilian engineers and naval personnel near a building way at the Charleston Navy Yard late in the war. Standing just left of the navy officers in a dark coat and tie is William Boyce, marine design engineer and head of the design section at the yard through the war years and after. *Courtesy of William and Betty Boyce, Charleston, SC.*

had no case. The ruling seemed strange, but a deeper understanding of union ties in the community sheds some light. Although Frain had a good work record during his two years of service at the navy yard, supervisors had reportedly cautioned him about distributing "propaganda" to fellow workers, and there was a rumor that he had communist affiliations. Flynn, by contrast, was not only a longtime navy yard veteran, but also an important figure in the existing union leadership, serving as president of the AFL local, as well as the chief executive of the state AFL. Furthermore, Flynn reportedly controlled many votes in the Charleston mayoral elections, which in turn helped garner him favor with public officials (like magistrates). Under the circumstances, it seems plausible that navy yard watchman and CIO radical Frain lost his case before he even filed charges.[107]

The navy yard commandant was just as unsympathetic to Frain as the magistrate, but for more obvious reasons. Since the assault occurred beyond the boundaries of the navy yard, the commandant determined the affair was outside his jurisdiction and no navy investigation was made.[108]

Although the *Frain v. Flynn* battle was one of the few instances of union rivalry or violence in Charleston before and during the war years, it suggests the complex nature of labor relations, especially at the navy yard. Generally union leverage was confined to the control of promotions and the assignment of members' work schedules—if a worker did not belong to a union he had little chance of getting a promotion or the opportunity to gain the most favorable work schedules (daytime work schedules were preferred to the midnight or graveyard shift). Thus union presence provided labor some influence over management, but not over larger issues such as contract definition and total working hours, especially at the navy yard.[109]

Though the union's influence in Charleston was somewhat ambiguous, union power and policy were often blamed for disrupting work schedules and causing delays. One observer of this influence was navy yard management team member William Boyce, the Brooklyn Navy Yard transplant who had come to Charleston in 1937. Not long before Pearl Harbor he was appointed chief design engineer. Years later he recalled that union activity had stepped up to some extent during the war, leading to rigid labor assignments, which at times delayed completion of work assignments. Union rules, according to Boyce, required management to strictly match tradesmen to all tasks. Consequently, before an electrician could thread a wire, a carpenter first had to drill the hole. This often led to delays when the necessary tradesmen were working elsewhere when needed. To avoid these delays, Boyce and a design team colleague would sometimes go on board a ship after normal working hours to make their own adjustments to propeller shafts or related operating mechanisms, bypassing union protocol. Yet Boyce's frustration over union "meddling" and delays were perhaps exaggerations because he admitted that union influence at the navy yard was not a major problem to management until long after the war.[110]

Another white-collar worker, Sherlock Hutton, recalled having a sizeable quarrel with union regulations. At the metallurgy lab, he and other specialists used machines that needed up to two hundred and fifty thousand volts for testing different ship parts such as propellers and shafts. With so much electricity concentrated in one piece of equipment, the union required the lab to have a certified electrician assigned during working hours to service the machine. Hutton claimed that the equipment was so new that electricians knew no more about the equipment and its operation than the lab scientists and technicians who used it for their daily tests. Another labor obstruction, Hutton remembered, was a union regulation requiring a forklift or some other hoist for all parts weighing over fifty pounds. This struck Hutton as absurd—sometimes he and his lab colleagues had to wait an hour or more for the right forklift to arrive to move a crucial part for an x-ray. To get things moving, he admitted, when possible he ignored regulations and moved the part himself.[111]

Despite these incidents, union members and management agreed that union power during the war was marginal. While the navy yard's unions were mostly affiliated with the AFL (because its labor was mostly skilled), the base was not a closed shop. And even though union membership increased steadily during the war, the bargaining power of the navy yard locals did not increase substantially, as Cecil Clay, a sheet

metal unionist, found when he came to the navy yard in June 1941. Few workers, he recalled, wanted the third shift (12:00 a.m. to 8:00 a.m.), and complained bitterly if they had to work this shift outside the normal four-week cycle. But certain workers had more influence with the union leadership than others, which led to accusations of favoritism. The resentment this caused led some members to quit. In the sheet metal union, local promotions were also a cause for tension. Occasionally workers with less experience gained advancement from journeyman status to leading man (foreman) because they were friendlier with the shop master. Members who felt overlooked resented this, leading some to drop their membership.[112]

But some workers denied that there were even these minor benefits from union membership. John Moore saw little gain from his union affiliation except the monthly meetings where he learned about better jobs at other navy yards. Robert Sneed did not even recall this meager perk. What he remembered was union ineffectiveness: although unions tried to bargain on workers' behalf, they had little or no power to back up contract demands in management negotiations.[113]

Of course union weakness was a national problem through most of the thirties, for the labor movement had faced a serious decline in membership early in the Depression years, which had only partially improved after Roosevelt's union legislation in the latter part of the decade. With jobs so scarce, unions lost their appeal as workers desperately sought any employment they could find. Even when the nation began to rebuild its defense industry in the late thirties and early forties, union membership only moderately improved. Enforced wage freezes soon after Pearl Harbor also kept interest in unions low. But all that changed when the War Labor Board (WLB) decreed the legality of a "maintenance of membership" clause; in consequence, union affiliation steadily increased through the remainder of the war. In part, the WLB decree was an effort to earn organized labor's support for a wartime limitation on wage increases and a no strike pledge. It stipulated that a worker hired into a unionized shop had fifteen days to resign from its labor organization. After that period he could not opt out for the remainder of the union contract and had to pay union dues.[114] Ignoring the clause could lead to punishment or dismissal. However, while the law stipulated severe penalties if a worker opted out of the union, such rules often were ignored or overruled in order to maintain production schedules.

B.A. McMahon, a pipe fitter at CSDDC, experienced the consequences of the decree. McMahon had his work card pulled by the union because he refused to pay his dues. After fifteen months of employment McMahon had neither paid his union dues nor resigned from the union, and was fired as a result. McMahon's skill was eagerly sought by other war industries, and he had a position waiting for him at Bell Aircraft in Atlanta. But the WLB decree was waiting as well; he could not accept the new job until the WMC gave him a statement of "availability for work." Without this document McMahon faced a ninety-day waiting period as a penalty for leaving his job without permission. McMahon claimed he was not unique in his desire not to be affiliated with the union; many other skilled workers also did not want to be union members. Requests by the Atlanta office to Washington for a ruling on McMahon's and similar cases appeared to support his claim. In any event,

This "Shipbuilder's Creed for '43" poster was probably a common sight in and around the Charleston Navy Yard to encourage its work force to build and repair ever more ships in the drive to defeat the Axis. *Special Collections, Clemson University Library.*

a pipe fitter's skills were too valuable to be wasted. Within a month of McMahon's firing, the WMC ruled that he and anyone else like him would be granted releases so they could work with "another essential employer."[115]

Though the labor union in Charleston could not enforce union membership and had little influence with yard practices, the navy yard union did become a strong defender of workers when navy inspectors attempted to criticize their efficiency late in the war. Despite the navy yard's impressive production record, a naval inspection team of high-ranking officers found problems in its overall work efficiency. While production within shops was praised, inspectors observed many "idle" workers aboard ships under repair or being outfitted. Those who were working appeared not to do so with adequate diligence. The inspectors concluded that the civilian workforce could be used more effectively by breaking down each job to its simplest elements. Although not clear on exactly what they meant in practical terms, inspectors implied that the various job sequences aboard each ship needed more orderly arrangements because "either too many men were assigned to one job or not enough."[116]

But union officers adamantly asserted that the problems did not lie with the workers. In fact, even before navy inspectors began their investigations, labor leaders had voiced opposition to management's views on work efficiency. It was not workers' efficiency that was at fault, union leaders contended. They alleged that the real problem lay with navy officers on the production lines—not only were there too many of them, but they were inefficient and often incompetent. This was what caused labor's production deficiencies. Not surprisingly, the navy inspectors disagreed with the union's analysis.[117]

Although labor and management friction existed in Charleston throughout the war, it never grew bitter enough to cause strike action. Work stoppages that did occur were outside the navy yard, concentrated in the building trades and often lasted no more than a few days. Through January 1943, four Charleston construction projects were struck or threatened with strikes. Apparently, to prevent scab labor from working on these sites during the strikes, union leaders demanded the right to screen all potential employees. In other words, the union would delay new employment until the disputes were settled.[118]

Sometimes white-collar professionals disagreed with management practices independently of the unions. As with most accelerated building programs around the country, Charleston saw a massive increase in new wartime labor in the months following Pearl Harbor. Even though thousands of new recruits were welcomed, the Charleston base had problems integrating all efficiently into their construction programs. This inefficiency appeared to linger in some navy yard departments for more than a year into the war. In February 1943, twenty-five frustrated engineers and draftsmen at the Charleston base petitioned the WMC in Atlanta, convinced that their expertise was not used at "maximum efficiency." The petitioners complained that yard policy was to hold many trained workers in reserve for "future building programs," even though they were finding themselves under-utilized for weeks or months at a time. Fearing that their request would be "vigorously contested" by management, the dispirited professionals sought employment at another place where their "capabilities" would be more fully used.[119]

Sergeant William Bendt began work at the navy yard as a laborer in 1939 and was promoted in less than a year to the personnel department. By the time this picture was taken in 1951, Bendt had already been back at the base for five years since his return from service in World War II. He had a long, successful career before retiring in the late 1970s. *Courtesy of William Bendt, Charleston, SC.*

To forestall the frustration of these employees and control the navy yard's severe labor turnover rate, management devised a plan to improve labor retention. In the spring of 1942, workers who asked to leave the Charleston facility were required by navy yard management to attend exit interviews. Captain Albert M. Penn claimed that during these interviews management was often successful in convincing workers to stay. Apparently, during the interview, management tried to pinpoint reasons the employee wanted to leave, and they then attempted to find a solution that convinced the worker to stay. And if the interview failed, according to Penn, many still returned when they were placed on a "no release" basis without an opportunity for comparable work for ninety days.[120]

In the Public Works Department of the navy yard, William Bendt, who had gained a promotion to the personnel department by 1940, dealt with employee issues until he was drafted into the army in the fall of 1943. Most of the cases he reviewed involved tardiness or leave without permission. After an interview to resolve the problem (where interviewers pointed out how important the employee's work was), employees usually reformed and changed their work schedules. Only in a few cases were more drastic measures required. Bendt recalled that in cases where a worker refused to reform, the rebellious employee usually left on his own accord before the department actually had to formally dismiss him.[121]

Nonetheless, when workers felt misused or not appreciated, some left to join other shipyards, which were eager for more qualified tradesmen. There were several rivals for skilled workers—in fact, just across the Georgia border. Even though the War Stabilization Board had mandated that workers could only change jobs if local employment agencies received authority from the regional director of the WMC, some tradesmen found ways to get around the law. The result was that occasionally Georgia shipbuilding firms were able to hire away skilled craftsmen from the Charleston Navy Yard, although not without protest, as occurred in late 1942, when the shipbuilding firm of J.A. Jones Construction Company Inc. in Brunswick, Georgia, hired a former Charleston Navy Yard electrician, Perry Morain, who had left the South Carolina facility voluntarily. Despite the WMC national directive that workers who voluntarily left their war job would be put on "no release" status for ninety days, Morain beat the system through a loophole in the law. Since his new employer was a private business, it did not need to adhere to federal provisions. According to the WMC regional office in Atlanta, J.A. Jones Construction was within the law when it hired Morain immediately after he left the Charleston Navy Yard.[122]

Despite the loophole, the navy yard tried to force the electrician back to its production lines (even though Morain was not a particularly efficient worker, having failed to gain advancement at the navy yard after temporary assignments as an apprentice supervisor and later as safety inspector). However the Charleston bid failed. Morain's new employers had given him a higher rating as soon as he started work at the Brunswick facility. Captain Penn, industrial department manager at the Charleston base, argued that allowing Morain to leave would set a bad precedent for other yard workers, but he failed to convince WMC authorities in Atlanta. Instead, WMC regional director B.F. Ashe countered that Morain would remain with Jones Construction because he had strong personal reasons for leaving Charleston and his work at the Brunswick company was "very satisfactory."[123]

Although Morain's case may not have been as significant for the retention of navy yard workers as Penn claimed, there was a large problem of labor retention in Charleston. Both before and after the electrician's defection, retention rates at the facility were low. By April 1942, WMC labor recruiters reported that the yard was losing three to four hundred employees per month. Even though some of the turnover was caused by the military draft, it was small comfort to navy management who tried to maintain production goals with a fluid workforce. For the first eight months following September 1942, predicted needs of Charleston's major war industries stood at 8,400 new workers. Two years later the difficulties of keeping sufficient labor continued to plague the yard. The worst decline was in August 1944. Despite 1,197 new hires, the Office of Community War Services, a labor research team of the Federal Security Agency, found that 1,963 workers had left the Charleston facility's employment.[124]

The daily leave records of the navy yard reflect similar problems. From March 1943 to February 1944, the Charleston base had the third-lowest sick leave rates nationally of the nine major navy yards, just behind Boston and Puget Sound. On the other hand, when all leave categories were combined—sick, annual, leave without pay and unauthorized leave—the Charleston base had the third-highest rate, with 14.3 percent of total working

hours lost. Only the bases at Norfolk (16.2 percent) and Washington (14.5 percent) had higher rates. Most alarming was the unauthorized leave rate: it stood at 4 percent, nearly twice the average for this category for the nine navy yards. Like Charleston, the Washington and Norfolk yards were located in communities that were strained by the housing shortage and the influx of thousands of new workers that greatly overextended their infrastructures. By comparison, the Boston and New York yards had the lowest time lost on the job, with 8.7 percent and 9.9 percent, respectively. This was due, in part, to the larger capacity of these major cities to provide adequate housing and better address other needs of workers.[125]

Federal government efforts to help with worker retention by restricting labor movement had limited effect, as Perry Morain's case indicated. During the early months of the war the Manpower Mobilization Board had ruled that any worker who quit a job could not be hired by anyone else and would also lose his draft exemption. But this directive incensed labor leaders, and the War Production Board dropped it, resorting to persuasion and negotiation to slow worker mobility. However, it seemed that the Charleston Navy Yard and its neighbor, CSDDC, had an independent, unwritten agreement preventing workers from leaving either firm to join the other, or any other war industry in the area. In spring 1943, W. Rhett Harley, state WMC director, reported that even when the local USES referred a prospective worker to one or the other shipyard, that worker was not hired if he already held a job in the Charleston area. One Charleston worker, K.J. Gillam Jr. experienced this unspoken agreement. Though a painter by training, Gillam had worked as a shipfitter helper at the CSDDC beginning in September 1942 because he could not get on at the navy yard in his trade. But when a navy yard appointment came the following February, carrying a higher pay grade, the CSDDC refused to release him.[126]

Wages and better working conditions were not the only reasons for the navy yard's problematic situation with labor retention. Other more logistical problems often caused absenteeism or departure. As early as 1941, inadequate housing and transportation affected employment levels and retention of workers at the navy yard. By 1943, despite improvement in these two areas, workers still protested to the navy yard commandant that poor housing and high rents would force them to leave the area if the problems were not rectified.[127]

With many workers living several miles or more from their jobs and with gas and tire rationing in full effect by May 1942, transportation was another problem. While some workers had access to private cars, many had to rely on an overworked bus system. In a little over twelve months, the number of passengers carried had increased from over 890,000 in July 1941 to more than 2.5 million the following August. Some craftsmen who lived on the other side of the city from the navy yard protested that it took two hours to get to work. Overcrowded schools and lack of day-care facilities were also impediments to workers coming to or staying in wartime Charleston.[128]

In spite of problems, Charleston's industries made important contributions to the war effort. As one of the biggest industries on the Southern Atlantic seaboard, Charleston's yard got the largest production quotas from the Department of the Navy. Washington provided new facilities to try and help meet these quotas. Although a third dry dock was completed

Above and Below: These odd-looking trolley buses, standing in front of the yard's main power plant building, were shipped to Charleston from the New York World's Fair after it closed in late 1940. Notice the World's Fair logo still on the sides. These buses were used to transport workers from one part of the yard to the other. With the nation just gearing up for war, all available resources were used to solve transportation shortages within in the ever-expanding naval facility. *South Carolina State Museum.*

Supervisors in charge of building way and dry dock assignments wait for their commission to the new dry dock #3 in the South Yard, February 3, 1943. This was part of the accelerated expansion of the navy yard begun the year before. *Courtesy of Palmer Olliff, North Charleston, SC.*

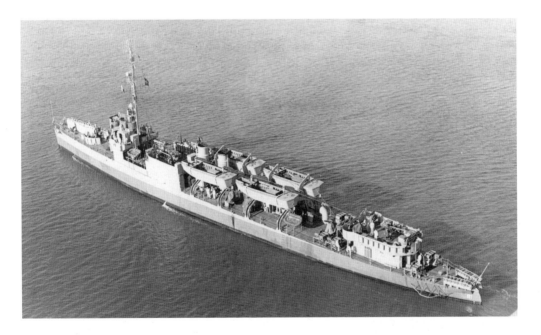

The USS *Dickerson* (APd 21), seen here September 26, 1943, was originally built in New Jersey as a destroyer in 1919. The Charleston Navy Yard transformed it into a fast transport by the middle of the war to get men and equipment to invasion beaches in the Pacific. In April 1945, off the coast of Okinawa, Japanese kamikazes damaged it so severely that it had to be scuttled by the navy shortly after. *South Carolina State Museum.*

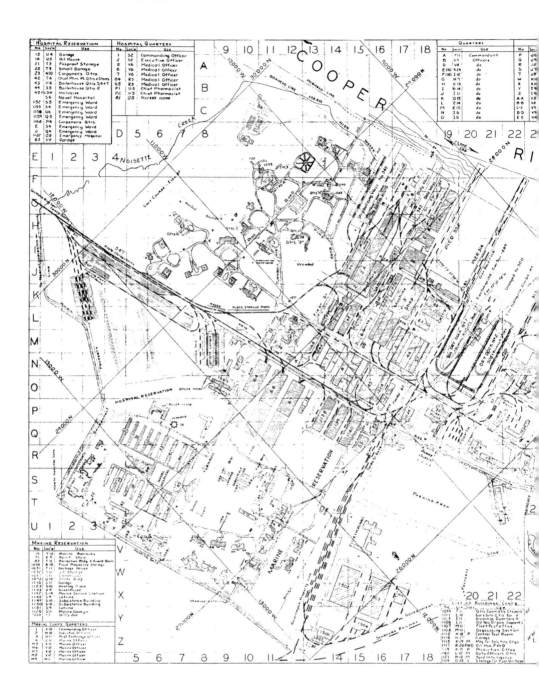

After one year of war the navy yard had expanded tremendously, adding thousands of men and materials as construction had begun on a major expansion to the south of the original yard complex. This became known as the South Yard. (1942) *Courtesy of the Navy Base Redevelopment Office Map Room.*

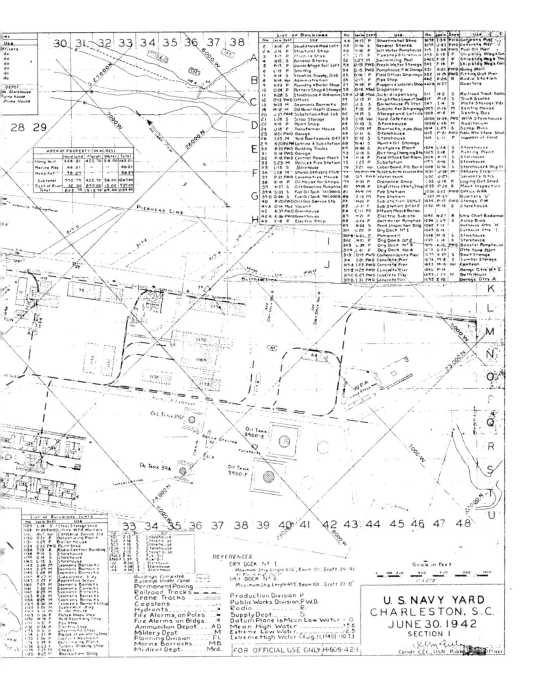

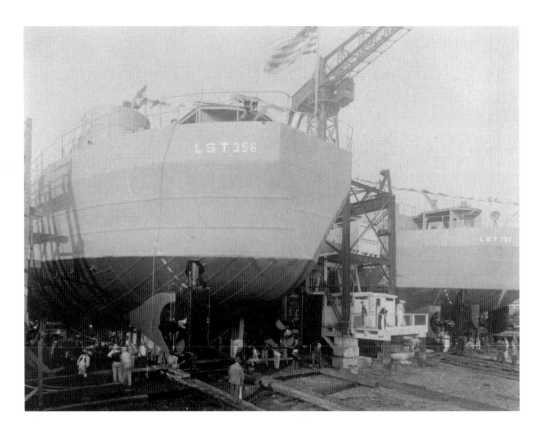

LSTs 355 and 356 on the building ways at the yard just before their launching on November 16, 1942. *South Carolina State Museum.*

in spring 1942, this was already insufficient to meet the accelerated production quotas of a wartime navy. To meet the navy's requirements for accelerated destroyer and destroyer escort production, the yard needed additions to its construction facilities. Consequently, the navy authorized the Charleston base to build, nearly from scratch, a second facility that became known as the South Yard. It included two smaller dry docks, shop buildings and piers. After an amazingly quick planning and approval process that took only two months, construction of the new facilities began in early spring 1942. Along with adding eight new shop buildings, building contractors also added new crane and rail tracks and enlarged an existing structure. Complicating the job was the requirement that large shop buildings must be built with wooden frames rather than the traditional steel ones in order to save the precious metal for war ships. Despite such restrictions the extreme urgency of the situation saw the new facilities completed by late winter of 1943. By then construction had already begun on the first two destroyer escorts (DEs)—even before the new dry docks were completed.[129]

Nonetheless, just as the DE program was getting underway, the Charleston yard had to shift direction again, to producing troop transport vessels and landing craft. Although the

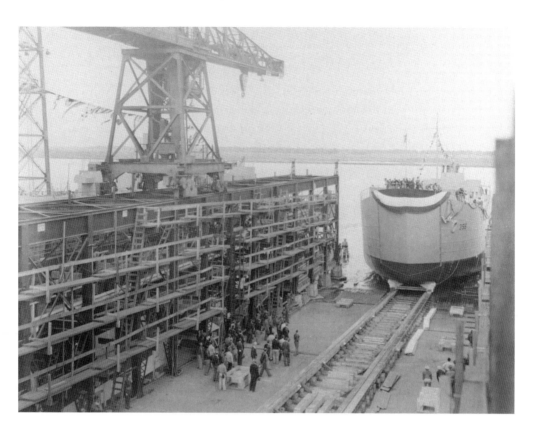

LST 356 entering the waters of the Cooper River off the yard's building ways #342 following its christening on November 16, 1942. *South Carolina State Museum.*

U-boat threat to convoys was still significant, its impact was waning. A critical need now was vessels to support the forthcoming invasions of the Pacific Islands and Europe. In the midst of the DE construction acceleration, the first landing craft also went down the ways in December 1942. By the end of the following year the new construction program was fully underway.[130]

Carrying out these massive construction programs required extensive planning, good worker productivity and sound labor-management relations. As additions to the yard were completed, shipyard production accelerated. By the time Germany surrendered, the Charleston facility had built more than two hundred ships and repaired or refurbished innumerable vessels ranging from cargo ships to destroyers. Yard productivity was so impressive, the U.S. Navy Bureau of Ships in Washington recognized the workforce for exceeding their wartime quotas. To commemorate this the Charleston base was awarded the coveted army/navy "E" pennant (a large blue and red streamer with a white "E" for Excellence), a prize accorded all the nation's industries that produced more than their assigned quotas. In October 1942, before a large assembly of navy yard workers, the pennant was presented with great fanfare. Charleston's high production performance continued to

please navy brass and led to four additional "E" pennant awards. Remarkably, the yard had maintained its impressive production record in the face of two sudden changes in shipbuilding priorities.[131]

Charleston's productive efficiency was, of course, measured in other ways as well. In 1943 the navy yard beat its previous record in constructing destroyers. Having completed a destroyer in only seventy-seven days in 1942, in May 1943, workers were able to finish two in just fifty-nine days.[132]

This achievement was attributable, in part, to the sense of urgency and the patriotic zeal of many workers. The growing labor shortage after Pearl Harbor and resulting recruitment and training of women and minorities for jobs normally performed by white males proved indispensable to the yard's ability to meet the high production goals demanded by the war.

As in the rest of the country, the recruitment of women for war industries seemed at first a radical step for South Carolinians. Before the war, the number of women working in United States industries was small. Even in a heavily industrialized Northern city like Buffalo, New York, in late 1940, only 85,000 women were employed out of a total industrial force of 230,000. Within three years, however, this number had more than doubled to 185,000. On a national scale, the increase was just as significant. While in the late 1930s only 8 percent of workers in durable goods production were women, by 1944 the percentage had increased to 25. Shipbuilding showed a particularly dramatic change: in 1939 only 39 women, nationwide, had jobs in this industry, but by March 1943, there were at least 23,000 women in that industry.[133]

Charleston mirrored the national trend. Few, if any, white women worked in manufacturing during the Depression. But less than a year after the nation declared war, the female production force grew dramatically. At the Charleston Navy Yard the number of women workers went from virtually none to 1,334 in a total workforce of 18,465 (7 percent). That same year the Port of Embarkation claimed 437 women out of a total of 2,744, and the Ordnance Depot had 210 women among its 1,800-person workforce. As the war continued, the number of female workers multiplied. By September 1944, nearly 4,900 (almost 20 percent) of the Charleston Navy Yard employees were female. The Port of Embarkation kept roughly its same percentage of women (about 15 percent), but females now numbered 975. Smaller industries in the area had larger percentages, including the General Asbestos and Rubber Company, where women made up nearly a third of its 880 employees. Although some of the new female workers were employed in traditional office jobs as secretaries and messengers, the increase on the production line was significant.[134]

Despite the wartime necessity for large numbers of working women nationwide, many industrial managers and male co-workers were loath to accept them, particularly during the first year of the war, except as a last resort. As long as enough male workers remained available, managers continued to draw from that pool. But as armed forces recruiting accelerated, fewer and fewer men could be found to shoulder the growing demands of war production. This in turn changed the attitudes of recruiters: in January

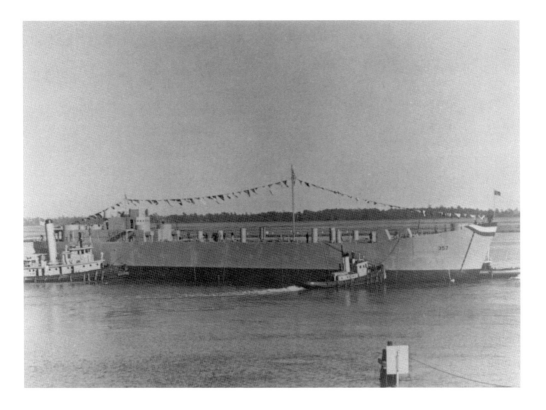

After the launching of LST 357, tugs take charge as it moves into the Cooper River, December 1942. *South Carolina State Museum.*

1942, only 29 percent of industrial managers willingly hired females, but six months later more than 55 percent of the nation's producers were amenable to employing them. Contrary to what one might expect, given the South's gender history, the Charleston Navy Yard accepted women more readily and speedily than the nation as a whole. In July 1942, several shops in the navy yard had female employees. One employee wrote that "its hard to tell men, where these wimmin [*sic*] will turn up next."[135] By early October only the rigger shop did not have women on its payroll, but even this changed later in the month. In part the acceptance was due to a navy department push; less than three months after the United States entered the war, the department was instructing its navy yards to hire women wherever possible, although it qualified its recommendation when it encouraged each facility to be certain, also, to recruit all unemployed males that it could.[136]

Even though the WMC mandate to hire females at the navy yard probably cushioned resentment against working women, the situation at the privately operated CSDDC remained male-dominated throughout the war. Since the latter's government contracts were modest compared to the navy yard's—building small vessels such as tugs and minesweepers—it was probably not under the same compulsion to seek female workers.

Even late in the war, the smaller shipyard's workforce employed only forty women in production out of a total force of twenty-eight hundred.[137]

In other industries, acceptance was more varied; the percentage of women workers at the Port of Embarkation exceeded that of the navy yard. Out of a force of 2,744, this facility had 437 female workers—nearly 16 percent of the workforce total—whereas the navy yard's female workforce then stood at only 7 percent of the total. The largest proportion of female workers was not in a war industry at all, but with the American Tobacco Company, whose workforce was more than 50 percent women. But the company had a history before the war of hiring large numbers of minority women in very low paying jobs.[138]

Though access to industry positions became more readily available, the transition was not easy. Women often had a tough initiation into the male world of shipbuilding. Important issues of pay discrimination, suspicious and hostile male workers and lack of familiarity with the production line all made their new working lives difficult, which may explain the high absentee rate of women during this time. These "negatives" certainly explain why Charleston recruiters faced so many obstacles in trying to increase their female workforce.

Historians have demonstrated that many women were attracted to production jobs because salaries were higher than in most jobs traditionally available to females. Even so, wages rarely reached more than 60 percent of those of males in comparable positions. Despite National War Labor Board (NWLB) pressure for pay equality, from 1942 on, differentials remained significant. While some of the discrepancy could be attributed to women's lack of experience in industrial positions, female workers rarely had equal opportunities for advancement in the labor hierarchy even after months of experience. Although wartime wages for women in the electrical and auto manufacturing industries were better than average, they remained consistently below those of their male colleagues. In the electrical generating and distribution equipment industries, women earned, on average, only 75 percent of what males earned. In twenty-five manufacturing industries, the female-to-male wage ratio started at 61.5 percent just before Pearl Harbor and four years later had increased only to 66.4 percent.[139]

In shipbuilding, male workers consistently earned more than women, even when the men were less experienced. In 1944 one analyst claimed that women's pay, whether in private or navy shipyards, showed distinct discrimination. One yard, unfortunately not identified, hired experienced female "mechanic learners" at fifty-eight cents per hour, but hired inexperienced males as "laborers" starting at seventy-four cents per hour. Although some women gained promotions they always remained several grades below male workers even if the men lacked comparable qualifications. In spite of federal directives to cease discrimination, by the time evidence of it became available, shipyard production was starting to slow, one labor investigator reported, and "most women employed [in them would] not remain after the war."[140] In South Carolina, male and female wage scales for various industries provide a glimpse at the disparity that must have occurred at the Charleston Navy Yard and elsewhere. In the Palmetto State's electrical industry, males

averaged $1,968.00 per year while females garnered only $1,246.06—about 63 percent of what their male counterparts made, a figure consistent with national differentials in the war years.[141]

Though the NWLB had the power to enforce equal pay for equal work, for various practical reasons, it did not. As of 1943, more than twenty-two thousand companies nationwide claimed to have eliminated wage differentials, but the vast majority of wartime industries had not. Moreover, the NWLB could only act if a union initiated a grievance against the employer, and unions had little interest in the issue of gender equity. Finally, the regulatory board was hesitant to overturn historical differentials in rates for "men's" and "women's" jobs.[142]

Another reason for wage disparity, and in fact, other types of discrimination as well, can be attributed to Washington's care to not inspire resentment among males in the workforce. To avoid disruptions in production, Washington seemed to have decided that, despite its directive, it was not politic to enforce equal pay laws. Male workers often resented female counterparts because they feared their workplaces were being "invaded"; some even believed that women would permanently displace males. With male management and labor already alarmed by the influx of female labor, it would have been even harder for them to accept equally paid women in their midst.[143]

With this type of male resentment in place, it's easy to imagine that women were discriminated against in other ways besides wage inequality. Susan B. Anthony II (no relation to the famous nineteenth-century women's rights reformer) described both the discrimination and stress levels that many of her female colleagues endured at the Washington Navy Yard, and she condemned the yard's callousness as the cause. Naval management, she accused, refused to allow women adequate lunch breaks (they usually got only fifteen minutes), and provided poor food. Moreover, the Washington yard and four other yards did not allow women a formal rest period, a normal practice at more up-to-date production facilities. These issues created hygiene problems as well. Restroom breaks were not permitted before lunch, forcing some women to wash their grimy hands in the buckets of dirty water used for cooling hot steel.[144]

Workplace conditions were difficult enough, but many women's hardships did not end when they left the workplace. Anthony described the extreme case of her co-worker, Esther, who worked what seemed an impossible schedule. Employed at the Washington facility on the graveyard shift (12:00 a.m. to 8:00 a.m.), Esther told Anthony that she had not slept in a bed for five months. Her domestic duties made it impossible. After returning home she had to help her three older children prepare for school and then wash and dress her two toddlers. Next she cleaned up the house. Sometimes she had to shop for food and other necessities with her young ones in tow. What sleep Esther got in the afternoon was patchy because it was taken sitting in a chair while keeping an occasional eye on the two youngest. Before midnight she would return to the yard, still tired (more likely exhausted).[145]

Even without domestic duties at home, the production line could be overwhelming. In 1943 a young female newspaper correspondent did a stint in a West Coast aircraft production

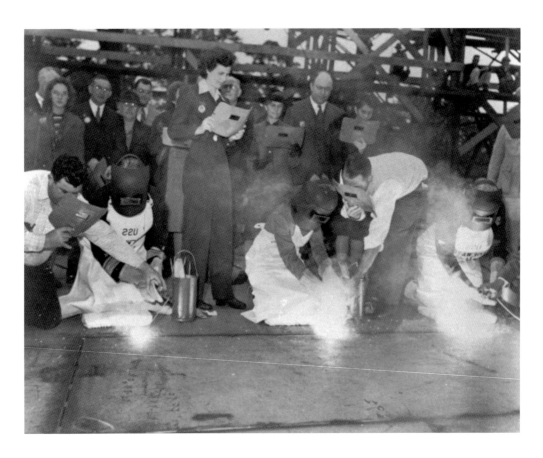

Laying the keel for the largest vessel built at the Charleston Navy Yard, the destroyer *Tidewater*, a large ship used to supply the destroyer fleet at sea or away from home, November 27, 1944. Notice that the welders appear to be females whom male instructors are assisting. The ship was launched in late June 1945. *Courtesy of Palmer Olliff, North Charleston, SC.*

plant in preparation for an article. After spending six nights on the midnight shift, she had developed calluses on her hands and lost four pounds. But worse was the noise on the factory floor. To give her readers an idea of its volume she suggested they take "a couple dozen Sam Goldwyn sound tracks, typhoons, throw in a few barking anti-aircraft guns and top it off with the bombing of London. Then you got it, that roar of production the Senators are always talking about."[146]

This young journalist's experience gives a sense of how terrifying industry work must have been to many women just starting. The shipbuilding industry was not much different. Women in all shipyards were facing the same challenging conditions and discriminating practices that Anthony witnessed in Washington. She surely would have been just as discouraged had she accompanied Charleston women to their jobs at the Charleston Navy Yard, CSDDC or the Ordnance Depot. At the Charleston Navy Yard, newly hired women workers, unlike men, had to mark time before they became eligible for the higher-paid

and more challenging shipyard production jobs. Eva Hutton remembered when she began working at its metallurgical lab during the summer of 1942, women could not enter dry docks or shipways until months later. Even by fall of 1942, when many women were employed and most shops had female workers in production, yard supervisors were reluctant to promote them beyond the lowest level within each trade.[147]

As the draft continued to deprive shipyards of experienced male workers, the obvious demand for women laborers increased. In spring 1944, for the first time since the war began, women were assigned skilled work in an electricians' apprenticeship program. After several weeks of training, navy supervisors reported positive results. Classes (with regular written tests) in subject theory were followed each day by task assignments aboard ship. Given responsibility to install wire ways and cable racks, the women quickly progressed to the installation of lighting fixtures, connection boxes and electrical panels. Soon electrical work on two ships was handled by 12 male electricians and 105 female trainees. The female electricians helped end work delays that previous manpower shortages had caused in ship overhauls and new construction. Navy yard authorities noted that these women trainees were "mastering necessary knowledge and techniques as they produce[d]." In addition, women's morale improved, and attendance and interest in their work significantly increased. Plans were readied to increase the scope of such training.[148]

Elsewhere in the yard, an all-female crew of shipfitters and welders was established to erect sections of DEs. Under a male supervisor the women earned high praise for doing a fine job. Having learned their skills outside the navy yard at a local vocational school, the nine-woman crew quickly mastered the shipbuilding skills and yard management announced that the female crew would begin training other women in the same skills.[149]

The achievements of women gradually won the respect of some of their male co-workers. Robert Sneed estimated that he trained more than three hundred women as pipe fitters during the war and thought that at least 75 percent of them proved equal to or better than many of the males under his supervision. Although they did not have the physical strength of the average male worker, the women seemed more motivated.

On the other hand, despite the business-like attitude of most women, some males tried to take liberties with their female colleagues during work time. This was rarely welcomed and sometimes led to fierce retaliation by the women who suffered such insults. In the pipe fitter shop a few women workers turned on their tormenters with wrenches, one male co-worker recalled, and they "beat the hell out of a man if they patted them on the behind."[150] The male victims would leave their workstations for first aid with their heads split open. One female worker stood up and fought like a man when she was accosted.

Katherine Archibald documented problems she and other female workers endured during the war at the Moore Dry Dock Company, a shipyard in Oakland, California. She argued that male antagonisms were vague and emotional, never based on rational thinking. The men she encountered were obsessed by the biological, sexual differences of women and rarely recognized the assistance and benefits that women provided. Sometimes women themselves would foster stereotypes. In one incident, the wife of a shipyard worker claimed that her husband was stolen from her by a female worker who

had used her feminine wiles to woo him from his family. When this accusation was published in a local paper, rumors soon spread through the Oakland yard. Many males in the workforce, and even a few women workers, thought that females, especially the unmarried ones, should be dismissed because of inappropriate behavior and lack of fitness for shipyard work. This led one supervisor to issue strict guidelines on feminine dress that Archibald believed was based as much on "sexless propriety" as it was on "purported" safety concerns.[151]

Male prejudices also existed at the Charleston Navy Yard. As late as February 1945, navy inspectors reviewing operations at the Lowcountry facility claimed, without explanation, that "women on board ship appear to be more of a detriment than benefit." Interestingly, navy inspectors also thought more women could be used "to advantage" in the yard shops.[152]

In the Charleston Navy Yard's wartime newspaper, *Produce to Win*, other male frustrations with female "invasion" of the workplace came to light. In 1943 the paper reported the formation of a male-only club for which "women could not qualify."[153]

Only a few people admitted overt male opposition to female workers in Charleston. One navy yard retiree, John Moore, then a young machinist, said later that most women were not much good and that most were immoral—some were prostitutes when they joined the yard, he claimed. (His accusation was reinforced by Robert Sneed, who respected and trained many women, but also admitted that a few women who joined the workforce were prostitutes. These women would find clients during working hours, discover an isolated place on a ship and ply their "other" trade with relative anonymity.) Furthermore, Moore remembered, some men resented women because they took away the easier jobs.[154]

In spite of government efforts to integrate females into their new work environments, Charleston women showed only mild enthusiasm in heeding Uncle Sam's call. Though women did enter the workplace, many others refused to forsake their traditional domestic roles. By the middle of the war, navy yard recruiters and local officials of the WMC and the USES complained that more than half of local women eligible for work would not join war industries. Furthermore, a significant number of women who did enter the production lines often left after a short time.[155]

Not unique to Charleston, female standoffishness was a wartime problem documented by many popular national periodicals. In 1944, writing in the *Saturday Evening Post*, reporter J.C. Furnas acknowledged the contribution of women to the nation's war industries and recognized that female war workers had more responsibilities than just assembly work to tend to. However, Furnas was still frustrated by the millions who remained at home. He felt that the production line needed them most, but if they would not work then they should at least volunteer their services to the USOs and the Red Cross.[156]

During the first year of the war, Charleston's navy yard was starved for female workers. To resolve this labor shortage, the Charleston WMC suggested three ways to increase women's participation in the workforce: relax shipbuilding skills requirements, transfer men from less essential industries and recruit women to replace them, and conduct an

active recruiting and training program to find women to fill specific job openings. It was thought that if these three things were accomplished, then the potential supply of women workers would reach at least seven thousand, excluding those women who had recently migrated to the city and the wives of men who had recently arrived for work.[157]

The WMC was optimistic because its survey had shown that 42,500 women between the ages of fifteen and forty-five lived in the county; it predicted that perhaps seven to fifteen thousand not yet employed would be willing to enter the workforce in some capacity. The predictions proved illusory. A combination of factors prevented full use of this potential labor source. Within a year of their original report, WMC officials determined that many of the jobs required heavy work that women could not do. Dual responsibilities of the home and the workplace forced many other female workers to leave the job because they could not handle an extra set of duties outside the home. Beneath these practical reasons, a subtle prejudice continued to exist among many managers, workers and some women, against women entering the job market.[158]

In spite of the ever-increasing need for war workers at the navy yard and other local industries, labor agencies such as the WMC and its subordinate organization, the USES, made women's recruiting campaigns secondary. In January 1943, though officials in the national office in Washington and local officials in Charleston tried to avoid a full campaign to recruit women, the Bureau of Placement for the WMC in Washington instructed regional subordinates to notify Charleston officials to promote to employers the acceptance of women workers. By the time a new recruiting campaign for outside workers began in January 1944, navy and USES officials realized that the local supply of females could not be persuaded in sufficient numbers to make up the labor shortfall. Charleston women mirrored the national picture in many ways with only a third of the potential female population induced to leave their domestic duties by late 1944.[159]

Service industries of all kinds were just as desperate for workers as were higher profile war-related industries. The most indispensable, perhaps, were drivers for the overworked city bus system as well as mechanics and others needed to maintain these vehicles. Charleston restaurants may have provided a less critical service, but their need was far larger. But like the transportation system, the food service could attract few workers. Neither could compete with the more lucrative war jobs. Restaurants, instead, had to rely on an overworked staff, which put in six-and seven-day weeks (and got meager return).[160]

As if problems of discrimination, low wages, poor work environment and an overly burdensome workload were not enough to keep women from joining the workforce, class distinctions also emerged between those who worked and those who did not. Ann Fox, an outsider who loved Charleston and came there to work in 1941, observed years later that most women who were middle class or above did not enter the labor force. Although members of the elite were a minority, Fox claimed that daughters of old Charleston families were not supposed to work in industry.[161]

As an effort to make employment more desirable for women, the Department of Labor created the Women's Bureau to provide advice on the unique needs of women workers.

The bureau's modus operandi was to send inspectors to industrial sites nationwide to examine working environments. Although the bureau had only advisory status, it provided guidance on the policies needed for effective management of the masses of new female war workers. In the spring of 1944, nine major recommendations were made to improve assimilation of women into shipyard work. The first requested the cooperation of male supervisors and workers. Men were assured that the feminine workforce would not threaten their job security, and at the same time reminded of the importance of women's participation for reaching the yard's production goals. Women were compared to "a new tool"—the effectiveness of which depended on men's ability to use it. As the bureau stated, "A measure of the success of a worker or supervisor lies in his ability to use new and unaccustomed tools." Some of the other points included taking particular care in selecting and placing women in jobs suitable for them, providing women pay and advancement equal to that of men and giving women sufficient time to become familiar with procedures and practices in the shipyards before assigning them to the production line.[162]

The Women's Bureau sent representatives to the Charleston Navy Yard at least twice. In January 1943, during the first visit, representatives discovered a number of serious deficiencies, including unsuitable restrooms, insufficient orientation for new female employees and inadequate work safety instructions. Apparently the visit and subsequent report spurred the navy yard management to make changes, for on a second inspection trip that June, the Women's Bureau found conditions much better.[163]

Another benefit of the Women's Bureau's visits was the formation of a women employees' counseling service at the navy yard. When first announced in April 1943, its staff consisted of one trained female member of the navy (part of a group known as WAVES, Women Accepted for Voluntary Emergency Service) with social work experience. But soon twenty-five women councilors were assigned to various shops around the yard. Besides one-on-one counseling, the service held weekly meetings for all female employees so they could voice their concerns and seek solutions to a variety of issues. Discussion topics ranged from how to dress for the production line to the timing of leave. But meeting themes were not limited to work issues. Matters such as childcare or insufficient time for food shopping were also discussed.[164]

The large majority of Charleston females who did not enter war industries were young wives. The few who did work usually left as soon as their first child was expected. Mrs. Clifford R. Passailaigue (Clifford was her first name) worked in the Charleston Navy Yard offices for a few months after marriage in 1941. But when she discovered that she was pregnant she returned to her traditional role as housewife with her husband's support.

Albert Rollins met his wife at the navy yard when she worked in the office pool, but as soon as she was expecting their first child in 1943, she left the workplace to manage the home and prepare for her first born.[165]

Married women who took jobs at the navy yard or in another war industry usually either had no children or offspring who were teenagers or older. In the fall of 1942, Mrs. G.F. Smoak became the first woman driver for the Charleston Health Department, operating a mobile venereal disease unit. While her husband worked in an unspecified

defense industry, her daughter, a student at the College of Charleston, worked an afternoon job in the drafting department of the South Carolina Power Company. In the same year, fifty-two-year-old Eliza Dewitt began working in the joiner shop as a helper trainee. With seven children, two of them in the army and one working at the navy yard as a shipfitter, her co-workers described her as "one of the best in the shop." Carrie Moore, another grandmother, worked in the sail loft on a sewing machine all day. With two of eight grandchildren in the armed forces, she drove from her home in Pregnall each day, a daily commute of more than eighty miles.[166]

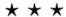

By late 1943 the persistent problem of recruiting and retaining new workers made the Charleston Navy Yard and the WMC determine that the labor shortage was extreme enough to justify a regional recruiting campaign, but one focused not on women but on men. Although the assumption that highly skilled females were unavailable was probably accurate, a significant need remained for semi-skilled workers. While local women were still trained for skilled jobs, WMC recruiters seemed reluctant to train women from beyond Charleston because they feared that the investment in their training would be lost because the women would not stay.[167]

Southern war industries turned to another, even more "unconventional," labor source: African Americans. As the accelerated need for workers made it imperative that blacks gain access to more and better jobs, they faced even more obstacles than women in achieving a reasonable proportion of war-related employment. Although African Americans lacked many of the skills needed in highly technical industries such as shipbuilding, training could go a long way to improve their fitness for work. The real issue was prejudice held by whites about blacks' abilities to learn and contribute. Most whites, regardless of status, did not think African Americans had the intelligence to compete for skilled jobs. Despite public pronouncements to the contrary, newspaper stories and letters to the editor revealed the inability of most whites to conceive anything more than a second-class occupational status for blacks. Interestingly, just before Pearl Harbor, one spokesman for the National Association for the Advancement of Colored People (NAACP") proclaimed that South Carolina was one of the South's most encouraging fronts in the fight to establish democracy in the South. The Ku Klux Klan was crumbling in the Palmetto State, giving more hope for black citizens to become full members of society.[168]

Yet while South Carolina's racial climate seemed to be improving, the openly racist voice of the local *News and Courier* made the status quo attitude of whites in Charleston quite obvious. The paper's editor remained adamant about the necessity to keep the races separate. Gunnar Myrdal, a Swedish economist, undertook a study of African American social and economic status between 1938 and 1942, which was published in 1944. His investigations pointed out ubiquitous "daily blasts against the Negro" in the Charleston paper—a publication he described as the "last surviving representative of a school of journalism [Negrophobia] which was at one time quite common in the state."[169]

In one typical editorial of March 1943, one resident of the elite "south of Broad Street neighborhood" proclaimed that blacks had a long way to go before they became more than a liability to society. Even though black wartime migration into the city would never rise above 10 percent, this writer dolefully predicted that at the war's end blacks would remain in the city to swell the community's relief systems. The only solution he could conceive—his assumption being that blacks owned little property—was to end property taxes in favor of a general sales tax so that whites would not have to shoulder all the tax burden.[170]

In late 1942, A. Phillip Randolph, president of the National Negro Congress and a leader in civil rights, drew only scorn from the editor of the *News and Courier* when he proclaimed that unless there was a drastic readjustment of racial attitudes, the United States could not win the war. The editor responded that guns, tanks and planes loaded with bombs would win the war, not a "readjustment of attitudes."[171]

Rumors and fears of violence contributed to the racial dynamic in Charleston. In one example of white paranoia, in 1942 the city's annual Labor Day march was cancelled due to fears of a possible "race riot." It was rumored that blacks had purchased eight hundred ice picks from a King Street store. Inundated with calls about these purchases, the local police chief must have kept the city mayor, Henry Lockwood, closely informed. It was later shown that only two picks were actually purchased during the time period in question.

Though the ice pick incident was based on rumor with no foundation, Eva McCartha, a young navy yard lab technician, remembered another racial confrontation that was very real. While she was riding the bus one day, some black men got on. When the driver told them to move to the back they refused. With little hesitation the driver pulled out a pistol, pointed it straight at the men and ordered them to move back. They quickly did so.[172]

By World War II, black citizens were beginning to assert their collective voice—a change from their passive acceptance of racial status in World War I. In March 1943, one South Carolina black resident wrote the Charleston paper to complain that it never said anything about black achievements but always focused on the problems and failures of the black community. The writer, whose letter the *News and Courier* published, offered to buy the port city daily a subscription to the black-owned *Palmetto Leader* so the white editor could learn about successes made by black South Carolinians.[173]

That same month, Gwendolyn Gomez, a student at the Avery Normal Institute, the most prestigious black high school in Charleston, wrote in a similar vein. She protested that blacks continued to make progress despite all the "odds that have been stacked high against [them]." Although she admitted that black slum areas existed in the city, white ones did also. Gomez boldly proclaimed that blacks did not need to follow the lead of whites when they had opportunities to make things better on their own.[174]

African Americans in Charleston did more than defend themselves in print. Some also took action to defend their rights in the workplace. In spring 1943, black workers at the American Tobacco Company in Charleston demanded an investigation of discriminatory wage practices carried on by the company. With the aid of their local union, they demanded that the president's Fair Employment Practices Committee (FEPC) investigate

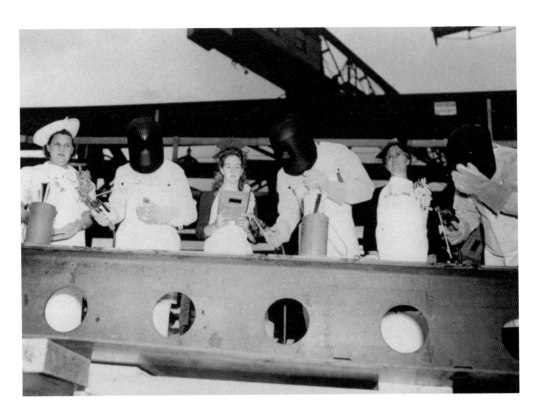

Above and Below: Keel-laying ceremony for LST 356 on September 7, 1942. *South Carolina State Museum.*

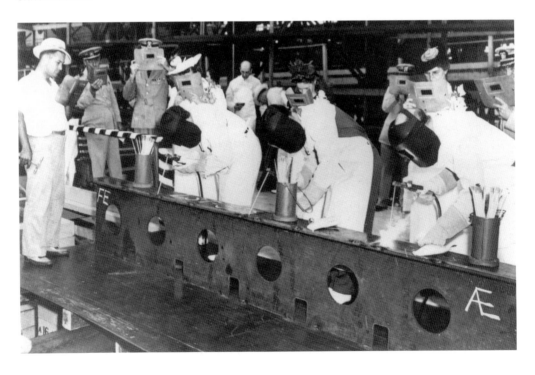

the charge that white workers received higher wages than blacks, though both did the same work.[175]

Efforts to resolve the second-class status of African Americans went beyond isolated letters to the editor and job actions. A biracial committee was established following the canceled 1942 Labor Day parade to find solutions to racial tension. Supported by Mayor Lockwood, the committee consisted of six whites and six blacks. Known as the Charleston Biracial Committee, it worked to resolve public transit problems, housing shortages and employment discrimination in war industries. The success of this committee is difficult to gauge since its meeting minutes are lost, but reduced racial tension in Charleston after 1942 suggests that it had some success in lessening wartime confrontations that appeared imminent early in the war. Its effort to influence new housing projects appeared to be at least part of the reason that minority housing projects were finally started in 1943, and increased recruiting of blacks to the navy yard may also have been attributed to the committee.[176]

In spite of social and economic racism, a small but growing number of African Americans filled the labor needs of Charleston's war industries. But even as labor demands increased, forcing white management to accept more black workers in skilled positions, the obstacles for minorities remained formidable. Before World War II, blacks were excluded from nearly all skilled positions. Those in the industrial sectors were concentrated almost exclusively in unskilled categories. In 1936 the Charleston Navy Yard's total workforce had reached 1,288, with African American workers totaling 179, about 14 percent. Just prior to Pearl Harbor there were approximately 2,000 African Americans on the permanent workforce out of a total of 14,000, and many worked in the rigger shop providing labor to move equipment on and off vessels.[177]

Though minority employment increased as the United States' war machine swung into gear, white supervisors continued to hold the same general suspicions about black ability as the rest of the community. Members of management and educators believed that few, if any, blacks could master the skills needed to be an electrician, boilermaker or machinist. In October 1942, the new year projection for "nonwhite" workers in war industries was 3,530 out of a total projected new workforce of 9,917. Of that number, 3,000 would fill semi-skilled positions with only 530 in skilled positions and none in supervisory roles. Of the projected 6,387 white males, on the other hand, over 3,000 of them would fill skilled jobs and 212 would work in supervisory and mechanical categories.

The CSDDC sought to hire even fewer minority workers in proportion to the navy yard. Its 1943 projections placed the private shipyard's workforce needs at 1,157. It was projected that 30 skilled and 40 semi-skilled blacks and 634 white skilled males would be needed.[178]

In spite of built-in prejudices, necessity forced Charleston industries to accept more black workers than ever conceived of in peacetime. But due to a lack of education among most South Carolina blacks, a majority of the new force would have to come from outside the state. By spring 1944, in South Carolina, not only were most skilled and semi-skilled black workers coming from other states but most unskilled laborers as well. And the latter,

of course, made up the majority of the new hires. One federal representative, who saw Charleston conditions firsthand, claimed that the need for unskilled laborers in Charleston was seven times greater than for skilled and semi-skilled minorities. The skewed level of demand was perhaps influenced by white's misinterpretation of black motivations. Both federal officials and local managers insisted that if minority workers were paid the maximum forty-cent hourly wage for a laborer, black workers would only report to work part of the week because they would have sufficient funds to live for the entire week. Consequently, wages remained low because of the mistaken belief that black workers would then be forced to work a regular week in order to live adequately. It never occurred to white managers that poor wages probably contributed significantly to high turnover rates for laborers.[179]

Oliver Perry, an African American who began as a laborer, soon proved his worth to his white supervisors even though he only had a sixth-grade education. Several months after he started, his supervisors promoted him to be a helper for a white crane operator. He quickly learned his duties and soon knew as much or more than the operators. Nonetheless he had no hope of promotion because of his skin color. This would not come until almost twenty years later.[180]

Even though education and literacy levels of whites were not significantly better—a problem great enough to draw public comment from the state superintendent of education—many remedial programs were available for them that were not available to blacks. As early as 1934, the navy yard had instituted an apprenticeship program to train whites in skills that were needed.[181] Nothing of the sort was available for blacks, of course. Even after more than a year of war, there was only one vocational training center serving Lowcountry blacks, a segregated section of the Murray Vocational Center in Charleston. By comparison, whites received training not only at this institution, but at local National Youth Administration vocational training centers as well as The Citadel and the College of Charleston. The only other black training centers were located in Orangeburg, at South Carolina State College, and in Columbia, more than sixty and one hundred miles, respectively, from the coast. This left minorities few opportunities to gain training for skilled jobs in war industries. Teacher and equipment shortages made the few segregated facilities inadequate. White political and educational leaders were simply unwilling to provide sufficient funds or more minority training centers. Openings existed in white training schools but segregation laws made it illegal for blacks to attend. Even after a White House directive ordered all educational centers and war industries receiving government funds to integrate, most states—in the South and North—resisted such orders and maintained segregated classes and workshops. Despite claims by the United States Office of Education that blacks were admitted for training at any Charleston-area National Youth Administration vocational center, most minorities in the area had to go elsewhere for industrial training. Some black South Carolinians were ambitious enough to seek job training in another state, but in doing so they faced an added disadvantage. Unlike most white trainees who sought schooling away from home, few blacks were provided a stipend or living allowance while they attended far-off industrial education classes.[182]

Despite these and other obstacles, war industries continued to reluctantly enlist minority workers. Although driven by necessity, such recruiting helped some blacks find more and better jobs. In September 1943, W. Rhett Harley, state director of the South Carolina USES, informed the regional office in Atlanta that the Charleston Navy Yard would hire all black trainees except those with wooden-boat building skills, a skill not needed at the yard. Such an about-face, however, reflected more the desperation for new workers than any change in racial attitudes.[183]

Most blacks were hired to work in custodial and other unskilled jobs. When skilled blacks were hired they were isolated from the other members of the workforce as much as possible in order to avoid regular mixing with whites. Thus when a government official claimed that there was no discrimination against black workers, he quickly contradicted himself when he observed that white workers refused to work if they were forced to associate with minority workmen. When it did occur, whether by accident or design, a storm of protest inevitably ensued.[184]

Other black workers met more overt hostility. In May 1944, Edward F. Tolliver, an African American driller with five years' experience at the navy yard, was working on an LSM when he had to walk a few steps to his toolbox to remove an implement he needed. As it happened, eight white men and women were chatting with one another near his box. When Tolliver reached into his tool chest, one of the women told him to back off, threatening to hit him with a tool if he came any closer. He protested his innocence, but two men in the group grabbed the driller and tried to "assault" him. Tolliver defended himself but was dismissed from the yard without a hearing or investigation. He reported his story to the regional branch of the Fair Employment Practices Committee, a presidential committee formed before the war to investigate and resolve cases of discrimination in government-managed or financed workplaces. According to Tolliver, when he told his attackers he had filed a complaint with the FEPC, his case was quickly reviewed by yard officials and his dismissal was overturned. He was reinstated in his job with four months' back pay. Tolliver's vindication is probably owed to the government officials' desire to avoid workplace controversy in the midst of an accelerated production schedule—a situation that gave FEPC officials more influence within defense industries than they had had before.[185]

However, as the war drew to a close, other discrimination cases had less chance of resolution. In fact, many complaints filed with the president's commission remained unsettled at the war's end. In Region VI, comprising South Carolina, Georgia, Florida, Alabama, Tennessee and Mississippi, 143 cases were still pending at the beginning of 1944, while 234 more were docketed in the first six months of the same year. Only 73 cases were resolved by June.[186]

One of the many unsolved complaints was that of Roy T. Nelson, a black electrician at the Charleston Navy Yard. Nelson alleged that he knew as much as most of his fellow white electricians but that he was given a lower rating simply because of his race. When he walked off an assigned job in March 1945, unspecified disciplinary actions were taken against him. Although his supervisor denied discriminating, Nelson's frustration reflected what was a common feeling among black war workers in Charleston when he

told the FEPC, "time when brain is most needed it is pushed aside because it is enclosed in a dark skin[;] then I ask where is the fair practice[?] where is the Democracy?" According to commission regulators, Nelson did not provide sufficient evidence for FEPC investigators to pursue the case.[187]

In the late winter of 1944, Carletta W. Wright protested being passed over for a job as a secretary in the navy yard offices. Despite earning a grade of 90.1 percent on a civil service clerical exam and interviewing three times for various vacancies, she failed to get a post. Claiming racial discrimination, Wright's charges went all the way to the Washington office of the Department of the Navy, but no record remains of the case's outcome.[188]

In spite of tremendous legal and social prejudices against black workers at the navy yard and other war industries, a few minority workers enjoyed recognition from upper management. Solomon Lucas, a senior laborer in the pipe fitter shop, was honored by his white foreman for devising a method that reduced by half the time required to handle pipes that had to be lifted and carried to new ships for installation. He received a twenty-five-dollar bonus for his ingenuity.[189]

Another example was Elias Corbin, a twenty-four-year veteran explosives operator at the Charleston Ordnance Depot, who supervised all the transportation of bulk explosives from the magazine area to the production plant. Perhaps this responsibility was a belated reward for his heroism two decades before when he was commended for bravery for removing ammunition from a smoldering source of explosives and saving valuable equipment and property.[190] Sadly, whites supervised and ran the operations at all facilities, so contributions like Solomon's and Corbin's were probably rarely recognized.

Federal decrees to the contrary, Washington's commitment to equal educational and working conditions for blacks proved inadequate. Hindered in many cases by regional and local administrators who were lukewarm, if not completely opposed, to racial equality, Roosevelt and his lieutenants had little opportunity to focus on changing gender and racial attitudes while the nation was fighting the greatest war in its history. Fear of disrupting war production and the morale of the fighting men forced men of good will, from the president down, to act very conservatively when it came to actually implementing racial and gender reform. Real reform would have to wait until the war was won. However, the measures taken out of absolute necessity to put both women and minorities in the workforce alongside white males would give both groups a taste of equality that they would not forget when the war was over.[191]

Despite the inability of Washington to initiate and enforce equal rights, most blacks still remained in the South to endure, along with whites, problems of overcrowding, food shortage and inadequate transportation. Charleston faced these and many other domestic problems, even as it tried to produce the ships and other materials needed for the war effort.

Chapter IV

Overcrowding, Rationing and Living in World War II

"If one only knows Charleston from the history books I guess a trip here is a bit of a surprise. But then man is suppose [sic] to undergo a complete physical change every seven years…if his mental processes do not undergo the same change…he is going to be bewildered by all the changes taking place around here."

J.W. Malony, manager of George Legare Homes, November 29, 1942 [192]

The irony of war is that it often brings material benefits to those that design and produce weapons used to weaken and destroy other nations. Since the stock market crash of 1929, most of the American population had been living a frugal, if not impoverished existence. As the nation began to prepare for World War II, new economic prospects, rarely dreamed of in the decade before, suddenly became possible. Before and during World War II, many families from inside and outside South Carolina came to the Lowcountry, drawn by the opportunities Charleston war industries afforded. By the last quarter of 1944, the Federal Security Agency estimated that more than fifty-five thousand people (both black and white) had migrated to the area since 1940. More than half of these came from other states and foreign countries.[193]

One Spartanburg family, the Russells, left the Upcountry to take advantage of the opportunities offered by the expanding Charleston Navy Yard. Throughout the 1930s the Russells had worked hard in the Upstate to make a living, with moderate success. Chester Russell Sr. ran a small electrical contracting business while he and his wife raised a family of four children. Prosperous by their neighborhood's standards—they had a washing machine and telephone—Russell earned his income in a variety of ways. Once Mr. Russell installed the electrical outlets in a nearby home for the princely fee of twenty-five cents. Another time he rewired a wing of the local hospital to pay for his daughter's tonsillectomy.

When news of the navy yard's rebuilding program came to the Upstate, Mr. Russell chose to sign on as an electrician at the Charleston facility for better pay and benefits. He came down in 1939, and brought his family in 1940 after finding a house near the navy yard. The following year his son began work at the navy yard, and eventually his two

older daughters married men who worked there. The Russells remember dealing with the crowded living conditions of wartime society in Charleston, but the added income and benefits gave them more money and opportunities than they had ever had before.[194]

The coming of war brought similar improvement to the Spitzer family's economic prospects. Prior to the Depression, Mr. Spitzer had owned and operated several grocery and meat markets in downtown Charleston. The economic collapse of 1929 soon ruined business and Mr. Spitzer was forced to sell out by the early thirties. The family moved to rural Berkeley County north of Charleston to try a hand at farming. Agriculture provided the novice farmer and his family with enough food for themselves and some surplus to sell at local markets, but gave them little extra to buy luxuries. By 1940, as Charleston's economic outlook began to improve, Spitzer and his family returned to the city to open a new grocery. Patronized by thousands of war workers and servicemen that had come to the city, his business thrived throughout the war.[195]

Yet while families like the Russells and the Spitzers found new economic opportunities in a revitalized Charleston, they were forced to reckon with the manifold social problems the war and quick expansion brought. Shortages never envisaged in the Depression appeared in the marketplace even before Pearl Harbor. Within weeks after the attack on Pearl Harbor, fuel, rubber and tires were rationed and were in severe demand. Within months luxuries such as cars and radios disappeared from showrooms and some foods, particularly coffee and sugar, were severely restricted or rationed.[196] Even clothing and shoes were rationed beginning in February 1943. Civilians were limited to three pairs of leather shoes annually and shoe colors were restricted to "black, white, army russet and town brown." Men's double-breasted suits were discontinued and the two-piece bathing suit for women was popularized to conserve on cloth consumption.

Other issues also affected daily life. Housing shortages that had plagued the city grew worse. Health issues, such as leaking septic tanks and rat infestations, confronted authorities on a variety of fronts. And the age-old problem experienced in many industrial communities—prostitution—became a large concern as the navy yard expanded and more and more military and naval personnel were stationed in the area. Navy and army officials would pressure city and state governments throughout the war to eliminate the sex trade.

While such problems may not have overtly affected the youth of the area, overcrowded schools and lack of preschool facilities for working mothers certainly did. The South Carolina school system had long been notorious for its inadequate schools and poorly trained faculties, and the war only exacerbated the poor conditions of the area's education system. The school system was certainly not equipped to accommodate the thousands of additional families with preschool and school-aged children. In addition, day-care needs grew more acute with increased employment of working mothers.

Recreational or other leisure facilities were sorely needed to give people temporary relief from stressful wartime living conditions and work schedules. But, like many other communities nationwide, the old port city was ill-prepared. There were not enough cinemas, parks, restaurants or nightclubs to accommodate the thousands of workers and military personnel that had come to the city.

Portion of Tom McMillan Homes, the first housing complex finished in 1941 to accommodate the growing workforce at the navy yard, located just outside the boundaries of the facility. *CNY Annual.*

In spite of these wartime problems and frustrations, Charlestonians continued to work and live with remarkably little overt contentiousness or violence. At least some credit for this should be given to the naval and military leaders in the community. Charleston, as both the headquarters for the Sixth Naval District and the center of one of the nation's major navy yards, received close scrutiny from high-ranking officers in both services. The admirals and the admirals' staffs stationed in Charleston took particular responsibility for ensuring that the city worked out social issues as quickly and thoroughly as wartime shortages and emergencies allowed. When local and state governments seemed reluctant or unable to solve problems, high-ranking officers used the power of their offices to get things done, sometimes over the objections of local officials. This method, of course, did not always work, but appears to have alleviated potential civil unrest to a degree.

Other Southern cities were not so fortunate. In Mobile, Alabama, for example, where the navy did not run the shipbuilding companies, and military leadership was not high ranking enough to prevent some of the major problems, tensions ran higher.

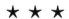

The earliest and most difficult wartime problem for Charleston during the first half of the war was finding and creating enough housing for the influx of war workers. Limited space in the city center made significant expansion unlikely. Where possible, old warehouses and

Part of a 350-unit development built by the FWA in 1941, John C. Calhoun Homes was one of several developments built to alleviate the housing crisis faced by yard workers and others coming to the area as the navy yard and smaller industries underwent a rapid build up prior to Pearl Harbor. Note that this image was taken more than fifty years later, in 1995, but the structure remains largely unchanged. *Courtesy Sara Fick, State Historic Preservation Office, SCDHA.*

Like most wartime housing in Charleston, each dwelling in the John C. Calhoun Homes development had single and duplex units to accommodate different tastes of residents. This photo of a single dwelling was taken in 1995. *Courtesy Sara Fick, State Historic Preservation Office, SCDAH.*

empty stores were converted into wartime housing, supplemented by large older homes that were either privately rented or leased to the government. City expansion was also hampered by the attitudes of native residents who made sure that the wartime boom had minimal impact on the city center by charging high rents and enforcing, when they could, rigorous historical building codes. As a result of these hindrances, the actual wartime population within the boundaries of the city center remained remarkably stable. Estimates for 1940 placed the resident figure at 71,725; four years later this had only increased by 9 percent to around 77,000. Beyond the city center, however, the population exploded. During the years of the war, the county's population increased by nearly 40,000, more than doubling its size from a little over 27,000 to a little over 67,000. Most of this increase occurred in the non-incorporated town of North Charleston.[197]

Although plans for the North Charleston community had been started at the beginning of the century, development did not take off until the late 1930s when the navy yard began its expansion. Before the 1940s the outskirts of Charleston were sparsely populated, making them obvious places for development. In 1940, government funds provided the financing for the building of two new public subdivisions, with a total of six hundred units, to house the growing numbers of navy yard workers. But Ben Tillman Homes (four hundred units) and Tom McMillan Homes (two hundred units) were just the beginning of a massive series of white housing projects. By the spring of 1941 an even larger housing complex, the six-hundred-unit George Legare Homes accepted its first residents. In the fall of the same year another housing complex with two hundred units, John C. Calhoun Homes, began accepting families. Yet another development, Palmetto Gardens, was finished about the same time. Unlike the other four subdivisions, which consisted of two-story apartments or duplexes, Palmetto Gardens, earmarked largely for army and navy officers and some civilian war workers, was made up of only single-family dwellings.[198]

Despite the development of communities like these, when the nation officially entered the war, the housing shortage grew even more acute. In response, extensions were added to the four developments already built. Across the Ashley River, the 410-unit St. Andrews Homes development was completed in March 1943 (to house CSDDC workers), and two larger subdivisions, the 2,400-unit Liberty Homes and its 1,286-unit extension, located just beyond the original four prewar complexes, were also being completed to house personnel from the Ordnance Depot, the Port of Embarkation and the navy yard (see charts on pages 98–99).[199]

These subdivisions were all reserved for whites; housing relief for minorities, despite its tremendous need, lagged way behind. After more than a year of war, government funds were finally allocated for the construction of two black housing projects west and north of the white developments in North Charleston. Begun in late 1943 and early 1944, Daniel Jenkins Homes, with 550 units, and Reed Hill Homes, with 200 units, were the only two major housing complexes created for blacks in Charleston during the war.[200]

The construction of private subdivisions had also accelerated. Starting before Pearl Harbor, private developers (with government financing) were building subdivisions in North Charleston and south of the Ashley River. Three of the largest were Dorchester

APPROXIMATE STATUS OF FHA HOUSING AS OF AUGUST 1, 1943 – BY PRIVATE CONTRACTORS

Name	Location	Number of Units Completed	Under Constr.		Estimated Approved Population
Dorchester Terrace #1	St. P. & St. M.	250	-----	-----	1,000
Dorchester Terrace #2	St. P. & St. M.	250	-----	-----	1,000
Dorchester Terrace #3	St. P. & St. M.	---	144	-----	576
Dorchester Terrace #4	St. P. & St. M.	---	363	-----	1,452
Dorchester Terrace #5	St. P. & St. M.	500	250	-----	3,000
Nafair	St. P. & St. M.	95	-----	-----	380
Whipper Broney	N. Charleston	25	-----	25	200
Byrnes Downs	St. Andrews	---	-----	550	2,200
Windsor Place	St. P. & St. M.	38	-----	-----	152
Garden Hill	St. P. & St. M.	53	-----	-----	212
Shoreview	?	---	-----	90	360
Avondale	St. Andrews	50	-----	-----	200
Carolina Terrace	St. Andrews	30	-----	-----	120
	TOTALS	1,291	757	665	10,882

From: "Report of Investigation of Proposed F.W.A. Projects," August 4-5, 1943, Charleston, Box 5, RCCPA, RG.212, NAII

STATUS OF PUBLIC HOUSING AS OF JUNE 30, 1943

	Project Name	Type Housing	Number of Units Total Comp.	Occupied upon Comp.	Pop. Est.
(1)	1-1 Mills Manor	(Pre-War)	140	133	—
(2)	1-3 Anson Borough Hms.	(Pre-War)	162	154	—
(3)	1-4 Wragg Borough Hms.	(Pre-War)	128	122	—
(4)	1-5 Green Homes	(Pre-War)	172	163	—
(5)	1-6 Mills Manor Add.	(Pre-War)	129	122	—
(6)	1-7 Tillman Homes	Perm. Fam.	400	380	1,240
(7)	H8901B Mfgn. St. Munr.	(Pre-War)	212	201	—
(8)	38021 McMillan Homes	Perm. Fam.	236	?	706
(9)	38023 Legare Homes	Perm. Fam.	600	570	1,860
(10)	38024 Palmetto Garden	Perm. Fam.	250	238	775
(11)	38025 Calhoun House	Perm. Fam.	350	332	1,065
(12)	38026 Liberty Homes	Dem. Fam.	2,000	1,826	6,200
(13)	38027 St. Andrews Homes	Dem. Fam.	410	410	1,272
(14)	38028 McMillan Ext.	Perm. Fam.	100	100	310
(15)	38029 Lucas Hall	Conv. Dorm.	369	350	369
(16)	38061 Kiawah Homes	Perm. Fam.	60	57	186
(17)	38062 (Navy Yard)	Perm. Fam.	30	?	93
(18)	38063 (Army)	Temp. Dorm.	50	?	50
(19)	38066 (Army)	Temp. Dorm.	200	?	200
(20)	38067A Victory Homes	Temp. Dorm.	72 >		200
(21)	38067B (Adj. to Tillman)	Temp. Dorm.	128 >	144	200
(22)	38068A Victory Homes	Temp. Couple	64 >		1,000
(23)	38068B Liberty Homes	Temp. Couple	336 >	286	1,000
(24)	38069A Ashley Homes	Temp. Fam.	150	480	2,165
(25)	38069B Liberty Homes	Temp. Couple	850 >	70	2,165
(26)	38075 ------	Temp. Couple	200	0	400
(27)	38076 ------	Temp. Fam.	550	0	1,705
	Totals (Excluding Pre-War Housing) *Total is 4,245 assuming housing 100% occupied 7,505		5,791	4,245	19,810

"Report of Investigation of Proposed F.W.A. Projects," August 4–5, 1943, Charleston, Box 5, RCCPA, RG 212, NAII.

Terrace, Waylyn and Nafair. Nafair, the first complex to go up in 1940, was designed with single-family housing units.[201]

Roughly 2,713 single-family homes were constructed in wartime. However, on the whole, wartime subdivisions consisted of either one- or two-bedroom apartments or duplexes of one or two stories. Each unit was designed with a small family in mind. Generally, the space included a kitchen, dining area and a small living room. It was not uncommon for a couple or a family who felt they had enough space to rent a room to a single worker. Such was the case with shipfitter Johnnie Nolan, who arrived at the Charleston Navy Yard in 1942. After boarding with a woman in Charleston during his first month of work, he moved closer to the yard and rented a room from a fellow shipfitter and his wife in the George Legare Homes subdivision. He paid ten dollars per week, which helped the couple pay the thirty-five-dollar rent that included all their utilities. Within a year, Nolan married the daughter of another colleague in the shipfitter shop and the new couple soon found a separate unit in the same housing complex.[202]

Even with construction and makeshift living arrangements, there was still not enough housing to accommodate the legions of new workers. Utilizing all options, the government began making efforts to adapt old buildings in the city of Charleston. During the first half of the war, the interiors of various warehouses and old homes were divided into rooms and small apartments for rent. In early 1943, the National Housing Authority announced plans to remodel an old grocery store on one of the city's major commercial avenues, King Street. According to the NHA, this was the first property in the area leased to house defense workers. The lease agreement stipulated that the local owners would be paid $707.06 annually from February 1943 until January 1950.[203] A similar arrangement was made regarding the navy yard's old Eliza Lucas Hall when it was remodeled to house four hundred bachelor navy officers.

In addition, some homes south of Broad Street near the Battery also became objects of "adaptive" reuse. During the same month that the old grocery store's renovation was publicized, plans were announced to re-work 50 South Battery, a large home built in the late nineteenth century, and 68 Meeting Street, another large home nearby. The plans called for the old homes to be divided into single rooms and small apartments for individuals or couples. Among the attributes that the fortunate wartime residents enjoyed were a "tiled walk leading to the entrance," with an upper window commanding a fine view of the Ashley River. It also had a "venerable grandfather clock on which dolphins were carved" that stood on the landing of the staircase leading to the second floor.[204]

Many war workers, whether they lived in old mansions or modern war housing, felt positive about their accommodations and recalled them fondly. In 1941, Lieutenant Jack Tripp from Florida was assigned to the Charleston Navy Yard to work on devising anti-submarine equipment and manuals. During his first months in the old city he lived in the Fort Sumter Hotel (a tourist haven in peacetime, the navy had requisitioned it for wartime use). After Tripp became familiar with Charleston, the young officer rented a room on the third floor of an old home on Calhoun Street. Then, when his wife joined him, they moved to a larger room on the third floor of an East Bay Street house, and shared a hall

Portion of Ben Tillman Homes—the second housing complex completed in 1941—another navy-yard-inspired residential community for the growing work force. *CNY Annual.*

Portion of George Legare Homes, which was the third housing complex completed in 1941 for navy yard workers. *CNY Annual.*

refrigerator with another tenant across from them. Even with the lack of privacy and his duties hauling supplies of coal up three flights of stairs for their stove, he found the living conditions pleasant.[205]

When Eva McCartha came to work at the navy yard in the spring of 1942, she and several other women rented rooms in a large King Street home, which decades later she fondly remembered. She recalled that on weekends a servant would bring breakfast and the newspaper to her room. Her future husband, Sherlock Hutton, lived in another boarding house downtown, and he and other workers remember eating their meals in a nearby house.[206]

In 1943, Johnnie Nolan and his new wife lived in a unit with all of the day's most modern conveniences: a small upright gas floor furnace, a gas-operated stove and a refrigerator. Of course, like most people, they did not have air conditioning, but Nolan never recalled conditions unbearable, even in the midst of the summer. Things were satisfactory enough for his wife and newborn that they continued living in the Legare Homes even after Nolan joined the marines.[207]

Other wartime Charleston residents were not so positive, focusing instead on overcrowding, lack of sanitation and the snobbish attitudes of the native Charlestonians. One anonymous New Yorker who came to work in the Southern coastal city complained in late 1943 that native homeowners were charging exorbitant rents for bad and inadequate housing. Another outsider was less severe but found the cramped lifestyle for her family frustrating. Mrs. R.B. Smith lived with her husband and two children in "a small third-floor" apartment for two years. The accommodations were crowded enough with the four of them, but they also had to share a bathroom with "eight business girls." Needless to say, Mrs. Smith was ecstatic in late 1942 when her family moved into a new home in the recently built Kiawah Homes subdivision.[208]

As the former New Yorker expressed, despite the war emergency and appeals to patriotism, not all Charleston homeowners were helpful to war workers, no matter how desperate the need. During a 1943 investigation of wartime Charleston, Atlanta journalist Tom Ham depicted the city as "a little old lady in lace, slightly bewildered by the boom wartime activity…brought to her doorstep." Ham reported that 90 percent of the city's "first families" south of Broad Street had opened their homes to the newcomers and servicemen, but there were some significant exceptions. In March 1943, the local board of the United Seamen's Service (USS) was dismayed to find local opposition to the conversion of 6 Gibbes Street, a home in the exclusive residential area near the Battery, to a boarding house and retreat for merchant seamen. Numerous complaints from neighbors voiced fears that the historic home would suffer irreparable damage if used by seamen for rest and relaxation. Although Ann Tiffany, a local member of the USS, defended the proposal, assuring the public that neither the home's beauty nor its antiquity would be altered, fears of unruly seamen entering the quiet neighborhood were uppermost in local residents' minds. Whether social stigma or genuine concern for the historical integrity of the old house motivated the opposition, by the end of the month the seamen's board dropped the idea and looked elsewhere.[209]

For a brief period, members of the Carolina Yacht Club probably wished that the USS had taken 6 Gibbes. After failing to secure that location for the boarding house, the USS announced in early April 1943 that condemnation proceedings would be filed instead against the exclusive club in order to make it into a hotel and recreation center for the same merchant seamen. In spite of backing from the national board of the USS in New York, the yacht club's commodore, Nathaniel I. Ball, apparently had enough influence to overturn the order. Within a week the threatened proceedings were stopped. However, club members seemed to fear that if they did not make some patriotic gesture they might be sanctioned by the military. Soon after Ball learned that the USS efforts had been stopped, he announced that naval officers were welcome to use the yacht club's living quarters and restaurant whenever they liked.[210]

Charlestonians' interest in preserving their historic buildings in spite of the desperate overcrowding caused by the war is also telling of residents' attitudes in this era of change. In 1943, amidst a housing crisis and emerging food shortages, one of "the grand dames" of the city protested the demolition of a "Negro slum" for a wartime housing development. The slums, she said, were excellent examples of "pure Adams architecture." The slums were lost, but even as this happened, eleven hundred other buildings were listed as significant historic structures worthy of preservation. A comprehensive listing with photographs of most buildings on the list was published the following year in a detailed study entitled *This is Charleston: An Architectural Survey of a Unique American City*.[211]

For some, Charleston's priority of historical preservation over war needs was truly offensive. One resident who came to Charleston in the fall of 1943 described the natives as "land proud, tradition-bound Charlestonians" battling to preserve their way of life regardless of the war, making life miserable for many newcomers.[212] Her complaint is arguably extreme, but it is certain that many new residents had to endure higher rents if they lived in private developments or rented from a landlord.

The federal government tried to freeze rents at March 1942 levels, but private rents continued to go up in spite of government penalties. In January 1943, the average rental rate for public housing ranged from $31.50 for a one-bedroom unit to $41.50 for a three-bedroom residence; private housing complexes and many private homes had significantly higher rents. In June 1942, Admiral William Glassford, commandant of the Charleston Navy Yard and the Sixth Naval District, ordered that rent increases since March be refunded, but his successor found that these orders had, in many instances, been ignored. In January 1944, Rear Admiral Jules James complained to the assistant secretary of the navy that private housing projects charged rental fees from $46.00 to $55.00 per month, not including utilities. When the cost of utilities were added, James fumed, the differential between private and public housing stood at approximately $28.00 per month.[213]

Complaints from navy yard workers were certainly not limited to the problems associated with housing in the city center. Not long before he wrote to Washington, James had received a joint complaint from 155 yard workers residing at Waylyn Homes. The complex was owned and operated by the private V-Housing Corporation of Charleston. James described the workers' position bluntly: "The rent was exorbitant, their situation

Part of a 2,000-unit development created during the middle of the war, these demountable, prefabricated buildings of Liberty Homes were built in Mississippi, shipped to North Charleston and reassembled in an effort to relieve the ever-present housing crisis for the navy yard. This image, taken in 1995, shows that the original asbestos shingles and siding have been replaced by asphalt roofing and synthetic siding. *Courtesy Sara Fick, State Historic Preservation Office, SCDAH.*

intolerable and unless something [was] done they would be forced to resign their jobs at the Yard." [214]

Other complaints addressed poor conditions. James had written to the navy department a month before receiving the above complaint, enclosing a petition with four hundred signatures from residents at Liberty Homes, the largest public housing project in North Charleston. The residents complained that insufficient gas supplies for cooking caused problems at home and also at the workplace. Without adequate facilities for food preparation, the residents predicted, the morale of their children and the productivity of working parents at the navy yard would be significantly affected. In addition, the house manager, the petitioners claimed, provided inadequate and over-priced coal supplies. He refused to permit outside coal dealers to deliver directly to each Liberty Home residence, forcing families to buy from the coal yard near the complex where prices were "far out of line with other local coal yards."[215] Residents also described poor mail service, inadequate fire protection and inadequate public transport to their jobs, especially on Sundays.

This duplex is another example of wartime housing built just before Pearl Harbor or during the first year of war. Sometime after 1945 this house was moved to its current location on Gaynor Avenue in North Charleston. *Courtesy Sara Fick, State Historic Preservation Office, SCDAH.*

This single cottage is one from the extension of the original private Whipper Barony development started in 1940. The extension was begun a year later and built by General Housing, a private builder of the area. Although material and labor for private housing was scarce, private developments like this show that the war did not shut down private construction. This example, seen here in 1995, is located on Helm Avenue in North Charleston where the Whipper Barony Extension started. *Courtesy Sara Fick, State Historic Preservation Office, SCDAH.*

Although war workers had legitimate complaints that could not easily be fixed, some native Charlestonians remained unmoved by the problems these newcomers faced. This unsympathetic attitude was even found among teenagers. In March 1943, Miss Leslie Dukes, a high school student living on Rutledge Avenue near the old downtown center, did not take kindly to those who saw her native city as "old and antiquated [as though Charleston] was a lost colony that forgot the advancing world." As far as she (and probably many others in her neighborhood) was concerned, since Charlestonians had not asked the complaining newcomers to live in their city, she would be glad when the dissatisfied ones left. Although she admitted that there were a few natives who had taken advantage of the situation to profiteer off others, these were a small minority. She also claimed, somewhat defensively, that the Holy City "compared very favorably with all seaports from Portland, Maine, around to Seattle." [216]

Unsatisfactory housing was only one of a litany of issues affecting the turnover and absentee rates in important war production facilities. In April 1943, the Roosevelt administration formed another executive war committee, the Committee for Congested Production Areas (CCPA), to assist overcrowded production centers to resolve or minimize shortages and work through bureaucratic obstacles that threatened war production. The CCPA worked with local leaders of designated production areas and federal agencies to try and resolve housing problems and food shortage issues and to improve local recreation facilities and overcrowded schools. Unlike some war bureaucracies created by the executive branch, this new committee had a small staff of no more than eighty-five, including field representatives. During its brief year and a half of existence this small organization played a significant role in resolving serious shortages and overcrowding in many cities. Under the direction of Corrington Gill in Washington, the CCPA eventually designated eighteen national war production sites as seriously congested—Charleston was one of these. The Charleston representative, J. Clarke Johnstone, a former WPA official, was based in Atlanta and represented the committee in Brunswick, Georgia, as well. He traveled between his home base and the two Southern war production centers regularly, negotiating between city and county officials and federal agencies such as the WMC, the Federal Housing Authority (FHA) and the United States Public Health Service (USPHS) to find solutions to many problems. [217]

One of the highest-priority projects that the CCPA worked on in Charleston was resolving sewer and sanitation problems in the wartime housing developments. An adequate sewer system was crucial to the completion and success of these housing projects. The safest system to install would use sewer lines that could handle the large, concentrated amount of sewage the thousands of residents created each day. However, by the spring of 1943, severe rationing quotas by the War Production Board (WPB) made the concrete and steel required for such a system difficult to acquire. Perhaps even more problematic was the Federal Work Agency's unwillingness to authorize federal funding for key sewer projects. The FWA refused to provide the needed funds for sewer lines to the new Dorchester and Waylyn housing subdivisions because they were privately owned and officials feared that the private developers would benefit unfairly from the

government funds. Even when local contractor J.C. Long offered to finance more than half of the cost for installing the sewer lines, the FWA still refused to provide the remainder for the privately owned developments.[218]

Unable to change FWA officials' minds, the South Carolina legislature passed a temporary measure allowing local contractors in cities with populations over seventy thousand to use septic tanks, which were less sanitary. Though easier and cheaper to build, the tanks posed a potential health hazard in the marshlands in and around the developments of North Charleston and other areas south of the Ashley River. Septic tanks were susceptible to leaking and the threat of serious epidemics developing in a large population center was very significant, especially in land with high water tables.[219]

By August 1943, "temporary" septic tanks had been installed in the newly built Waylyn Community and Dorchester Terrace. After an inspection in the fall, acting Surgeon General W.F. Draper informed CCPA director Corrington Gill that the septic tanks showed little evidence of seepage, but that this would change when the drought then affecting the Charleston area ended. When normal rainfall returned, Draper predicted that it would be "difficult if not impossible to dispose of sewage properly."[220]

State and local public health authorities were equally concerned about the new risk the temporary sanitary measures were bringing to the community, but the housing shortages forced them to make compromises that they normally would not have made. For the time being, any septic tanks already installed would continue to be used, but CCPA representative Johnstone was called in to work through the bureaucratic maze and find a long-term solution. While working with local contractors and navy representatives, Johnstone and Gill discovered more alarming news. The USPHS reported that some people, despite their housing needs, were refusing to live in the new additions to the Dorchester and Waylyn subdivisions because septic tanks posed such a serious potential health hazard. On November 22, 1943, a USPHS officer claimed that 1,500 to 1,600 housing units in the Charleston area were empty, including 570 at the Dorchester Terrace complexes and another 300 at the Waylyn complex, and would remain so unless their septic tanks were replaced with sewer lines. However, despite the porous nature of the soil that made these areas "entirely unsuitable for septic tanks," Byrnes Down, another private housing project south of the Ashley River, was going up and had plans in place to use septic tanks.[221]

Though the South Carolina legislature had created a new sanitary sewer district for the developing area so that local bonds could be raised to pay for sewer line construction, the new commissioners of the district were only starting to prepare an application for federal funds. In the meantime, work on the Byrnes Down project was continuing, while Charleston and Washington staffs of the CCPA were working with the FHA to try and ensure that adequate sewers were incorporated.[222]

Despite the emergency, by March of the new year, Johnstone and officials from the navy still had no resolution. By this time the navy had revealed that anticipated fears of overflowing septic tanks were a reality, announcing that 127 septic tanks and 44 grease traps had overflowed in the Dorchester and Waylyn housing projects. Moreover, 99 homes had water in their yards.

When working through regular channels failed to get the sewage systems built, the navy used its authority to get the lines installed. Arguing that employee illness caused by inferior septic systems might hinder productivity at the navy yard, Rear Admiral James demanded that the subdivisions housing yard workers be given priority. By the end of 1943, funds and materials for sewer line construction were being used for the Mayfair and Dorchester 2 and 3 housing projects.[223]

Fortunately, the feared widespread disease from leaking septic tanks never occurred. Nevertheless, public apprehension and concern remained great enough that some septic-tank-equipped housing developments still could not fill their units, despite the continued housing shortage. In early November of 1943, Gill was informed that there were "probably 200" vacancies because of the adverse publicity surrounding the septic tanks. The developments in question were not identified, but later that month, acting Surgeon General Draper claimed that 94 vacancies existed in the recently completed 750-unit Waylyn subdivision extension. Eventually Johnstone's persistence bore results. By late 1944 Byrnes Down and other private housing projects had modern sewage systems installed or were in the process of having them completed.[224]

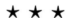

Another equally disturbing health problem plagued city officials during the same period: rat infestation. The city was not prepared to deal with the growing amounts of garbage produced by the new population, and traditional trash disposal methods caused problems. As late as October 1943, most downtown merchants continued placing refuse on the street the night before garbage pick up. Before morning, boxes and their contents were often scattered throughout the streets. The presence of rats was disturbing enough, but in February 1943, Leon Banov, county health officer, gave the alarming report that 81 percent of the rats in the city tested positive for typhus.[225]

Banov and the USPHS went into swift action to get the situation under control. Using simple but effective materials, Banov and local volunteers made "rat torpedoes" by placing poisoned bits of food in folded pieces of newspaper that resembled little bombs. These were then distributed in the thousands throughout the alleys, crawl spaces and other likely refuges of the deadly pests. Local billboards and newspaper ads urged residents to "Kill Rats Like Japs"; prominent society ladies held residential teas referred to as "rat teas" to publicize the campaign. By the fall of 1944, local efforts and a local rodent control ordinance were successful enough that several cities around the nation sent representatives to Charleston to study their methods. By the end of the war, typhus cases were virtually eliminated.[226]

These housing shortages and corresponding health issues were results of a large population increase in the white community. But in the black community, where the population growth was much smaller, the roots of the shortages were different. The black community in Charleston had always suffered from poor and deficient housing. After 1941, extreme overcrowding continued to be a problem, even though the number of black

immigrants to the area never rose beyond 9 percent. In a March 1944 population study, it was observed that in 1940, 36.8 percent of black households had more than 1.5 persons per room, whereas only 9.6 percent of white households experienced such crowding. Four years later, even though the minority population had not risen significantly, black overcrowding remained basically the same. On the other hand, the white population, which had increased substantially, had much lower rates of overcrowding, and due to massive building, had risen barely .2 percent above prewar levels.[227]

In September 1943, CCPA representative J. Clarke Johnstone advised that special consideration be given to the problems of the black community, stating that many black inhabitants in the city were without basic housing and recreation outlets. Government funding was granted in late 1943 for two minority housing developments, Daniel Jenkins Homes and Reed Hill Homes. In the fall of that year, it was suggested that one portion of an unidentified 750-unit development be reserved for black military personnel and their families, but this provided only minor improvement. Segregation laws and white prejudice prevented equitable resolutions to minority problems. In October, Henry Lockwood, the mayor of Charleston, claimed that it was impossible to find more housing for black military personnel within the limits of Charleston. If the federal government could not find or construct more housing for blacks, the only recourse he could see was to seek the financial help of Charleston's small prosperous black community. There is no record if this was done.[228]

Though it was not until this late date in the war that government officials began to give heed to the extreme housing crisis in the black community, local black leaders had made attempts prior to this. Howard Bennett, principal of the local prestigious private black school, the Avery Normal Institute, had informed the city fathers of the problem less than a year after Pearl Harbor through the Negro Community Council of Charleston. Armed with evidence gathered by Avery students and others in the African American community, Bennett presented the city government with the results of the study showing the grave living conditions that many African Americans found themselves in. Although the report itself apparently is lost, the general impressions were that overcrowding and unsanitary conditions were serious. One Avery student wrote that some people she visited lived in "appalling" conditions. The Charleston Negro Community Council reported that twelve thousand minorities had entered the city over the past year. It's not surprising, then, with the severe strains placed on the city and its residents that racial tensions were high in Charleston.[229]

Although major racial violence did not occur in Charleston as it did in other Southern cities, like Mobile, Alabama, or Beaumont, Texas, racial prejudice was palpable, at least to most black residents. Principal Bennett recalled years later that the large numbers of rural whites entering the old city for war work brought a greater amount of tension to racial issues than had been the case prior to the war. Harboring what Bennett considered a greater hostility toward blacks, these outsiders could be quite threatening. It was not beneath them to "throw a black on the ground and step on them just like they weren't there." He had encountered such prejudice himself: in one incident during the war, Bennett stepped in front of a white man to board a bus. Incensed, the man threatened to get a knife and

Save waste fats for explosives

TAKE THEM TO YOUR MEAT DEALER

Cooking fat was an important item that housewives across the nation were asked to save. The fat was a vital ingredient in making gunpowder, and households were asked to deliver their contributions to the local butcher on a weekly basis. *Special Collections, Clemson University Library.*

cut Bennett's "head off." Fortunately nothing more than words were exchanged, but the confrontation demonstrates the level of racial animosity that seethed under the surface in some quarters of the city.[230]

In the midst of the housing and sewer difficulties in the fall of 1943, when making his first visit to the Charleston area, J. Clarke Johnstone concluded that the city "has serious problems which require coordinated and continuous attention of local, state, and federal officials." One of those problems was the growing food shortage crisis.[231]

Food rationing was implemented gradually in the Palmetto State. In 1942 grocery shelves had begun showing shortages; in the spring of that year the Office of Price Administration (OPA), the federal government agency responsible for monitoring and distributing consumer items such as food, gas and tires, began rationing sugar. In the fall, coffee was added to the ration list. Even though there had already been grocery shortages months before, the comprehensive rationing of meats, canned foods and other selected processed edibles did not begin until February of 1943. The following month every grocery and meat market in the Charleston area had to display (as in most areas of the country) a chart listing the foods that were rationed and the ration points each item cost to purchase. To further complicate matters, the ration points charged could change weekly, depending on the supply determined by the local food rationing board. Thus, a can of pork and beans could cost three points one week and four points the next. This system often became a nightmare for store managers who were responsible for making sure the system was implemented and run fairly. At the end of each month they had to account for all ration points they collected and report to wholesalers and the local food rationing board of the OPA.[232]

The rationing system was no less of a headache for the store patrons. At the start of each month each family was to pick up their monthly quota of eighty points in ration stamps from the local school where teachers and other volunteers handed them out. Blue points were for canned foods and red ones for meats. Families now had two food budgets, the fiscal food budget and the ration stamp budget. If the family's ration stamp allocation ran out before the start of the new month, the family would be restricted to buying foods that were not rationed (i.e. cereal, milk, fresh fruits and vegetables and fresh fish). Sometimes, in an emergency, a kind neighbor could be persuaded to relinquish extras they had.[233]

The comprehensive food rationing system was implemented over a four-week period. For ten days, starting February 20, 1943, the sale of all canned goods was suspended to prevent hoarding; On March 1 rationing began on these items. Four weeks later, on March 29, meats, butter, margarine and edible fats (i.e. lard) were included in the rationing scheme.

The national ration plan was instituted in an effort to ensure equitable distribution of scarce foods, but some regions still had alarming scarcities of certain staples. In the Lowcountry, two foods that were essential to most daily diets were rice and grits. One

official observed that rice, grits and meal were the staff of life among the local population, but in 1943 supplies of both were growing dangerously low. Since the war's beginning, federal authorities at OPA had allotted the Charleston area 85 percent of its normal peacetime supply. The reduction from 275,667 hundred-pound bags of rice in 1941–42 to 238,537 bags the next year may not have been such a large problem if Charleston's population had not continued to grow at such a rapid rate, but as new workers continued to pour in, rice supplies became inadequate.

Charleston rice broker Artie Schirmer had difficulty explaining the need for more rice to federal officials in Washington who were unfamiliar with local diets. In a telephone conversation with Washington OPA officials in the fall of 1943, Schirmer had to defend his community's need to an incredulous official at the other end of the line. Although the OPA official in Washington thought "fifty million pounds of rice" for four months seemed adequate, the Charleston rice broker claimed, "That's no rice for South Carolina…retailers are selling two pounds to a customer." Eventually Schirmer, with the CCPA, convinced the OPA to increase Charleston's rice supply by shifting some of the state's quota from the Upcountry to the coast. By December local papers proclaimed that the area's rice supply was much improved.[234] Through the lobbying of rice wholesalers like Schirmer and the help of CCPA representative Johnstone, Charleston's rice quota for 1943–44 was increased to 499,000 hundred-pound bags. One can only imagine how citizens of the Upcountry must have felt about this, but in the fall of 1943, South Carolina Senator Burnett Maybank was so impressed by the work of Johnstone on improving the rice supply that he complimented his "quick action and splendid work."[235]

Nevertheless, food distribution throughout the Southeast appeared to be in a "decidedly unfavorable situation…in comparison with the rest of the country." Despite Johnstone's success with the rice allotment, labor leaders were not so sure the food supplies were sufficient. In March 1944, Johnstone and federal, city and wholesale representatives tried to reassure them, but labor leaders remained convinced that food shortages were still serious. Russell H. James, chief of Civilian Food Requirements, bemoaned the stubborn attitude of Charleston's labor bosses who refused to believe that Charleston's food supply was sufficient for meeting the needs of local war industry workers. In response to the conflict, a survey of food supplies in the city was instituted in the last week of March. Representatives from all levels of government, wholesalers and labor leaders planned to tour the food warehouses and some of the more than three hundred area groceries to review food supplies. In doing this, both James and Johnstone hoped that the survey team would finally convince labor leaders that there were adequate provisions. If the survey proved that the labor leaders were correct, the leaders wanted to organize food commissaries that would bypass wholesalers and grocers and distribute food directly to war workers to ensure that they received the proper allotments.[236]

During the same month, South Carolina Governor Olin D. Johnston learned that even though special rice shipments had been requested for the Charleston area, the extra quantities were still insufficient. Moreover, labor claimed that local grocers were discriminating against families new to the region. Longtime residents of the area,

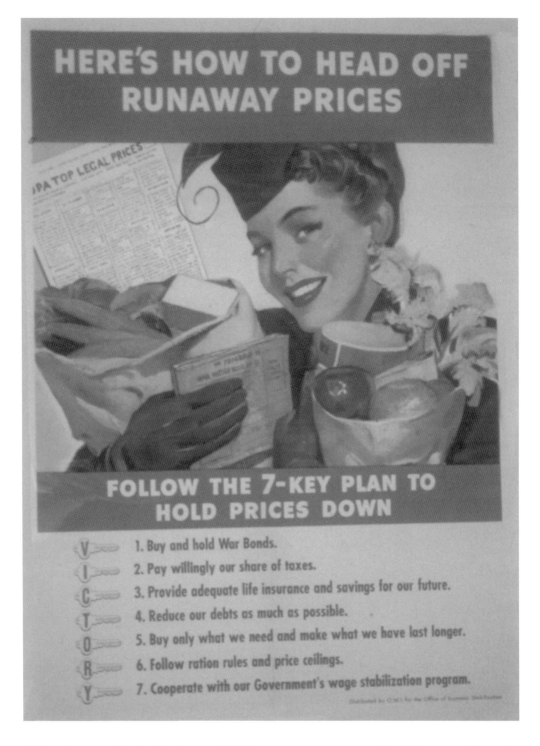

Although most South Carolinians did their part to support and aid the war effort, the government kept reminding people of their duties, from buying war bonds to obeying ration restrictions. *Special Collections, Clemson University Library.*

presumably those who had lived in the community before the war, could obtain the groceries they wanted from their neighborhood grocer while newcomers could not. It seemed that in response to the overwhelming number of customers, area merchants were more likely to "cater to the wishes of their [longtime residents] than they [were] to additional customers."[237] Russell James admitted problems in food distribution but continued to claim that the city's food supplies were as good as any for the Southern region. The food survey supported Russell's claim and convinced labor that they did not need to have food commissaries. However, the survey did recognize needed improvement in distribution between wholesalers and grocers. Russell ordered his agency to "focus attention on assisting the local distributors to correct any malpractice in the distributions that may exist." Nevertheless, by August 1944, reports had again reached Governor Johnston that rice shipments were still not sufficient for the increasing population and the canned-food inventories were low.[238]

Civilian food allotments concerned navy yard and CSDDC officials as well. Many employees complained about poor or inadequate food resources, convincing navy yard recruiters that labor turnover was based, in significant measure, on this issue. The city's smaller shipbuilding center had alarming statistics to substantiate the claim. Vice-president of CSDDC, L.L. Lewis Jr., asserted that a high percentage of the more than 100 percent turnover rate in 1943 "was due to lack of food." After the Civilian Defense Consumer Commission had collected "full statistical data on the cost of living, in food, rent, and all commodities," labor leader John Irwin claimed that prices in the Lowcountry city had increased more than anywhere else and were "souring [sic] beyond" the workers' ability to pay.[239]

Nevertheless, Johnstone thought workers' diets were fine. He attributed employees' food complaints to higher expectations brought on by a boom economy. During the prewar Depression days, none of them would have called this diet inadequate. Furthermore, when he reviewed worker turnover and absenteeism rates at the Charleston Navy Yard during a two-month period from August to September 1943 (where he found extremely high rates of 82 percent and 88 percent, respectively), food shortages were not cited as a reason. Rather, "health, home, location of family etc." were the reasons given.[240]

Former wartime workers reflecting on the 1940s recall food shortages, but none significant enough to cause worker turnover or reduce productivity. Sherlock Hutton ate most of his meals at a house near his boarding home. The proprietor made breakfast and dinner for him and many others living nearby. The cook also provided him a bagged lunch for work. However, Hutton recalled that this was "so lousy" that he soon stopped taking the lunch and ate at the yard cafeteria, where the meals were somewhat better and insufficient food quantities were never a problem.[241]

Gerald Teaster was just a young boy during the war but his father worked at the navy yard, and he never remembered a problem with food shortage. Another son of a navy yard worker, Jack Williamson, recalled that food rationing made certain items scarce, especially sugar and meat, but that there was never a time when his mother lacked sufficient staples for the family to eat properly.[242]

Probably Charleston's most desired staples, sugar and meat, were missed most during the war. When sugar was needed for a special occasion the host had to borrow rationed portions from relatives and friends. Such was the case for Ann Fox's 1944 wedding reception. As she planned for this big occasion she was faced with the possibility of little or no sweets for the party. Friends and relations gave her enough of their rationed sugar to make the wedding cake and other sweets to serve all her reception guests. Retail confectioners were not so lucky. One of Charleston's old candy establishments, the sixty-one-year-old Onslow Candy Store, was forced to close in March 1943.[243]

Periodically, meat supplies were also extremely low. When rationing began in the spring of 1943, Charleston butchers complained that they had almost nothing to sell. In response, the OPA ordered increased meat quotas, but one butcher claimed the increase was so small that it had little impact on the shortage. Nevertheless, as the people and food administrators grew accustomed to the rationing system, most serious shortages came to an end by the summer. Meat supplies were significantly less than in peacetime, but rarely exhausted.

To supplement the rationed meat allowance, some workers hunted wild game on their infrequent days off. Navy yard electrician Chester Russell liked to hunt when he had the time. Occasionally he and some friends would take a day in the country to hunt game birds and, less frequently, deer, and brought the game home for Mrs. Russell to cook. In the beginning this was a problem because Mrs. Russell did not know how to prepare wild meat. But, as the expression goes, "necessity is the mother of invention," and with time she learned to cook a very tasty wild bird or venison that everyone enjoyed.[244]

Of course some consumers used the black market to skirt the problem of rationing. Because of its criminal nature, there are few accounts to measure how many Charleston suppliers and consumers bought illegal goods, though the constant reminders in newspapers and posters that only government prices be paid for consumer goods indicated that illegal purchasing occurred. In any case, local food administrators reported that the black market significantly declined after the first few months of national rationing. In October 1943 the South Carolina Food Distribution director claimed the illegal sale of beef in Charleston had declined from a maximum violation rate of 41 percent in June to 18 percent three months later. The administration hoped that Charleston's forthcoming ordinance to fine violators would reduce this rate even further.[245]

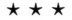

Another rationed item was gas, which severely restricted public and private transportation. During the war years, people were asked to limit travel to essential activities. Most obeyed these wartime restrictions, but, as could be expected, some residents tried to skirt the laws.

Private automobiles were growing in popularity by the early 1940s, but the Depression years and then the coming of war made them less commonplace. Many people depended on public transportation for commuting to work and long-distance travel. As the wartime

population grew, so did the pressure on the public bus system. In addition, the tire and gas rationing applied to public vehicles as well as private ones.[246]

By the end of 1942, morning and afternoon rush hours were becoming extremely crowded, making bus commutes more difficult for workers living beyond the vicinity of the navy yard. In December, despite an increasing ridership and revenue, replacement parts and fuel were growing more difficult to acquire. Those who maintained the fleet were being forced to "use all their ingenuity to make ends meet." In late 1942, transit authorities appealed to riders to change commuting habits. Housewives and other non-war industry workers were urged to use the bus during non-peak hours—10:00 a.m. and 4:00 p.m.—when possible.[247]

Since the trolley system had been replaced by motorized buses in 1939, Charleston residents had no alternative public transportation. Between 1940 and 1944, annual passenger traffic on the city bus system increased by 6,000 percent. Twenty-five million passengers used the system during 1943 (nearly five times its 1940 usage), and by September, in spite of transit authority appeals, the buses were termed "overcrowded and extremely inconvenient." Labor recruiters believed this was another issue contributing to recruiting problems at the navy yard and also thought it contributed to tardiness and absenteeism. Other area war industries, especially the Pittsburgh Metallurgical Company and West Virginia Pulp and Paper (Charleston companies north of the yard), also complained that poor transportation hindered their workers. Various alternatives were attempted to improve the situation.[248]

In August 1943 the South Carolina Power Company leased 59 buses from the U.S. Navy to supplement its 59 over-taxed vehicles then on the road. By this time, 15 buses daily were off the street with routine maintenance or unexpected breakdowns. It was estimated that 900,000 passengers per week rode the system on a daily bus schedule that ran twenty-two hours. To operate this fleet, 210 drivers were hired by late summer of 1943. Another 150 buses served rural commuters, people living outside the metropolitan Charleston bus routes.

It goes without saying that frustrations were common. In January 1943, Louis P. Towles, a Charleston commuter living in the old city, called bus service "intolerable." Towles worked at the navy yard and claimed that he waited forty-five minutes for a bus on Rutledge Avenue. Even though "at least eight" buses passed, each with very few passengers, none stopped.[249] Delores Russell took the bus to her work at the air force base outside of Charleston. Leaving her North Charleston home, Miss Russell had to transfer to another bus before reaching the nearest bus stop to the air base. Then she still had a two-mile walk before she reached her work station.[250]

The public bus system, supplemented by private buses, became the predominant mode of transportation in Charleston during the war years, but some people still drove their cars. While the South Carolina Highway Department claimed that automobile registrations were down more than thirty thousand for 1942–43 from the last full year of peace, many who lived in rural areas far from any kind of bus service still had to depend on their own vehicles to get to their war jobs. With housing at a premium, it was impractical to move closer. One

extreme example was James W. Barber, a navy yard mechanic who had a 160-mile round trip from his home in Cameron (in central Orangeburg County) every day. Leaving home each morning at 4:30, he could reach the base in two hours. Never late in nearly a year of service, he was only absent four days in that time. Anyone operating their own vehicle had to contend with gas and tire rationing, not to mention wartime speed limits of thirty-five miles per hour on the highway. To assist workers like Barber, the navy yard formed a workers' rationing board from which extra gas and tire certificates could be acquired by those with a legitimate reason. This gave navy yard workers some additional benefits, but complaints over the poor quality of tires were common. The better-grade tires were reserved for those driving great distances like Barber. The lower grades wore out so rapidly that replacing them became very expensive.[251]

In September 1942, South Carolina Governor Richard Jeffries announced that all state highway department vehicles would have a wartime speed limit of thirty-five miles per hour, unless it was a highway patrol car on duty. By the new year, all private car owners were under the same restrictions. J.L. Munzenmeir of North Charleston was one of the first violators of this wartime law. While driving a Standard Oil truck, he was clocked at fifty-two miles per hour by the state highway patrol. He claimed his speed was forty-five miles per hour, but still pled guilty. Not only was his truck ration card suspended, but an additional ten days' suspension was imposed on his personal "A" gas ration card.[252] Speed was not the only violation Charleston residents faced. Charleston police cited Sue Plair for pleasure driving in early 1943 after she was discovered driving friends to a restaurant and then to a nightclub. Brought before a Charleston magistrate, Plair was found guilty and had her A and C gas rationing privileges suspended for twenty-one days. No doubt Miss Plair was not the only one who used her car for pleasure trips. Although tourist travel was significantly down in the Charleston area, some drivers ignored the ban to see the spring blossoms at Middleton Place, Magnolia Gardens or the beach. It appears that authorities did not strictly enforce the emergency law but rather made examples of people such as Plair. Selected prosecutions, coupled with gas rationing, seemed to have effect.[253] At the end of the first year of war and traffic restrictions, there was at least one positive attribute: the South Carolina Highway Department reported the lowest traffic death toll for October with only nineteen deaths—thirty-nine fewer than the year before.[254]

While rationing of all kinds proved a major headache for most in Charleston, there were other problems just as difficult to solve. Another illegal activity that local, state and federal authorities made a concerted effort to eliminate was prostitution. The "red light district" had always existed in the old city, but as the war approached and more war workers and military personnel flocked in, the "ladies of the night" and their promoters came in increasing number to ply their trade. Some navy and army officials had moral objections to the trade, but the most important reason for their wanting to stamp out the vice was its threat to the health of soldiers and sailors. Medical, military and political officials were in agreement that prostitution was the dominant cause of the spread of syphilis and gonorrhea. According to a November 1941 study, the number of venereal disease cases in South Carolina was the second highest in the nation, at 156

cases per 1,000 people (second only to Florida). As early as March 1941, South Carolina communities around military installations, including the navy yard, were singled out for their ineffective measures to curb prostitution. Federal officials, led by the USPHS, determined that a significant reason for the poor record was the surprising lack of state laws prohibiting prostitution. South Carolina had no criminal law to prosecute prostitutes or their clients. Washington applied pressure on South Carolina lawmakers to change this, and after federal officials' intense month-long lobbying campaign on Governor Jeffries and the legislature, a criminal statute was signed into law on March 17, 1942.[255]

But South Carolina's lax approach to law enforcement for prostitution had already created problems between navy and Charleston authorities and would continue to do so. Before Pearl Harbor, Admiral William H. Allen, commandant of the Charleston Navy Yard, made twenty-seven Charleston "establishments" off limits to sailors and demanded the city do a better job of controlling the vice. Mayor Henry Lockwood's efforts did not satisfy the admiral, and a few months later the naval officer appealed to several local organizations, including the chamber of commerce and the county law enforcement agency. With navy assistance and support, civilian law enforcement established a 1:30 a.m. curfew for all beer parlors. In addition, the city fingerprinted all taxi drivers (who had been singled out as allies and purveyors of prostitution). But such ordinances only temporarily satisfied the navy. On February 8, 1942, a taxi driver was murdered, creating a new rift between the navy and the city. Shortly after the murder, Allen made Charleston "out-of-bounds" to all navy personnel. A week later in a public meeting where the mayor and admiral defended their policies, the audience accused Lockwood of condoning poor law enforcement on the vice. Faced with hostile criticism on all sides, Lockwood announced a severe crackdown on prostitution throughout the city, and to assist the over-extended police force the admiral provided a shore patrol.[256]

A Social Protection Committee established for Charleston early in the war and made up of prominent citizens of the community was assigned the duty of organizing methods to reduce prostitution and find ways to stop the spread of venereal disease. The committee called for the cooperation of the police and the local health department. The latter provided nurses and doctors to man clinics for testing and treatment of patients. Local police, with the assistance of the shore patrol provided by the navy, brought in patients, whether they volunteered or not. The health department agreed to hold clinics late at night and, if necessary, on Sundays, for people suspected of having the disease who were detained by the police.[257]

It appeared that police methods were based more on suspicion and fear than clear evidence, and women, not men, were the focus of the roundups of "suspicious" persons. In November 1942, after prostitution had been declared unlawful, six young women were arrested downtown in the early hours of the morning. After appearing before a magistrate, they were held for "medical exams" by the health department. The males arrested during the same night received fines or jail sentences. Whether authorities thought to examine the males was never stated, and it is unlikely they did. It would be

two years before the Social Protection Committee would request that men arrested be given the same health exams and treatment as women who were detained.[258]

There is no way to determine how many of these women arrested were prostitutes but it is unlikely that all were. As in other war production areas, in Charleston there was a significant number of teenage girls who eagerly went out with sailors and soldiers. In February 1943, Colonel James T. Duke, commander of the Port of Embarkation, noted in a public address that girls between ages fourteen and sixteen were often seen at all hours of the night with "men in uniform," but he did not think there was any way this could be prevented. The colonel's remarks suggest that the navy may have suspected that prostitution was not the principal reason for Charleston's high venereal disease rate. Prostitution may have only been one of several contributing factors, as there had been other, long-standing social health problems within the state that were as significant, if not more so. Nonetheless in the eyes of government officials, there was no question that the illicit trade was the main cause of the high disease rate.[259]

By late 1944, Community War Services authorities claimed that prostitution had been virtually eradicated, though "operators" continued to make repeated efforts to re-open houses of prostitution. Perhaps the number of "red light districts" was reduced, but authorities admitted that local venereal disease clinics still gave approximately seventeen hundred treatments weekly and that the mobile clinic gave another five hundred weekly.[260]

Perhaps with sexual vice such a public issue, the general community was spurred into giving unsolicited commentary on what they considered "immoral behavior." Early in the war, a Charleston matron wrote that an unmarried couple was staying in a cabin on Edisto Beach, about thirty miles south of the city, and she requested that the "dirty dive" be raided. Another "concerned" citizen claimed that something needed to be done about the "lewd" movies shown in local cinemas, which he felt were "countering the good influence of churches" on soldiers and sailors.[261]

It should be noted however, that after more than a full year of war, the police force in the port city was still significantly under-manned. Just twenty-six officers and six working squad cars handled a metropolitan population that had grown from a prewar level of 98,771 to 144,635 in 1942. Even more amazing was that the North Charleston community, where most of the increase was occurring, had but one lone patrolman, and he did not have a vehicle. Navy shore patrols and army military police officers supplemented local police with "excellent cooperative relations," and it is little wonder that Mayor Lockwood needed such assistance.[262]

While local law enforcement faced manpower shortages due to wartime booms, area citizens were facing shortages that may have seemed, to them, more severe. By 1942, overburdened movie houses, restaurants and recreation facilities had become another problem. Although many newcomers who came to work in the navy yard and other wartime industries claimed they had little time for visiting sites and enjoying movies,

enough did to put a severe strain on what facilities were available. John Muir brought his family from the North to work at the navy yard and claimed he had little time to see the area and meet residents beyond the George Legare subdivision where he lived in North Charleston. But many war workers did find time in their long work schedules to enjoy what there was available, which, due to the wartime population boom, was far from adequate.[263]

Local efforts by garden clubs and other civic organizations tried to alleviate the problem. One of the best examples of this was organizing a USO club at the historic Joseph Manigault House, one of the first old homes in the city to be protected by the 1930 preservation ordinance. Like hundreds of USO clubs around the nation, the club at the Manigault House provided rest, relaxation and dances for servicemen and women during their off-duty hours. Prior to Pearl Harbor, hundreds of volunteers joined together to provide money and muscle to make the old home into a service club. One group of women planned and made draperies for its many large windows. Garden clubs throughout the state supplied funds to landscape the surrounding gardens and lawns after the city leveled and filled in the grounds with dirt. Servicemen provided volunteer labor for the reconstruction of various parts of the house. Throughout the war the house was the center for many servicemen's dances as well as a place for lonely off-duty soldiers and sailors to get a meal and relax by reading and talking with USO volunteers. Red Cross classes were also held there to teach first aid and other emergency services to Charlestonians.[264]

In November 1943 a new North Charleston USO club was also completed on Park Circle to replace an older one called the "Ball Park USO." Financed with $75,000 of FWA funds, the new complex was a framed structure that included a large lounge, snack bar, men's shower room, game room and a "dance hall complete with a stage." Nearby General Asbestos Rubber Company provided volunteers, affectionately called "Garco Girls," and organization to the new facility.[265]

In spite of the local efforts to increase Charleston's recreation facilities, by the time it was declared a congested production area in the summer of 1943, both these and its restaurant facilities were proclaimed woefully insufficient by the city's CCPA representative. In September 1943, the area had ten cinemas with a total of 7,200 seats for whites and 1,850 for blacks. For a population that was reaching at least 140,000 by this time, many more were needed. Attempts to increase the numbers of movie houses proved difficult because of blocking attempts by local movie house owner Mr. Albert Sottile. The local cinema mogul had started the first Charleston movie house at the beginning of the century and had maintained a monopoly ever since. While he had been able to keep up with the movie needs of the peacetime public, he was unable to do so after December 1941. By the fall of 1943, CCPA representative J. Clarke Johnstone was making efforts to get the city to turn the county hall in downtown Charleston into another theater. However, city fathers were difficult to convince.[266]

Just as troubling was the low number of local restaurants compounded by reduced operating hours. The town had only eighty-seven restaurants with a total capacity of 5,100, supplemented by fifty-six soda fountains and "beer gardens" with an additional

capacity of 1,200. This was quite inadequate, especially with servicemen and civilians "overrunning the town" during weekends. Segregated eating facilities were fewer, with just fifty-three and a capacity of only 885 in total.[267]

By the fall of 1944 some efforts had been made to improve the restaurant situation. The overcrowding in city eating establishments seemed resolved, except on weekends when the influx of servicemen peaked. Part, if not most, of this relief was provided by the expansion of the navy yard cafeteria. With four cafeterias serving ten thousand hot meals per day the opportunity for men to receive adequate meals was significantly increased. Another seven thousand cold meals were available at the yard's smaller canteens that provided sandwiches and drinks. Nonetheless, even with these significant additions, dining needs continued to rise, especially since every new canteen or "serving line" opened at the yard was immediately crowded.[268]

Crowded theaters and restaurants may have hindered some from enjoying free time, but some recreation and sporting activities continued to flourish even though facilities were limited. The navy yard had several teams in softball, bowling and basketball that competed in city leagues during the war. Most shops in the yard were represented by a team in these and other activities. The larger shops, such as the shipfitters', probably had an advantage over smaller shops, but this did not discourage interest. Competitions were followed closely in the yard's newspaper. Fewer team-oriented activities such as cycling, swimming and checkers also had plenty of participants. The navy and army had their own leagues in these athletic and recreational pursuits that had followings throughout the war. Even so, not only were sports facilities lacking, but administrators for the programs were needed. By late fall 1943 an application for Lanham Act funds for the hiring of more administrators to develop and run various recreation programs had been submitted.[269]

At the same time, interest in college and minor-league sports decreased significantly. While most inter-collegiate sports at The Citadel continued, football was suspended after the 1942 season for the rest of the war. Lack of quality athletes (many enlisted or were drafted by the end of the first year of war) and travel restrictions were instrumental to the decision. Basketball and baseball continued, but with reduced schedules. Minor-league baseball had always had a significant following in the Lowcountry, but it did not survive during the war. Roosevelt gave blessings to Major League Baseball to continue for the benefit and morale of the nation, but his support did not trickle down to the minor league teams. Due to gas rationing and restrictions on manpower, Charleston's team, the Rebels, along with the rest of the teams of the South Atlantic League it was affiliated with, disbanded after the 1942 season for the remainder of the war.[270]

Wartime society affected essential domestic affairs in the average household on a daily basis as well. The complicated rationing system, housing and transportation problems and the lack of recreational outlets were just some of a long list of nuisances. For young families with

Children of navy yard workers in a federally financed nursery at one of the wartime housing complexes near the facility. *Courtesy of Palmer Olliff, North Charleston, SC.*

mothers working outside the home for the first time, there was also the important matter of childcare.

In 1943, congressional hearings were held across the nation on the issue. Many opposed mothers working outside the home because of the belief that the effects of a mother's absence could be harmful and contribute to the delinquency of a child. A Catholic priest bluntly stated that a mother's primary duty was to her husband and children. Judge Michael J. Scott, a respected legal mind in St. Louis, Missouri, agreed, concluding that no one could replace the mother in the home. National leaders such as J. Edgar Hoover, director of the Federal Bureau of Investigation, and Katherine F. Lenroot, chief of the Children's Bureau, also concurred that without a mother at home, children would fall into a "maze of delinquency and disease."[271]

Fortunately for the war effort, such domestic attitudes were not universal. Although a majority of the Charleston area's women (36,015) remained homemakers as late as March 1944, the metropolitan area had 20,685 women employed in a variety of occupations, many in war industries and some in service-oriented jobs. This was compared to 12,026 women employed just four years before.[272] The majority of the new female workers were not young mothers, but a significant number were with children under ten. Young working mothers used a variety of methods to find care for their young ones. Perhaps the preferred

choice was to have a relative or close friend care for their children. Catherine Bowens of Georgia, for example, came to the Charleston Navy Yard to operate a crane. During her shift her sister watched her baby.[273]

But many families from other regions of the country did not have relatives nearby. Consequently, to provide a semblance of the home atmosphere, a few Charleston wartime housing complexes organized their own day-care centers. In late 1942, a center for young children was organized at John C. Calhoun Homes. Without any support from local or federal governments, mothers formed a "Mothers' Club." Each of the twenty-five members was assessed four dollars per month, and the pool of money was used to hire a woman from nearby George Legare Homes who had fifteen years of professional childcare experience. Mrs. Cornelison, president of the Calhoun Mothers' Club, assured the public that their day-care center was only a temporary measure that required communities like hers to work together for the war effort. She implied that only during the war emergency would traditional roles of the mother change. Once the war ended mothers would return to their normal child-rearing functions. The Mothers' Club's defensive posture probably was a response to local stories suggesting that working mothers were the cause of their offsprings' tragic death or delinquent behavior. Childcare supporters must have cringed just a little when four-year-old Willis Washington fell off a second-floor porch to his death while his mother was at work. Some mothers who may have thought of leaving the home for outside employment must have hesitated when they learned of this tragedy.[274]

Reports of delinquent behavior by older children were not uncommon. In early 1943, three boys were arrested for possession of stolen articles and stealing twenty-five dollars from a city bus while the driver briefly left to visit a nearby filling station. During the same period three teenage girls were charged with disorderly conduct when arrested at 3:20 a.m. in a Meeting Street restaurant. Since they could not pay their forty-dollar fine, they were sent to jail for fifteen days.[275]

No matter what the prevailing philosophy about child rearing or the perceived consequences of a mother's absence might have been in Charleston, as the first year of the war came to an end, government and industrial officials became convinced that if they had more childcare facilities, female employment in war industries would increase. The WMC estimated that "eight hundred more women" would enter the labor force if sufficient nurseries existed. CCPA representative J. Clarke Johnstone disagreed with this assumption. In September 1943, he observed that Charleston-area women showed an "apathy" toward nursery schools and thus considered the city's available facilities "adequate." Nonetheless, six months after Johnstone's analysis, another government official claimed that the lack of young-childcare facilities remained an "obstacle" to recruiting more female war workers. According to his investigation only 17.4 percent of Charleston-area mothers with children under ten were in the labor force, with only about two-thirds of this number working full time.[276]

Despite the influx of workers and their families after Pearl Harbor there was only one government-operated day-care facility near the navy yard nearly two years after the nation entered the war. Along with the social stigma attached to day-care facilities, political

disagreement in Congress and the opposition of certain federal agencies to increased funding for nursery schools held up extensive expansion of the national day-care program. Although the Federal Works Agency urged expansion, the Federal Security Agency, the Children's Bureau and the U.S. Office of Education opposed it. Even though the FWA controlled the funds under the Lanham Act, there were too many members of Congress opposed to childcare center construction in 1943 to expand the program. In fact, during 1943, a bill to terminate Lanham Act funding for this purpose was only narrowly prevented when the House tabled a Senate majority vote. Aided by a determined group of union and pro-women lobbies, the House overrode the Senate and managed to substantially increase national funding for nurseries and trained staff to run them. After 1943, the fruits of this campaign began to have a positive impact in Charleston as well as the rest of the nation. National day care use steadily grew after the second year of war.[277]

National public figures for childcare facility use increased by the spring of 1944, with 87,406 boys and girls enrolled in 2,512 nurseries, compared to 58,682 in 2,065 centers at the end of the previous year. Charleston nurseries reflected the increase. In early 1943 one of the first government-sponsored nurseries was organized at George Legare Homes to care for a maximum of 30 preschoolers. Later that same year, Liberty Homes had a nursery for navy yard workers' children between the ages of two and six. The weekly fee was three dollars per child.[278] By the fall of 1944, four nursery schools were operating, one each in Liberty Homes, Liberty Homes Extension, George Legare Homes and Daniel Jenkins Homes, with a combined attendance of 225. Two more day-care centers were sought for Dorchester Terrace and another for Chicora Elementary School. South of the Ashley River, the St. Andrews housing project operated another preschool facility with a capacity for 45 children. The navy yard was particularly pleased about having these facilities and hoped to see more opened to attract even more women into the workforce.[279]

While the suburbs were opening preschool programs by the middle of the war, within the city of Charleston none existed as late as November 1944. Despite the continued hope by federal and navy yard officials that this would change, it appears that it was probably too late, since the war was drawing to a successful conclusion.[280]

As industry and government tried to resolve the childcare issue, they were also faced with public school overcrowding. As early as 1941, Charleston-area schools felt the impact of the great population increase. Educational institutions near the navy yard bore the greatest burden. In 1940, when Delores Russell entered North Charleston High School, its administration had already been forced into a double shift system for the school day. Students were assigned a morning or afternoon shift, each lasting four to five hours. The young Russell was assigned to the afternoon, starting her classes at one o'clock and going until five or five thirty in the afternoon. The overcrowding and deficient curriculum of Charleston schools prompted Russell's parents to send her to the all-girls Memminger High School in downtown Charleston for her final year. She graduated from there in 1942.[281]

Memminger not only had a better curriculum and faculty than North Charleston High, it was not overcrowded. Like the rest of the schools within the city, the downtown

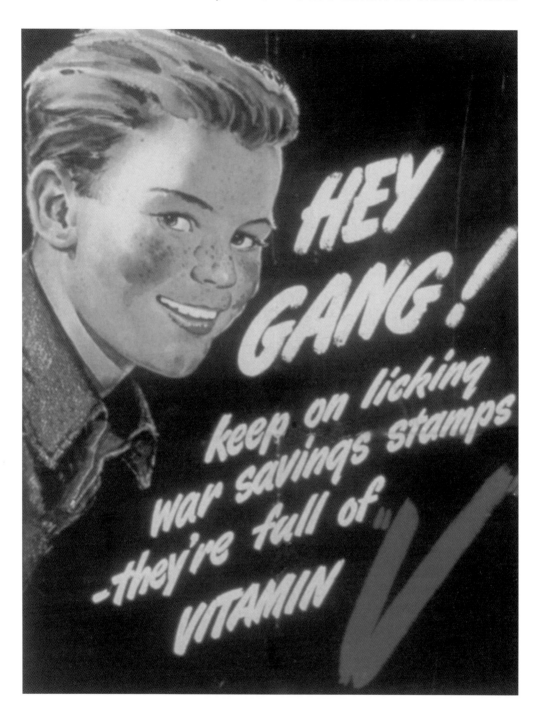

Children were encouraged to support the war by purchasing savings bond stamp books. Each week children of all ages often purchased at least one stamp—costing between ten to twenty-five cents per stamp—to fill their books. It took about eighteen dollars to fill the book, and after the war the government redeemed them for twenty-five dollars. *Special Collections, Clemson University Library.*

school had normal class hours. Because of the city center's minor population increase, its schools had a stable student population throughout the war. Comparisons of the school years for 1940–41 and 1943–44 show that white attendance figures for the city's educational institutions had less than a 1,000-student increase, from 5,624 to 6,597. Attendance levels of black students in the city were virtually unchanged, from 5,793 to 5,800. Outside the city limits, in county schools, the expansion and overcrowding within white schools was remarkable. The suburban white student population between the 1940–41 and 1943–44 school years increased by over 30 percent, from 11,714 to 15,563. By contrast the suburban black student population over the same period remained relatively stable—12,237 to 12,977.[282]

The Charleston-area schools did not appear to have serious faculty shortages, but the population increase must have surely caused problems for Cooper River School District Number 4, which suffered the brunt of the skyrocketing enrollment. (Total students went from 3,409 in 1939 to 10,000 five years later.) Consisting of twenty-four schools in 1944, the district's boundaries extended from Charleston's city limits north to Summerville, and from the Cooper and Ashley Rivers east to west. Although an accelerated building program was started during the first year of war to expand or add to the prewar schools of the area, the Cooper River School District superintendent did not think that his schools had enough room for the ever-growing student population. Despite the construction of a thirty-one-room school for whites near the new Liberty Homes development north of the navy yard and a six-room school for blacks in the Reed Hill community, classes were growing too fast for the district. Dorchester Terrace School, with a capacity of 468 students, had 600 enrolled for the 1944 fall term. This school did not adopt double shifts; instead each teacher was given a significantly higher student-teacher ratio and "make-shift rooms" were created to accommodate more classes. During the same year, when the Liberty Homes School, with a capacity of 1,116 students, saw enrollment increase by nearly 500 students, the institution was forced to make some of its grades run on a double shift. Nonetheless, the overcrowding did not lead to new construction. WMC officials determined that Liberty Homes was a temporary community and that once the war ended most of its residents would disperse, making new construction unnecessary for the long-term. The double shifts that some students had to endure were not considered significant inconveniences because students lived "fairly close to the school."[283]

Delores Russell found the double shifts at North Charleston High difficult, but in early 1943, J.J. Owen, the principal of the same high school, painted a more positive picture. Even though he admitted that the institution's student population was double the school's normal capacity (967 from 567 in the last year of peace), he said that faculty and students were adjusting well to the overcrowding. Half the teachers taught the morning session from 8:45 a.m. to 1:15 p.m. and the other half did the afternoon shift from 1:30 p.m. to 6:00 p.m. Classes included practical sessions for girls in home economics, while boys took manual training and aviation. Owen proclaimed that the school had gone to war, so that each subject taught "became a tool in the hands of those [students] who will fight for our liberty."[284]

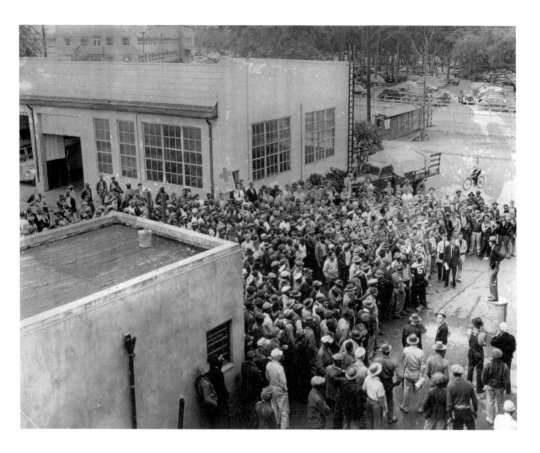

Workers of the yard's transportation and maintenance shops gather to learn how they can support the latest Red Cross fundraiser, March 18, 1943. This was one of many causes that navy yard workers were called on to support throughout the war. *Courtesy of William Bendt, Charleston, SC.*

Other former students of the period recollected little or no difficulty with adjusting to crowded conditions. Gerald Teaster, who attended Dorchester Terrace School, recalled no measurable change between peace and wartime as far as class sizes and logistics were concerned. Jack Williamson attended Chicora Elementary but never was required to attend a double shift. He did recall many new students from places ranging from Birmingham, Alabama, to Southern California that enrolled and later left.[285]

Aside from the change in normal class routines, the war atmosphere in the nation gave students an additional anxiety, especially if they had a relative or family friend serving overseas. Jack Williamson described each school day as "always serious business." Every morning class began with a review of the latest news from the various war theaters. With a brother serving in the navy overseas, these reviews were very important to Williamson.[286]

Schools across the nation were also instructed to teach students about why America was fighting and how each pupil could help in tangible ways to win the war. Charleston-area

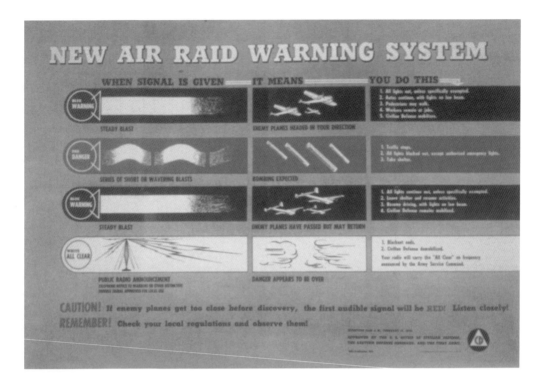

One of the many civil defense posters placed in communities throughout South Carolina was this air raid siren notice distributed in 1943. It explains the different siren sound patterns used to warn of approaching enemy air attacks and provides instructions on what people should do during a raid. *Special Collections, Clemson University Library.*

students and adults of all ages demonstrated their patriotism for a variety of war-related causes by giving their time to civic activities.

One notable effort was the national Victory Garden campaign that began in the spring of 1942. By the time the campaign was in full effect, the local newspaper published gardening tips on a weekly, if not daily, basis, and extension agents from Clemson College held regular public workshops on cultivating, fertilizing and harvesting a variety of vegetables. The Victory Garden campaign became very successful during the cultivating season of 1943, with one Charleston seed dealer announcing that sales had been so brisk that he could have used two or three more assistants and tripled his sales if he had had more supplies to sell.[287]

Because space was more limited within the city center, most new gardens were seen in the suburbs outside the city limits. During the spring of 1943, extension agents claimed that Victory Gardens had tripled since the previous year. During this period nearly every one of the ninety-five residences of the Nafair subdivision had a vegetable plot, and families were proud of their carrots, onions and peas. Another family of the same subdivision raised chickens as a hobby.[288]

At Mitchel Elementary School on James Island, just south of the city, students replaced the traditional flower gardens of the prewar era with productive vegetable plots. The youngest pupils were assigned four-by-four- foot plots. Older children could get larger gardens that could reach the size of eight by twenty feet. Most students worked in their gardens for an hour in the morning before classes started, and at least one class confessed that it spent another hour of school time every day working on their plots. Produce harvested ranged from beets, radishes and carrots to string beans and onions. While some of this was to be reserved for the school lunches, most of the harvested goods were intended for home consumption by students' families.[289]

Civilians also contributed significantly to commercial agriculture. As factory managers desperately sought more labor, the employment needs of farmers were overlooked. However, as numerous newspaper articles and letters to the governor made clear, the farm labor shortage could not be ignored. It was estimated that U.S. armed forces and the lend-lease program would need half of the vegetables grown in 1943—more than Victory Gardens were needed to sustain civilians. Labor to cultivate and harvest commercial farm produce was essential. In February 1943, the farm labor shortage was so acute that one civic group planned to recruit businessmen and other Charleston residents to volunteer their time for the county's labor-starved farmers. Through the rest of the war farm labor shortages continued to inspire similar volunteer efforts.[290]

Some schools enlisted student brigades to go out into the fields surrounding the city to plant and harvest crops. In May 1943, a crew of eight high school males became the first to volunteer, and gave their assistance to help harvest E.F. Bellinger's potato crop on Charleston's outskirts.[291]

Other war-related school activities had a more military component. Many boys participated in military drill once per week. General William Moultrie High School in Mount Pleasant formed two platoons and, by January 1943, was making plans for an obstacle course for physical training. During the same period, North Charleston High School boys and girls took courses in aviation that included pre-flight training and "basic ground work." Shop classes made model airplanes that were used for training ground observers, volunteers who watched the skies for enemy aircraft. The models gave observers a three-dimensional way of learning how to identify the many different types of enemy aircraft they might see.[292]

Adults also gave their time to the war effort. Whether employed in a war industry or not, people volunteered their time, energy and resources to help Uncle Sam. Among the most publicized were war bond drives. Workplaces, banks, Red Cross branches and other outlets avidly promoted bond purchases to help the government finance the war effort.

Navy yard workers were solicited regularly to contribute to yard bond drives, and competition in and outside the facility was regularly used as an incentive. Each shop within the yard regularly reported its worker participation rate. At the end of each major national drive the yard commandant announced the shop with the best participation rate and most bonds purchased. While many employees purchased $50 and $100 bonds with

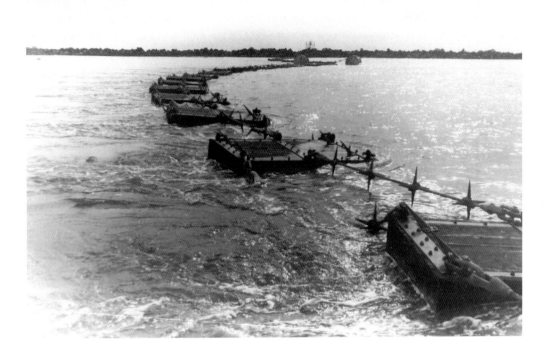

Motorboat booms were placed across the Cooper River to protect the entrance to the navy yard, February 4, 1942. *South Carolina State Museum.*

every paycheck, a few did much more. In the pattern shop, Robert Finke purchased a $1,000 bond one day and the next, for "dessert," bought another for $100.

The Charleston shipbuilding facility also competed with other national navy yards. After leading the nation's navy yards in bond sales for two months in the summer of 1942, with 90.65 percent worker participation, Charleston Navy Yard enthusiasm began to decline. The competition was taken seriously enough that yard officials became alarmed in the new year because Charleston had fallen almost into last place. In February 1943, the Charleston Navy Yard had the second smallest buyer percentage of the nation's eight major yards. While Portsmouth Navy Yard employees had 94 percent participation, the South Carolina yard had dropped to under 86 percent participation. Navy officials grew more concerned when the participation rate fell another 4 percent the following month. After an intensive lobbying campaign by bond sales representatives in each shop and many stories in the yard newspaper, sales participation improved significantly that fall. Many shops had just at or under 100 percent participation. The competition may not have been as great in other Charleston war industries, but the pressure to buy bonds became a patriotic duty that most people accepted eagerly.[293]

Another important volunteer effort was the civilian defense program. State defense officials had begun to organize civilians more than a year before Japan attacked Hawaii.

By 1943 the Charleston-area civilian defense force had more than thirteen thousand volunteers with duties ranging from aircraft spotting to emergency first-aid work and scrap drives. As a coastal county, in the war's first year Charleston was also integrally involved in assisting the navy and coast guard patrol the coast for German U-boats.[294]

All Charlestonians took part in periodic air raid drills. The city had several throughout the war period, beginning before December 7, 1941. Civilian volunteers were used to help clear streets of traffic and crowds when the air raid siren sounded. At night volunteers would check assigned blocks in their neighborhoods to make sure everyone had their blackout curtains drawn so enemy aircraft or ships off shore could not use the light to home in on a target. Captain John S. Abbott, local coordinator of the South Carolina Civilian Defense Force, urged that everyone who drove an automobile should have the upper half of their headlights "blacked out" so that enemy aircraft could not use them as a beacon.[295]

Air raid drills were a frequent activity in Charleston until the latter part of 1943. Sometimes the results of the practice raids called for better participation, since large numbers of people ignored the practice sessions, continuing with their normal business despite the siren warning. But during a February 1943 practice raid, defense officials were generally pleased with the results. Unlike previous drills, Abbott was pleased to see that there was no "panic or congestion in the streets." The only problem was that when the nine o'clock precautionary alert went off, many people mistakenly thought this was the all-clear signal to turn their interior lights back on instead of waiting the additional ten minutes as instructed.

Part of the problem with air raid drills may have been insufficient civilian defense volunteers to supervise procedures. Charleston's civilian defense leaders frequently complained they needed more volunteers to help with some aspects of the group's operations. At the beginning of the new year in 1943, Mrs. Henry Wade deSaussure announced that many more volunteers were needed for three surgical dressing rooms at the Red Cross production center in downtown Charleston. There was also a need for more night patrol volunteers to inspect homes for proper blackout procedures.[296]

Although the reasons for insufficient volunteers is unclear, one possible cause may have been that many people of both sexes were already working in the war industry. It could not have been easy to work eight- to ten-hour shifts at the navy yard or CSDDC, then come home and immediately prepare to go back out and patrol a street or section of beach for another few hours. However, there were some that did. For the last two years of the war Robert Sneed spent three or four nights each week patrolling the shore near his home at Folly Beach, some ten miles south of Charleston. His main duty was to make sure beach house lights were blacked out on the ocean side. Using horses issued by the coast guard, he patrolled the beach with two other volunteers for three hours. Sneed's assignment ended at midnight so he could get some rest before returning to the pipe fitter shop at the navy yard in the morning. Gerald Teaster remembered that his father also had a regular guard shift at the navy yard in addition to his regular job as a shipfitter.[297]

In the early months of the war, civilian defense volunteers were not only needed on land but also on the seas. During the first year of the war, with the coast guard and navy still undermanned, and in the midst of rearming, a devastating German U-boat campaign during the first half of 1942 had panicked the East Coast into thinking that enemy craft might be used to disrupt life and work in shipbuilding centers such as Charleston. Early in the crisis, civilian boat owners volunteered their crafts and their time to patrol the waters around the harbor. By the end of 1942 much of the U-boat threat had receded and the volunteer effort was superseded by a rejuvenated coast guard and navy. With the menace of German submarine attack declining and the improving fortunes of Allied forces overseas, people began to feel more secure and the need for home defense seemed less important.[298]

As the war drew to a close a new set of issues confronted Charleston. Eager to keep the economic bonanza brought on by wartime production, the old Southern port, suddenly thrust into a modern economy, hoped to find ways to keep some of the shipbuilding production after the war and build up peacetime consumer and service industries. In anticipating a postwar world, city fathers began to look beyond the war even while the nation was still fighting its enemies.

Epilogue
Postwar Realities, Hopes
and Dreams

The wartime boom has been replaced by a broadened basis for business progress.
Charleston Grows, *1949*

In August 1945, after nearly four years of war, Charleston erupted with joy at the news of Japan's surrender. Delores Russell had been ready to go to bed as she left her late work shift, but by the time she reached home, her bedtime plans had been forgotten and she pulled her "dancing shoes" out of her closet instead. There was "no, way [she] was going to miss" the victory celebrations. She and her sister and some friends went down to King Street to join thousands of others elated that the years of sacrifice, worry and frustration were finally over. She recalled streets jammed with cars, the clamor of honking horns, fellow Charlestonians embracing and kissing each other and an air of incredible excitement.[299]

Descriptions of the scene Russell remembered have been repeated by hundreds of others with similar recollections. But in the time following, as elation settled, for many people concern for the future tempered the joy of victory. With Germany and Japan defeated, it was feared that as the wartime boom economy turned to a flatter peacetime one, the country would experience another depression. Charlestonians knew that it had been the war that had pulled the region out of extreme depression and they had not forgotten the boom-to-bust economics that had followed World War I. As a result, even before the war's end, many feared a return to unemployment and poverty. Thankfully, the state government had already considered this danger, and, as a preventative measure, in 1942 formed the South Carolina Preparedness for Peace Commission, charged with studying potential dangers and making recommendations as to how the state could avert the potential unemployment problems that might occur at the end of the present war.[300] Within the commission's purview was the implementation of changes to government organization and tax structure to help keep the economy thriving. As the war drew to a close, the commission issued a report predicting that a $200 million public works program

would be needed for the Palmetto State if it were to avoid severe postwar unemployment. The Reconstruction Planning Committee (a county organization formed shortly after the Preparedness for Peace Commission began work) recommended adding fifty new industries to the area, filling in more marshlands, encouraging tourism and the convention trade and expanding transport networks in the city and county.[301]

However, at the end of World War II several factors that had not existed at the end of World War I added a boost to the economy, making the situation less desperate than had been anticipated. First, preemptive measures had been taken by the federal government in 1944 to ensure the economy would continue to thrive. The Roosevelt administration had proposed and was able to pass a comprehensive package of GI benefits that would provide unprecedented grants for low-interest housing and business loans, free education and other "spending" incentives for returning war veterans and their families. These federal initiatives, along with the job preferences returning soldiers were offered, gave World War II veterans an advantage that their fathers had not enjoyed after the 1918 armistice. Charlestonian veterans responded as Americans everywhere, taking full advantage of the offerings. Clifford Passailaigue's husband used these benefits, for example, to return to school in 1949, as did Dorothea S. Holmes's husband.[302]

In addition to federal initiatives, many people found themselves at the end of World War II with amassed savings they were eager to spend. Increased incomes during wartime and the unavailability of consumer goods left Charlestonians, as Americans elsewhere, eager to begin spending.

But prior to war's end, even with knowledge of these positives, peace commissioners felt they had reason to remain concerned. Palmetto State citizens might have had more than $400 million in savings and an additional $426 million in war bonds, but the commission feared that as soon as the Axis surrendered, the state's savings would vanish. The commission envisioned most of the wartime savings leaving the state, either when South Carolinians purchased Northern-made durable goods like cars and trucks or when they invested directly in stocks and bonds of out-of-state corporations. With little capital left at home to develop state industries and services, commissioners were convinced of inevitable postwar unemployment.[303]

But if the pessimistic long-term predictions seemed exaggerated, the immediate postwar future for Charleston's highly militarized economy did appear problematic. The war had barely ended when the port city's war industries began to layoff workers—the navy yard would continue to reduce its workforce over the next five years.

By August 1945, yard employment had already fallen from 26,000 at its peak in 1944 to under 20,000, and the following month the navy ordered more cutbacks that, by year's end, reduced employment to 17,000 with further downsizing to follow. By September 1946, the workforce stood at fewer than 10,000.[304]

While other military facilities had much smaller wartime workforces, their reductions were still significant, at least in the short run. By the end of 1946 the army had deactivated its large air base and turned it over to the city to become a civilian airport. The Port of Embarkation, north of the navy yard, met a similar fate, becoming, in late 1945, a part

of the state's fledgling Ports Authority. Both the port and the airport would eventually prove to be significant additions to the city's economy, but their early postwar impacts were modest.[305]

As industries changed hands from federal to state and city organizations there were even further extreme employment reductions. The Port of Embarkation counted about seven thousand wartime employees in November 1944. In the early months of state operation, the former Port of Embarkation staff numbered just eighteen permanent employees and an additional force of longshoremen hired on a contract basis.[306]

As Charleston's war industries shrank, so did the area's population, and parts of North Charleston, according to some residents, became a "ghost town." Many war workers and their families chose to return to their prewar homes—Johnnie Nolan's Alabama in-laws returned to their native state soon after the war ended; the young Gerald Teaster returned with his parents to Spartanburg. By 1950 Charleston's population had fallen to 164,000 from a peak wartime population of about 220,000.[307]

City fathers did not take the decline lying down. The city's reconstruction planning committee made plans to recruit other industries to replace or augment those gone or on the decline. And to some degree it succeeded, thanks to cheap labor and the availability of large amounts of new and cheaper electric power from the recently completed Santee-Cooper Hydro-Electric Dam project. By 1949 the city's chamber of commerce claimed that more than two hundred new industries and other businesses had been attracted to Charleston, four times more than the committee had hoped for when plans were put in place. One could guess this estimate was overblown, since only two years before the *Saturday Evening Post* had reported that "46 new industries" had been attracted to Charleston since the war, but the number indicates that Charleston's economy was growing significantly. The new industries included six furniture-making firms, such as the Charleston Chair Company; two optics companies; and a food-processing conglomerate, the Kraft Manufacturing Company. Although few of the new industries had more than two hundred employees, as a whole they represented a significant economic infusion to the postwar metropolitan economy.[308] These industries could not rival the employment numbers and payroll of the navy yard, but nevertheless, they brought diversified development unheard of before the war. The old industries were still important—the navy yard, despite its workforce reductions, remained Charleston's largest employer into the postwar era.

Despite a failed attempt by the yard's AFL labor leaders (with support from both the navy and state government) to ensure the yard's postwar future by convincing the Department of the Navy to expand the facility's functions, the navy yard found itself with plenty of work in the wake of Japan's surrender. This may be attributed to a couple of factors. In late 1945 the navy renamed the facility the Charleston Naval Shipyard and integrated it with nine other area commands, including the naval hospital, the naval air station and the marine barracks, designating the entire complex the United States Naval Base, Charleston. The wartime headquarters for the Sixth Naval District, formerly in downtown Charleston at the Fort Sumter Hotel, was returned to North Charleston. The second factor contributing to the steady workload at the navy yard, perhaps more

important than the organizational change, was the change from a directive of building ships of war to modernizing existing vessels. Even as it completed its last warship in November 1945, the facility was designated as a major repair and overhaul center that would refit ships with the latest electronics and weaponry.[309]

During this period the yard also began refitting submarines. After the Germans had proved the strategic value of their U-boats during the war, American naval strategists saw the need to improve this arm of the service. The first boat to receive an overhaul was a captured German submarine, U-2513. A revolution in submarine design for its day, it had a high underwater speed and could run beneath the surface powered by its diesel engines while its batteries recharged. Since its German crew had sabotaged its propeller shaft before capture, the shipyard repaired this and its hull. At the end of this project the shipyard earned praise from the navy for completing the work in the prescribed time, and soon after President Truman made a deep dive in U-2513 off the Florida coast. A year later, the Charleston facility won the official designation as a submarine repair and overhaul yard. This would remain one its primary functions until its closure in 1995.[310]

Thus, the yard had a new role that would help sustain it in the long-term. However, in the immediate future, as the navy yard's administration converted to peacetime operations, the navy's duties became focused on decommissioning or "moth-balling" hundreds of war vessels. The shipyard's shrinking workforce devoted most of its postwar energies to canceling war contracts and removing weaponry, electronics, ordnance and supplies from war ships. Between 1946 and 1948 about four hundred vessels including destroyers, destroyer escorts and landing craft, were decommissioned, stored, scrapped or sold.[311]

The operations were time consuming, and occasionally became dangerous. The trickiest task was ordnance disposal. Ensign Eason Cross was assigned to supervise the dumping of depth charge igniters from his soon-to-be-decommissioned destroyer. During one work detail Cross saved his work crew from certain annihilation when he stopped two sailors from beginning a contest to see who could throw explosives the farthest into the harbor. Because they were potentially so unstable, the igniters could have exploded when they hit the water.

Less dangerous, but equally time consuming was the removal of food and other stores from each ship and determining what to add to war surplus and what to destroy. In spring 1946, shipyard docks became so crowded with vessels being decommissioned that twenty-two LSMs and fifty LSTs had to be beached in the north yard to permit stores removal.[312]

Even with this work, the yard struggled at the war's end to stay afloat. Later, in the Korean conflict and the advent of the cold war, the need for a nuclear-powered submarine fleet would again render the yard useful, but in the years following the war this could not have been predicted. As feared, the Charleston facility seemed headed for reductions on similar scales to those of the 1920s. In the midst of the federal government cutbacks, and in spite its recent designation as a submarine overhaul base, workforce reductions continued. Its lowest employment level was recorded in December 1949, when just over forty-six hundred workers were employed. Within five years after the end of the war the naval

facility's workforce fell to less than a fifth of its peak employment. No one was exempt from the reductions.[313]

Despite the recent reorganization of the Charleston yard, Washington continued to seek ways to reduce the navy's wartime facilities in the name of more efficient peacetime operations. In 1949 the Charleston base was designated for decommissioning. As part of an overall economy drive in the federal government, Secretary of Defense Louis Johnson sought to layoff seventy thousand employees at naval installations nationwide. A board of admirals recommended that the Charleston Naval Base be closed. To support the proposed shutdown, proponents cited the accelerated silting of the Cooper River after the Santee-Cooper project began operation in 1942, only twenty miles upstream from the navy base. But thanks to the strong lobbying efforts of Congressman Mendel Rivers and Senators Burnet Maybank and Olin D. Johnston, the shutdown never occurred.[314]

The five thousand women war workers in Charleston bore the highest proportion of layoffs. Edna Brown, the Anderson, South Carolina, native, had spent two years in the navy yard offices doing payrolls and other administrative duties. In summer 1945, despite her dedicated service that included faithfully purchasing war bonds, Brown was released by the yard after failing a civil service exam she took in an effort to keep her job. Interestingly, she was not too disappointed. Brown was relieved to be away from war work that had been "rough." She eventually used the money saved from her bonds to go back and finish work for her high school diploma. Soon after she began a twenty-five year career in Anderson's opportunity school offices.[315]

Brown's reaction appeared to typify the reaction of many women who received navy yard pink slips. Even though one researcher claimed that 90 percent of female war workers at ten shipyards across the nation wanted to stay after the war, women at the South Carolina facility generally did not mind returning to their domestic duties full time. Ruth Newton, for example, had spent three years in the navy yard supply department distributing everything from towels to guns. After a difficult transition, she had learned her job well, but by the end, she was ready to go home to Williams, South Carolina, to "be plain Mrs. Newton and serve tea every afternoon." [316]

Women also left the workplace out of patriotism. Many women had entered the workforce after Pearl Harbor, believing it was their duty to serve the nation in a time of emergency, and at the end of the war, most saw it as their patriotic duty to relinquish their war jobs to returning veterans. Such was the attitude of Dorothy Brown, a wartime welder, who voluntarily left the Charleston Navy Yard on V-J Day with the expectation that a man would take her place. Helen Allen had loved her job as a junior supply inspector at the navy yard, but she felt a stronger call to return to her domestic duties and her new husband as soon as the Axis surrendered.[317]

Most women workers saw their jobs disappear, but there were many males who also faced layoffs. Not even veterans returning to their old jobs could always depend on a guaranteed position. Those who had the unenviable task of notifying workers that they no longer had a job had difficulties facing their fellow workers. William Bendt returned to the naval facility in January 1946 after serving two years in the army in European battles from

Normandy to Germany. As a former employee he had veteran preferences returning to his old job in the personnel department. Soon he was assigned to notify fellow employees in the Public Works Department that their services were no longer needed. Usually initial layoff notifications were delivered to groups of thirty. If the laid-off worker then wished to meet with him, Bendt made an individual appointment to explain the reduction in force and what the worker was entitled to. Each worker had thirty days to remain on the workforce before he had to leave and, during that time, he still earned annual leave. Bendt held several of these meetings. For at least a year, he remembered, people were being "laid off left and right."[318]

And yet over this period, Bendt did not recall any anger or protest. Years later, the personnel employee recalled that while some seemed a little bewildered and unsure about what they would do once they left, most were ready to leave. Many had come from communities outside the area and wanted to get home to more familiar surroundings and friends they had left behind. Most also didn't mind leaving their crowded, often make-shift accommodations.[319]

Nonetheless, many veterans did enjoy preferences. Johnnie Dodds, an electrician, returned to his old job after a stint in the navy and remained for the next three decades.[320] When John Moore came back from the navy in 1946 to reclaim his machinist job he was determined that "no one was going to stop [him] from returning." The workers who made room for Moore, however, were not happy with their sacrifice. Moore, in fact, recalled many years later that some displaced workers resisted their dismissal with violent confrontations. If some did, it appeared to be just a small number.[321]

More precarious was the postwar employment of black workers. While racial harassment remained a problem, a few were able to stay on at the naval facility in skilled positions. Most who had earned such advancement during the war, however, were not so lucky. By late 1944, according to James Lester, he and many fellow minority welders and burners had their ratings reduced to "second or third class." The demotions were not investigated.[322]

Black workers often faced overwhelming difficulties in redressing discriminatory practices in the workplace. Although regional officials of the FEPC in Atlanta made extensive efforts to correct unfair working conditions in Southern shipyards, they faced incredible opposition from white authorities and failed to bring about suitable changes. Nothing convinced management and labor to allow blacks a fair shake with salaries commensurate to their skill level. In spring 1945, when Southeastern officials of the FEPC attempted to hold hearings on discriminatory practices in regional shipyards, attacks against the agency by Southern congressmen prevented the hearings from taking place. If the federally mandated agency faced such extreme obstacles, it is not difficult to understand that few individual complaints were filed. An indication of this is that in the deep Southern states—the Carolinas, Georgia, Florida and Tennessee—a total of only 234 cases were filed for investigation during the first six months of 1944. Of this number only 73 were satisfactorily resolved in that time.[323]

Oliver Perry, who had become a helper for one of the navy yard's many cranes, had later been drafted into the navy by the middle of the war. In 1946, after more than two

years of service, mostly on the West Coast, he returned to Charleston to resume his old job. He reclaimed his job, but management tried to reduce his job grade and those of his fellow black workers. He and others fought the illegal action by taking their grievance to the federal government, demanding their original job classifications. After some reluctance by authorities the men succeeded in keeping their work status, but that was as far as Perry would go in the early postwar era. Realizing that legal recourse against job segregation and full access to promotion was virtually impossible, the South Carolina native waited. It would be more than decade before he confronted the system again to become a skilled crane operator, a job he had known how to do since 1943. It was not until the early 1960s, when federal desegregation laws were passed, that Perry could realistically challenge his second-class status and achieve the employment level for which he was qualified and entitled.[324]

But the denigration of black laborers was not limited to military installations. Throughout Southern society blacks were forced to give up better-paying wartime jobs and revert to low-paying domestic work or laboring jobs. In South Carolina, despite strong recommendations from the wartime peace commission that the state's blacks needed vastly improved education if they were to be an asset, not a burden, to the state's economy, the state did little. Five years after the war South Carolina blacks, though 43 percent of the population, held only 13.3 percent of industrial jobs and earned just 10 percent of total wages.[325]

Coupled with racism at official levels, apathy and division within the black community was another barrier hindering a more successful stance against discrimination. Never during the course of the war was African American leadership able to unite a significant portion of the black community to protest their second-class status. Septima Clark, a Charleston native, returned to the Lowcountry in 1947 to teach and get involved in the budding civil rights movement. Yet despite the desire of many within the black community to overcome discrimination and second-class status, suspicion and prejudice hindered the creation of a solid front. During the early postwar period, Clark met with lighter-skinned African Americans. Even though she was well educated and determined, the fact that her parents came from working-class stock and her father was a former slave made her an outsider in the minds of fair-skinned, socially prominent blacks. Clark recalls often being frustrated in her efforts to push civil rights by attitudes within her own community that she was "socially inferior." Miriam DeCosta-Willis, another African American who grew up in Charleston during the thirties and forties and became a literary scholar, recalled similar problems in uniting black Charlestonians. She remembered that fear and paranoia were everywhere among the black community and that whenever civil rights leaders tried to change the status quo, "their own people would betray them."[326]

The only members of the postwar black community that realized significant improvement from the prewar era were schoolteachers. For decades, equally qualified black teachers earned far less than their white counterparts (in 1930 black male teachers earned an average of thirty-four dollars per month, a quarter of whites' salaries). Although the Fourth U.S. Circuit Court of Appeals had ruled such discrimination illegal in 1940,

South Carolina had refused to comply. Undeterred, minority teachers sued the state and finally won. Even so, most black teachers' salaries at the end of the war still trailed those of white teachers. The cause was less overt racism than discrimination's historic impact. As of 1945, 69 percent of black teachers held no bachelor's degrees (compared to 29 percent of white teachers). With generally better education and training, whites naturally claimed higher salaries (in 1945 some 70 percent had higher incomes).[327]

Another modest triumph was the gradual growth in interest, at war's end, in another, unorthodox education program within the black community—citizenship schools. Organized primarily for adults, the earliest manifestations of this instruction began in the late thirties when a native of the Sea Islands, Esau Jenkins, gave unofficial lessons on the U.S. Constitution to black passengers of his bus service to and from Charleston. After the war Septima Clark traveled to civil rights workshops at Highlander School in south-central Tennessee to discuss with other activists how to bring about social justice for minorities throughout the South. By the mid-1950s, she had encouraged other Charlestonians to go with her on many trips to the school, including Esau Jenkins and Charleston local NAACP Secretary Bernice Robinson. By the late 1950s they had founded similar schools on the Sea Islands, teaching illiterate blacks to read and write while instructing them about their political rights. Their efforts laid the groundwork for growing political energy within the black community, the full impact of which would become apparent in the 1960s.[328]

Regardless of the desires of most African Americans, as far as most whites in Charleston were concerned, the status quo would, and had to, remain. Their attitude was epitomized by Lowcountry journalist and politician W. W. Smoak, who professed that all men should be "free and independent to follow the inclinations of their own desires," but still insisted on the separation of the races.[329] Without this, he believed, Southern poverty would continue due to the "shiftlessness and inability of the negroes in the South to advance." Smoak had heard the claims of "negro leaders" that whites prevented African Americans from advancing, but he was certain it was not true. According to Smoak, white Southerners were the black man's best friend and the source of whatever advancement blacks had achieved.[330]

But in the postwar years a growing number of blacks became unwilling to accept such demagoguery and prepared to stage public challenges. South Carolina's best-known black journalist and political activist, John McCray, was one who spoke out. McCray responded that those whites "who would lead, advise and direct South Carolina Negroes" were "largely responsible for Negro suppression and injustices." Pointing out that blacks had done well with the meager resources available to them, McCray charged that whites' offers of support and help were often disingenuous. While segregationists such as Smoak privately claimed to favor more black-owned banks, industries and hospitals, as state legislators they were unwilling to provide blacks the assistance needed to achieve these ends—aids they had generously given whites.[331]

The average black citizen was also becoming more vocal. In July 1945, Sergeant Theodore M. Wright, stationed at the Walterboro Army Air Field, asked editors of the *Charleston News and Courier* how they differentiated their policy of segregation and white

supremacy from the "Nazi Super-Race Theory." Appealing to South Carolinians (and the nation) for tolerance, Wright depicted the "sting of discrimination and racial hatred as a moral wrong."[332]

As the ideas and actions of Sergeant Wright demonstrate, a key legacy of World War II would be the erosion of the segregationist system and the frustration of white hopes of returning to the same social caste system it had before 1941. Bold statements by men like McCray and Wright showed beginnings of an awakened black citizenry and suggested that whatever the consequences, a new era in the struggle for civil rights was not far off. Membership in the struggling NAACP grew in the latter stages of the war and in its aftermath reached more than a thousand members in the spring of 1946 alone. Although it would have been premature to say in 1945 that a visible statewide campaign for black equality was emerging, it would perhaps not have been inaccurate to claim that a prelude was visible.[333]

But postwar racial tensions continued, demonstrating persistent white antagonism to reforms of segregation. In Charleston this opposition was rarely direct; instead discrimination showed itself through a sort of benign neglect of the problems the black community faced. Instead of looking for ways to resolve the housing and educational needs of the minority population, local and state government tried its best to ignore them. If community life did improve for Charleston blacks after the war, the change was only marginal.

Most fundamental of all to the well being of African Americans was housing, and in the postwar era living conditions for most black Charlestonians seemed to have changed little from prewar days. African American housing remained far below standard, and despite the war boom, there was virtually no new housing available for blacks, even two years after Germany surrendered. Most minority families still lived in overcrowded or poorly maintained homes that lacked basic necessities, including indoor plumbing and basic ground maintenance. A quarter of all black homeowners still had no running water, and more than half of those who did had only an outdoor faucet. One two-story tenement housed fourteen families, one room per family. The thirty residents shared one outside toilet and one water supply line. For these pitiful accommodations the landlord asked seventy dollars per month from the families, collectively.[334] Finally, while whites had access to a growing new housing market, there were virtually no homes available to African Americans. White contractors and developers had no interest in promoting their postwar developments for minority buyers.[335]

Services, especially in the areas of welfare, recreation and housing, also remained significantly below the minimum standards, and far below comparable ones for whites. While programs to improve child welfare were significantly better at the end of the war, licensing of foster homes for black youth was still lacking. Furthermore, the oldest institution for black youth in the Lowcountry, Jenkins Orphanage, remained poorly maintained and understaffed.[336]

It was true that by 1947 recreational facilities had improved with a more active YMCA for blacks, but this facility was still inadequate. Its modest headquarters only had space for a small office and a room for table games. Financial resources to build a larger center simply

were not available. In addition, playing fields and playgrounds for black youth and young adults were seriously deficient compared to those available to the white community. White Charlestonians certainly did not get all the recreational facilities they wanted, but they always got more—sometimes shockingly more—than blacks. The Municipal Parks and Playgrounds Department of the city used nearly all of its resources to provide supervised playgrounds for whites. None of the public housing projects for blacks had any recreational services for their tenants. Moreover, despite the many beaches in the Charleston area, segregation laws excluded blacks from all of them.[337]

One tangible social benefit to blacks that grew out of the war appeared in the political arena. As more blacks entered the city during the late 1940s, displaced by new mechanization in farming, their political power began to be recognized. This first manifested itself during this early postwar period, when the new mayor, William G. Morrison, had public housing built in the city to finally start alleviating the housing crisis in the African American community. He then added blacks to the police force. In large part because of this new approach by the white mayor, it was minority voters who were crucial to his second victory during the contentious 1951 mayoral race. Political pundits would consider it one of the main instruments in Morrison's reelection.[338]

Charleston would not become a leader in the civil rights struggles that began in the 1950s, but the impact of the successes of integrating the public transportation system in Montgomery, and the Freedom Rides of the early 1960s in Alabama and Mississippi, would not be lost on Charleston's African Americans. They would be slower in achieving it, but would eventually overcome segregation. And the catalyst for this social change, as for the city's economic changes, could be found in the unprecedented social disruption and economic fluctuation wrought, ironically, by the world's most destructive war in history.

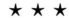

As Charleston came to grips with postwar problems and the black community's push toward integration, the white community became even more zealous supporters of a growing local initiative to preserve and venerate the past. While Charleston business and political leaders strove to consolidate and expand the economic gains of the war era, they also continued to focus attention on preserving the deep past. Unlike many other cities with historic buildings, Charleston was not bent on tearing out the old to make way for the new. Quite the opposite: in 1947 the Historic Charleston Foundation was formed to "preserve and use the architectural and historic treasures of the area." Businessmen dedicated to modernizing the city and attracting new industries took pride in the old city's history and character and tried to protect it by pushing new developments to the North Charleston area. But the old town was not completely immune from modern intrusions. Despite a spirited local preservation effort to save historic structures, there were a few notable losses, perhaps the most significant being the Charleston Orphan House of 1790, which was condemned to the wrecking ball in 1953 and replaced with a Sears, Roebuck department store. More often, however, preservationists won the battles against

modernization. Later, in the same decade, an effort to modernize historic downtown with a skyscraper was defeated in the wake of a concerted campaign by local preservationists.[339]

While Charleston's unique reverence for the past might have been a driving force behind the victories of historic preservationists, practical and economic considerations were also involved. Tourism had already become one of the area's major industries. Now, in the postwar era, the city sought to re-establish and expand this trade. Chamber of commerce promotions painted old historic Charleston as part of "an invaluable American heritage" protected from the "new industrial movement" occurring seven to ten miles north.[340] The exclusion of new industry from the old city provided Charlestonians with the best of both worlds: modern economic development without "disastrous cultural sacrifices" to the community's historic center. Thus, after a severe decline in tourism during the war, visitor numbers and spending rebounded, with nearly five hundred thousand tourists spending just under six million dollars visiting the city in 1948. Four years later this figure had doubled. As tourism grew, so did the supporting amenities. New hotels, bed-and-breakfast houses and restaurants appeared in and near the historic area, especially along historic Market and Meeting Streets.[341]

As the frustration of wartime rationing, congestion and anxiety faded, Charlestonians of both races looked forward to a future of continued economic progress. Despite an inevitable downturn in the early postwar era, the Lowcountry city did not face the economic depression that followed World War I. Even though navy yard employment declined significantly, it still remained the area's largest employer for the next several decades. New industries of a smaller scale supplemented and expanded the port city's economic base like never before. Furniture making, publishing and the import/export business of the new state Ports Authority made the immediate and long-term future of Charleston's economy much better. Moreover, the rejuvenation of the tourist trade continues even today.

As for the former Charleston Navy Yard, as the cold war intensified during and after the Korean Conflict, the renamed Charleston Naval Shipyard became an integral part of the U.S. nuclear-powered submarine fleet. As new strategic weapons replaced the conventional diesel-powered ones, Charleston became a center for testing and refitting them. The shipyard also sent crews throughout the world to refit or repair these modern subs and provide instruction to allied nations and their nuclear fleets.

The Charleston facility never again saw employment levels of World War II, but was still an important center of employment until the mid-1990s. In 1995, after the resolution of the cold war, with the defense department's reduction in budget, the base was deactivated. Today many of the yard's buildings and dry docks remain as reminders of the once-bustling and important naval facility.

Sadly, the stories of the men and women who worked there and the yard's contributions to World War II are hard to find today. Now the yard is the location for an icon from

another war—the Confederate submarine *H.L. Hunley*, raised from its underwater grave outside Charleston Harbor in 2000.

Former employees of the navy yard, some who worked there during World War II, are organizing to establish a monument to recognize the facility's World War II contributions and the impact the war industry, and the war itself, had on a struggling Southern city— commemorating the rebirth of Charleston.

Abbreviations

AFL	American Federation of Labor
APC	small coastal transport vessel
BAR	Board of Architectural Review
CCPA	Committee for Congested Production Areas
CIO	Committee for Industrial Organization
CNY	Charleston Navy Yard
CSDDC	Charleston Shipbuilding and Dry Dock Company
DD	destroyer
DE	destroyer escort
FEPC	Fair Employment Practices Committee
FHA	Federal Housing Authority
FSA	Federal Security Agency
FWA	Federal Works Agency
LSMs	landing ship mediums
LSTs	landing ship tanks
NAACP	National Association for the Advancement of Colored People
NHA	National Housing Authority
NWLB	National War Labor Board
OCWS	Office of Community War Services
OPA	Office of Price Administration
POW	prisoner of war
PWA	Public Works Administration
USES	United States Employment Service
USN	United States Navy
USO	United Service Organization
USPHS	United States Public Health Service
USS	United Seamen's Service
WAVES	Women Accepted for Voluntary Emergency Service

WLB	War Labor Board
WMC	War Manpower Commission
WPA	Works Progress Administration

Notes

Introduction
1. As quoted in Burns, *Soldier of Freedom*, v.
2. Jeffries, *Wartime America*, 197; Blum, *V Was for Victory*.

Chapter I

3. In Verner, *Mellowed by Time*, 68.
4. Boyce interview.
5. For an in-depth look at the economy in and around Charleston for this period, see Coclanis, *Shadow of a Dream*, 138, 142–143, 155–156; for a discussion of the Charleston exposition, see Harvey, "Inter-State and West Indian Exposition," 85–94.
6. For the political maneuverings to move the navy yard to Charleston, see Hopkins, "Naval Pauper to Naval Power," 2–3, 6–8. For a brief but useful look at the early development of the Charleston Navy Yard (CNY) and the reluctance of several in the navy brass to develop the yard during its first decade, see Bauer, *Bases*, 79–80. For a more descriptive look at this early period, including many images, see McNeil, *Charleston's Navy Yard*, 9–20.
7. Statistics on demographics for 1940 show that the city population stood at over 71,000 while the county population as a whole had reached 121,000. The latter was a modest 19.8 percent increase from 1930. For details, see "Charleston, SC, Progress Report No. 1," November 25, 1944, (prepared by the Federal Security Agency, Office of Community War Services), Table 1, in Records of the War Manpower Commission (WMC), Series 12, Box 19, RG 211, National Archives, Southeastern Region, East Point, GA, (SE Archives). For examples of infrastructure improvements made in the city, see Cann, "Burnet Rhett Maybank," 114–118.
8. For a look at the importance of ancestry in Charleston and how this translated into an appreciation of old buildings and the historic center, see Coclanis, *Shadow of a Dream*, 155–160; Bellows, "At Peace with the Past," 1–5; Verner, *Mellowed by Time*, 8–12. Another example of the city's appreciation of its historic buildings was the

publication, in the midst of World War II, of one of the first municipal inventories in the nation, which listed nearly fourteen hundred buildings ranging from residences to government buildings; see Stoney, *This is Charleston*. For an anthropological perspective on old family control of "downtown Charleston" during the twentieth century, see Press, "Cultural Myth and Class," 257–263.

9. Moore, "Charleston in World War I," 1–31; also see Hopkins, "Naval Pauper to Naval Power," 8–10. For a complete number of ships built and repaired, see Bauer, *Bases*, 83.

10. Hopkins, "Naval Pauper to Naval Power," 8–11; Bauer, *Bases*, 84.

11. For a good chronological examination of the CNY during the 1920s and early '30s, see Hopkins, "Naval Pauper to Naval Power," 10–12. For favorable reports on CNY repair work, see "Commissioner of the Philadelphia Navy Yard to the Secretary of Navy," January 12, 1927, (Office of the Secretary, General Correspondence), in General Records of the Department of the Navy (GRDN), Box 3499, RG 80, National Archives, Washington, D.C. (NAI).

12. "Commandant, CNY, to Assistant Secretary of the Navy," September 14, 1933, (General Correspondence), GRDN, Box 3499, 1926–40, RG 80, (NAI).

13. Hopkins, "Naval Pauper to Power," 12–13; Cann, "Burnet Rhett Maybank," 114–115. For FDR's political acumen and his long interest in naval subjects, see Burns, *Lion and the Fox*, 51–52, 61. For examples of the friendly relations with South Carolina governmental officials, see "Mayor Maybank to Marvin H. McIntyre, Secretary to the President," November 30, 1936, South American Trip Folder, Presidential Papers, Franklin D. Roosevelt Presidential Library, Hyde Park, New York (FDR).

14. Cann, "Burnet Rhett Maybank," 115–116; for details on some of these navy yard projects, see "October 27, 1937," *Navy Day Year Book, 1937*, xerox copy provided by Palmer W. Olliff.

15. Bendt interview.

16. Memo dated April 21, 1938, "Apprentices taken on at the Major Yards for the years 1934 through 1937," (General Correspondence), GRDN, Box 2342, RG 80, NAI. It should be noted that the memo stated that no apprentices were recruited for the naval air stations at Norfolk, Virginia, or Pensacola, Florida, during this time. For details on how this program worked and what positions the CNY trained for in 1937, see *Navy Day Year Book 1937*, 54–55.

17. For data on CNY workforce increases in the thirties, see "Civilian Personnel Report," February 1942, GRDN, File 6, Box 80, RG 80, NAI and "H.E. Luckey, Rear Admiral to Thomas MacMillan, U.S. Congressman," April 29, 1936, (General Correspondence), GRDN, Box 3499, 1926–40, RG 80, NAI; Boyce interview. According to Cann's dissertation the yard workforce reached two thousand by 1936, but such an estimate is too high for this period. See his "Burnet Rhett Maybank," 115.

18. Weyeneth, *Historic Preservation*, 2, 11.

19. Ibid., 15–18; see Hosmer Jr., *Preservation Comes of Age*, 234–236, 240–242.

20. Weyeneth, *Historic Preservation*, 13, 18; Cann, "Burnet Rhett Maybank," 97–98.

21. Cann, "Burnet Rhett Maybank," 46–63; Fraser, *Charleston! Charleston!*, 378–379.

22. Cann, "Burnet Rhett Maybank," 93–95; Fraser, *Charleston! Charleston!* 380–38; Weyeneth, *Historic Preservation*, 11–12.

23. Cann, "Burnet Rhett Maybank," 81.

24. Ibid., 75, 80–81. According to an outside observer reporting to Roosevelt after a visit to the Charleston Navy Yard and the city in 1935, even the "consistently unfriendly" *News and Courier* recounted the city's prosperity at the time; see Brown Memo (FDR).

25. For unemployment statistics in Charleston, see Cann, "Burnet Rhett Maybank," 72. For stories of individuals, see Holmes interview; Dodds interview.

26. Cann, "Burnet Rhett Maybank," 75–76.

27. Fraser, *Charleston! Charleston!*, 379; Cann, "Burnet Rhett Maybank," 110–111.

28. *Year Book, City of Charleston* (1925), xlvi.

29. Fraser, *Charleston! Charleston!*, 381; Fields and Fields, *Lemon Swamp*, 194–195.

30. Fields and Fields, *Lemon Swamp*, 196. For a more conventional, but still frank, look at the housing projects during the 1930s, see Cann, "Burnet Rhett Maybank," 105–108.

31. Anderson interview. For a perspective on the continued hope and pride within the black community during this period, see Fields and Fields, *Lemon Swamp*, 196.

32. For a somewhat rosy picture of the atmosphere that these trades gave the city in the late thirties and forties, see Wyly interview, and Molloy, *Gracious Heritage*, 189. See Fields and Fields, *Lemon Swamp*, 214–216, for another view about how many blacks perceived *Porgy and Bess*, the quintessential dramatic version of the huckster; for Myrdal's observation on the lack of Charleston black businesses, see his *American Dilemma*, 1260.

33. See *Yearbook, City of Charleston* (1932–1935), 16–17, 20–21, for details and photos of the swimming pool and Municipal Yacht Basin. For more details on some of the city projects funded by New Deal money, see Cann, "Burnet Rhett Maybank," 98–101.

34. Callcott, *Economic and Social Conditions*, 21. For employment at the paper mill, see "Resurvey of the Employment Situation in the Charleston Area, South Carolina," October 5, 1942, (Prepared by the Bureau of Employment Security), Table 1, in WMC, Series 12, Box 19, RG 211, SE Archives.

35. For details about farm ownership, see Caroline S. Alston, Demonstration Agent, "County Home Demonstration Report," Charleston County, 1941, Cooperative Extension Service, File 1224, Box 49, Special Collections, Strom Thurmond Institute, Clemson University (Clemson). For recollections on truck farming and shipping farm produce to New York, see Wyly interview.

36. For details of the project, and particularly the part that Jimmy Byrnes played in the negotiations, see Robertson, *Sly and Able*, 202–206, 210–229, 236–243. For Burnet Maybank's enthusiastic part in the project, see Cann, "Burnet Rhett Maybank," 145–177. For a general history of the project, see Edgar, *Santee Cooper*, 4–9.

37. Cann, "Burnet Rhett Maybank," 117–118; Heyward, "Mellow Past and Present Meet," 310–312.

38. Moise, *Ports Authority*, 13–19.

39. Ibid.

40. During 1941 only one coastwise steamship traveled between Charleston and other

cities along the eastern seaboard every ten days. Even worse, there was no ship traffic with the Gulf Coast and only one ship entered Charleston from the west coast each month. Ibid., 21, 23–24.

Chapter II

41. Burns, *Lion and the Fox*, 388–392, 395–396; O'Neill, *Democracy at War*, 9, 14–15, 16–18.

42. This brief overview of the boundaries and size of the navy yard is based on maps of the period supplied by the Charleston Naval Redevelopment Corporation now in charge of the CNY site, decommissioned by the U.S. Navy in 1995. The author thanks the map room of the CNRC for providing copies. For early World War II additions to the yard complex, see "Charleston Naval Shipyard History, 1901–1958" unpublished manuscript (*c.* 1960), 39–41. The author is indebted to Palmer Olliff, retired CNY worker and historian, for providing a copy to him. For details on the expansion, see McNeil, *Charleston's Navy Yard*, 100; and Hopkins, "Naval Pauper to Naval Power," 14–15.

43. *Navy Day Year Book, 1941*, especially pp. 21, 39, 93. The author is indebted to William Boyce for providing a copy. For details on ship construction during the late thirties and early forties, see McNeil, *Charleston's Navy Yard*, 101–102. For more details of the war-era expansions, see "Charleston Naval Shipyard History," especially pp. 38–41.

44. McNeil, *Charleston's Navy Yard*, 101–102. For details on the administration of the Sixth Naval District and its boundaries, along with details of the other naval districts in the nation, see Furer, *Administration of the Navy*, 521–522.

45. For more information on the destroyer "lease program" to Britain and the havoc wreaked by U-boats on British shipping in the second half of 1940, see Miller, *War at Sea*, 101–102, 105–106; also O'Neill, *Democracy at War*, 21. For the focus on destroyer construction in Charleston, see McNeil, *Charleston's Navy Yard*, 101–102, where it states that the yard built twenty destroyers up through 1944. However, an unpublished history of the facility ("Charleston Naval Shipyard History," 44) claims that nineteen were built.

46. McNeil, *Charleston's Navy Yard*, 102–103; "Charleston Naval Shipyard History," 44–45. No data could be found for the total number of vessels repaired during the war but an indication of the size of the job is suggested by the number of workers assigned to this work: in 1941 employment grew from 300 to 2,176 and by 1944 reached its peak at 6,993 workers, almost one-third of the total work force, see "Charleston Naval Shipyard History," 44.

47. The records for the CSDDC are scarce, with only a few located in the National Archives. For details on labor statistics and its work for the navy, see "Injury Summary Reports," June 2–3, 1943, (Production Division Administration), file CSDDC, 1943–1945, in Records of the U.S. Maritime Commission (USMC), Box 521, RG 178, National Archives, College Park, Maryland (NAII); "Industrial Health Survey of CSDDC," February 4, 1943, ibid.

48. For statistics on the cargo shipped and hospital vessels received by the Port of Embarkation, see *Charleston News and Courier (CNC)*, June 17, 1945; for details on the

work of the Stark General Hospital, see *CNC*, February 12, 1943. Note there were other industries in the city including the American Tobacco Company and the General Asbestos and Rubber Company, but these played minor roles in war production compared to the those mentioned in the text. For statistics on workers at other war industries and major services in Charleston, see "Progress Report No. 1," November 25, 1944 (SE Archives).

49. For the problem that the Charleston Navy Yard already faced by 1939 in hiring and maintaining its increasing workforce, particularly skilled labor, see "unknown at CNY to Captain Charles W. Fisher, Director of Shore Establishments Div.", October 25, 1939, (General Correspondence), GRND, Box 3499, RG 80, NAI; for the war period, see "Resurvey of Employment," October 5, 1942 (SE Archives).

50. For information on these and other trades at the navy yard, see *Navy Day Year Book, 1941*, 39, 47, 57; for particular skills in the yard also see Clay interview; Sneed interview; Moore interview; Williamson interview.

51. "CNY to Captain Charles W. Fisher," October 25, 1939 (NAI).

52. Ibid.; "W.H. Allen, Commander, CNY, to Manager, 5th U.S. Civil Service District, Atlanta," October 24, 1939, (General Correspondence, Office of the Secretary Navy), GRND, Box 3499, RG 80, NAI. To see that the job qualifications were being reduced by the first year of war, see "Resurvey of Employment" (SE Archives).

53. Sneed interview; for farm conditions in the state and South in general from the 1920s to 1940–41, see Callcott, *Economic and Social Conditions*, 98, 99, 109–110.

54. For Penn's remarks, see *Navy Day Year Book, 1941*; "Charleston Naval Shipyard History," 48; for further details on the problem of labor needs through the war, see chapter 3.

55. Memo: "Civilian Personnel Matters, CNY," March 1941, Division of Shore Establishments and Civilian Personnel (DSECP), GRDN, File 6, Box 80, RG 80, NAI.

56. Ibid.

57. "Secretary of the Navy to Commandant, CNY," December 2, 1940, DSECP, File 6, Box 80, RG 80, NAI. This documents the training of more CNY supervisors to work at new private yards, but it also implies that supervisors out of such a program did find their way into the CNY itself; see Sneed interview.

58. "Report of Frank Cushman, Dept. of Navy, Washington, D.C., re: CNY," February 2–3, 1942, DSECP, File 6, Box 80, RG 80, NAI.

59. "Civilian Personnel Matters," March 1941 (NAI).

60. For CNY wages, see "Resurvey of Employment," October 5, 1942 (SE Archives). On the continued call up of workers during the war, see *Produce to Win*, June 25, 1943 (hereafter cited as *PTW*). A nearly complete series of this paper from its inception in July 1942 through October 1945 is filed at the South Caroliniana Library, University of South Carolina (SCL); for stories of workers who were called up, see *PTW*, October 1, 1943, and October 20, 1944. Many other issues of this newsletter have notices of employees leaving for war service.

61. Moore interview.

62. Sneed interview.

63. Passailaigue and Ellis interview by author; other people interviewed remarked on

the influx of workers from all over the state and region. See Nolan interview (the author is indebted to Al Hester for providing a copy of this interview to the author); Williamson interview.

64. Pack letter to author.

65. Brown interview.

66. Hutton and Hutton interview with author. The author is indebted to the Huttons for some undated newspaper articles they provided about their war work. Recruiting for the CNY extended all the way to California, see C.W. Lombard, District Personnel Director, Report, March 23, 1945, GRDN, File: "A-9-Reports," Box 4, RG 80, NAI.

67. C.W. Fisher to W.A. Allen, CNY, February 18, 1942, DSECP, GRDN, Box 80, RG 80, NAI.

68. For the national ambivalence about women workers during World War II, see Costello, *Virtue Under Fire*, 179, 184, 185–186; Straub, "Policy Toward Civilian Women," 163–164. Hartmann, in *Home Front and Beyond*, says that government agencies fully supported the recruitment of women during the middle of the war, 55. The statistics on women workers at the navy yard and the CSDDC are based on projections and numbers found in federal government reports and the newspaper. According to the *CNC*, May 26, 1943, 1,300 women were working on the production line alone; a total of 4,811 worked in all departments by the early fall of 1944. See "Estimate of In-Migration in Charleston, S.C. Labor Market Area," October 6, 1944, attached to "W. Rhett Harley, State Director, WMC to Dillard B. Lasseter, Regional Director, WMC," October 6, 1944, RWMC, Box 19, Series 19, RG 211, SE Archives. For further statistics on the total number of employed women in Charleston compared to those who were not, see "Progress Report No. 1," November 25, 1944 (SE Archives).

69. For women's abilities in war industries, see Arnold, "Postwar Chances," 303, 318; "United States Civil Service Commission, Circular Letter No. 1671, Supplement 1, Subject—Recruiting Workers for the U.S. Navy Yard, Charleston, S.C.," January 3, 1944, WMC, Box 9, Series 3, RG 211, NAII. Estimates for the national figures on women workers in shipyards across the nation place the peak number at about 10 percent; see Hartmann, *Home Front and Beyond*, 59.

70. On estimates for women's employment in shipyards across the nation (at both navy yards and private yards), see Bauer, *Maritime History*, 308–309; for estimates of female workers at the CNY by fall 1944, and other war industries in the city, see "Estimate of In-migration," October 6, 1944 (SE Archives). For the reluctance of war industrial management to hire women despite government directives to do so, see Straub, "Policy Toward Civilian Women," 164.

71. *CNC*, December 20, 1942.

72. Sneed interview.

73. *CNC*, January 20, 1943. On the west coast, one foreman claimed that women were "our best welders and shipfitters," quoted in Costello, *Virtue Under Fire*, 185.

74. "Statement Concerning Charleston Shipyards," April 8, 1942, RWMC, Box 12, Series 11, RG 211, SE Archives; for demographic changes in the black population, see "Wartime

Changes in Population and Family, Charleston," March 1944, Records of the President's Committee for Congested Production Areas (CCPA), Box 1, Entry 7, RG 212, NAII.

75. "Statement Concerning Charleston Shipyards," April 8, 1942 (SE Archives).

76. "Resurvey of the Employment," October 5, 1942 (SE Archives); for poor education levels of African Americans within the state, see Newby, *Black Carolinians*, 218–223.

77. "Labor Market Development Report for Charleston, SC," May 1943, CCPA, Box 5, RG 212, SE Archives.

78. For a full examination of this and other subtle forms of resistance, see Kelley, "We Are Not What We Seem," 75–112.

79. "Statement Concerning Charleston Shipyards," April 8, 1942 (SE Archives).

80. Merl E. Reed, in "Black Worker and the Southern Shipyards," 459, claims that the CNY established a black building way, but none of the interviewees who worked at the yard during the war recall it. For details on FEPC hearings and the small number of cases brought by Southern workers, see Reed, *Seedtime*, 15–156.

81. Moore interview. Despite this harassment, the new machinist persevered, withstood the prejudice of white workers, and had a long career at the CNY until retirement in the early 1980s. Moore declared he became one of the "best machinists" at the Charleston facility. For other examples of discrimination at this time, see an editorial entitled, "Against 'intermingling'" in *CNC*, November 7, 1943, and a letter to the editor, March 26, 1943.

82. Perry interview.

83. For black workforce totals at CNY, see J. Clarke Johnstone to Corrington Gill, Director of FEPC, "Confidential Memo, Charleston, South Carolina," May 11, 1944, WMC, Box 19, Series 12, RG 211, SE Archives. For a brief survey of training for black workers in shipbuilding trades, based on a survey of WMC documents, see W. Rhett Harley [SC state director of USES] to Field Supervisors, September 6, 1943, WMC, Box 9, Series 3, RG 211, SE Archives and "Black Workers Training in South Carolina," January 28, 1943, WMC, file: "Training Negroes," Box 1, Series 18, RG 211, SE Archives.

84. *Loftin*, "Mid-Gulf South," 293–294; Thomas, "Mobile Homefront," 70–71; for more details about the riot and the black experience in general in Mobile shipyards, see Nelson," Organized Labor," 952–988. On racial tension in Charleston, see Drago, *Initiative, Paternalism and Race Relations*, 206; Moore, "No Room, No Rice, No Grits," 24 and *CNC*, September 12, 1942.

85. "Recruitment Program for the Charleston Navy Yard," January 15, 1944, (Regional State and Area Press Relations), WMC, Box 1, Series 16, RG 211, SE Archives.

86. Various issues of the *CNC* and *The State* (Columbia, SC) offer examples of the employment ads for the navy yard during the prewar and early war years. For examples of CNY employment ads outside of South Carolina during early 1944, see "Clippings on Charleston Navy Yard Recruiting" WMC, file, Box 3, Series 16, RG 211, SE Archives, especially *The Centreville Press*, Centreville, AL, January 27, 1944; *Birmingham Post*, Birmingham, AL, January 10, 1944; *Jacksonville Daily News*, Jacksonville, FL, January 23, 1944. For navy yard projections on the increased numbers of workers they would need

for the first half of 1944, see "Anticipated Labor Needs, CNY," (*c.* January 1944), WMC, Box 2, Series 16, RG 211, SE Archives.

87. "War Manpower Radio Script," (January, 1944), WMC, Box 1, Series 16, RG 211, SE Archives.

88. Frank Constangy to WMC State Directors, March 28, 1944, WMC, Box 2, Series 16, RG 211, SE Archives; ibid., April 27, 1944.

89. Grover C. Harris to W.B. Klugh, Regional Chief of Placement, Atlanta, January 10, 1944, WMC, Box 1, Series 16, RG 211, SE Archives.

90. See Krammer, *Nazi Prisoners of War*, 79–113.

91. On POWs interned in the United States and in South Carolina, see ibid., 40–42; on navy recommendations for POW labor use, see Memo: Chief of Naval Operations to Commandants of all Navy Yards, February 2, 1945, GRDN, File: Belligerents, Box 10, Industrial Manpower Section, RG 80, NAI; "Commandant, CNY, to Commander General, Fourth Service Command, Atlanta," January 19, 1945, ibid. POWs were used in the county for a variety of jobs, ranging from cultivating and harvesting crops to repairing equipment, see *CNC*, June 18, 1945.

92. Moore, "Nazi Troopers in South Carolina," 310, 314. Moore estimated that there were about eight thousand Axis POWs interned in the Palmetto state in 1945, the peak year. By June 1945, there were four camps still identified in the Charleston area with the following numbers of POWs: Charleston Army Air Base (250), Charleston Port of Embarkation (500), Stark General Hospital (250) and Holly Hill (250), where the jobs ranged from waiting on tables and "mess work," to helping with engineering projects and pulp and wood cutting. For these and other details, see *CNC*, June 18, 1945.

93. Passailaigue and Ellis interview; Pack letter to the author; *CNC*, June 18, 1945.

94. *PTW*, January 29, 1943.

95. *CNC*, November 29, 1942. In the same article, a housewife from Oklahoma tells about a knitting club she organized for her complex that included members from twenty-three states. Also see Nolan interview.

96. *CNC*, January 8, 1943.

97. *CNC*, February 14, 1943; also quoted in Moore, "No Rooms, No Rice, No Grits," 26–27.

98. Ewing, "Charleston Contra Mandum," 579–581; quoted in Moore, "No Room, No Rice, No Grits," 27.

99. *CNC*, March 21, 1943.

100. Moore, "No Rice, No Room, No Grits," 31.

101. Anonymous to Jeffries, November 20, 1942, Papers of Governor Richard M. Jeffries, 1942–1943, (Jeffries Papers) South Carolina Department of Archives and History, Columbia, SC (SCDAH).

102. Passailaigue and Ellis interview; Williamson interview.

103. Williamson interview.

104. Sneed interview; Dodds interview; Memo: Johnstone to C. Gill, September 3, 1943, CCPA, Central File, Box 4, RG 212, NAII.

Chapter III

105. *PTW*, February 12, 1943.
106. For details on this case, see "Commandant, CNY, to Assistant Secretary of the Navy," February 17, 1938, (with four enclosures), (General Correspondence), GRDN 1926–1940, Box 3499, RG 80, NAII.
107. Ibid.
108. Ibid.
109. The author is indebted to Mr. Cecil Clay, retired union member, who worked at the CNY during the war and later became a state and national leader of the sheet metal workers AFL union, for giving details about union activity and influence during this period in a taped interview with the author.
110. Boyce interview.
111. Hutton and Hutton interview.
112. Clay interview.
113. Moore interview; Sneed interview; Boyce interview. William Boyce stated that union members "could have been called sea scouts because the union was pretty ineffective."
114. Blum, *V Was for Victory*, 140.
115. S.M. Derrick, Acting Area Director of Charleston, to Frank A. Constangy, Deputy Regional Director, December 16, 1943, WMC, Box 1, Series 18, RG 211, SE Archives.
116. "Industrial Survey Division, Report No. 7, Industrial Activities," Navy Yard, Charleston, SC, February 21, 1945, (General Correspondence), Records of the Office of Naval Operations (ONO), Box 746, file: "NY7," RG 38, NAII.
117. Ibid.
118. On work stoppage notices, see Frank E. Scheetz, Secretary, to A.E. Moore, United Employment Service, January 28, 1943, WMC, Box 1, Series 18, RG 211, SE Archives; for L.D. Long's reply, see L.D. Long to A.E. Moore, February 2, 1943, ibid.
119. Petition letter to Dr. B.F. Ashe from 25 signed "Engineers and Draftsmen," February 1, 1943, WMC, Box 17, Series 12, RG 211, SE Archives. Note that while strikes did increase after 1942 they were generally of short duration, often a day or less, and did not affect war production to any degree. See O'Neill, *Democracy at War*, 212–213.
120. Penn to Dr. B.F. Ashe, WMC, March 3, 1943, Box 17, Series 12, RG 211, SE Archives. Each CNY shop had elected representatives who met with management to resolve problems related to the workplace, see *PTW*, July 16, 1943.
121. Bendt interview.
122. There are several letters and replies on this case; what follows are the main ones: William Glassford, Commandant, CNY, to Perry M. Morain, December 5, 1942, WMC, Box 17, Series 12, RG 211, SE Archives; A.M. Penn, Captain, CNY, to Dr. B.F. Ashe, Regional Director, WMC, January 12, 1943, ibid.; Frank A. Constangy, Deputy Regional Director, WMC, to Office of the Commandant, CNY, April 6, 1943, ibid. It should be noted that

efforts by the government to prevent workers from jumping from one job to another were severely criticized by labor unions early in the war and the Manpower Mobilization Board directive was soon lifted. See Perrett, *Days of Sadness, Years of Triumph*, 266.

123. There is a discrepancy in the correspondence about the date that Morain was hired on in Brunswick; the WMC reported this as January 28, 1943, while Morain placed it as December 28, 1942. See Morain to Dr. B.F. Ashe, WMC, January 25, 1943, ibid.; Penn to Ashe, March 3, 1943 (SE Archives).

124. "Resurvey of Employment," October 5, 1942 (SE Archives); "Progress Report No. 1," November 25, 1944 (SE Archives).

125. "Working Time Lost in Continental Navy Yards Through Absences," June 6, 1944, (General Correspondence), GRDN, file:A9-10 *Statistics*, Box 9, Industrial Manpower Section, RG 80, NAI. It was reported that the Boeing plant in Seattle, which had 39,000 workers in June 1944, had employed 250,000 people during the previous three years, see Burns, *Soldier of Freedom*, 334.

126. W. Rhett Harley, State Director, WMC, to B.F. Ashe, March 30, 1943, WMC, Box 17, Series 12, RG 211, SE Archives; K.J. Gillam Jr. to Dr. B.F. Ashe, February 10, 1943, ibid. On the short-lived government attempt to prevent worker mobility, see Perrett, *Days of Sadness, Years of Triumph*, 266.

127. The issues of housing, transportation and school shortages are dealt with in more depth in chapter 4. For selected references on early war housing and transportation problems, see "Site Board Report, Johns Island Operational Training Field," May 22, 1942, Army Air Force Records, Bulky files, Box 832, RG 18, NAII; "Resurvey of Employment," October 5, 1942 (SE Archives). For continued problems with housing, transportation and education through 1944, see "Progress Report No. 1," November 25, 1944 (SE Archives).

128. "Resurvey of Employment" October 5, 1942 (SE Archives) and "Progress Report No. 1," November 25, 1944 (SE Archives)

129. For numbers on total destroyers and destroyer escorts built during the war and the reasons behind it, see pp. 41–42 of this study. The 397 vessels were lost to U-boat attacks on the East Coast and the Caribbean during the first six months after Pearl Harbor, see Gannon, *Operation Drumbeat*, 388–389; for a local slant on why the CNY was shifting production to DEs, see *PTW*, May 21, 1943; for yard expansion, see McNeil, *Charleston's Navy Yard*, 42–43.

130. McNeil, *Charleston's Navy Yard*, 126–127.

131. Ibid., 102, 127, 131–134; The author is indebted to Mr. Palmer Olliff, retired navy yard worker and amateur historian, who provided the author with a copy of the "Roster of Ships Built at Charleston Naval Shipyard," giving a list of every vessel built, including the date its keel was laid and when it was launched, from the first vessel constructed before World War I to the early post-World War II period. Note that DEs took longer to build than landing ships because they were more complicated, having sophisticated anti-submarine gear to detect U-boats along with more compartments below decks. In addition, accelerated construction was aided by many sections for landing craft and DEs

getting subcontracted out to firms around the Southeast who shipped them to the yard for assembling. For details on subcontracting, see ibid., 127.

132. *PTW*, October 27, 1942. A special release of *PTW* stated that CNY had won the award three times, January 10, 1944, WMC, Box 2, Series 16, RG 211, SE Archives. In addition, see the story in *CNC* May 27, 1943, on the renewal of CNY's and the General Asbestos and Rubber Company's E flag awards. For the total war production at CNY and record-breaking times in completing destroyers, see McNeil, *Charleston's Navy Yard*, 101–102.

133. *CNC*, May 27, 1943; McNeil, *Charleston's Navy Yard*, 99. On Buffalo, New York, statistics, see Adams, *Wartime Manpower Mobilization*, 10–11.

134. For statistics on women employed in shipyards, see Weatherford, *American Women and World War II*, 134. For the percentage increase in women working in durable goods production, see Honey, *Creating Rosie the Riveter*, 21; for further details on women in shipyard production from 1939 to 1943, see Newman, *Employing Women in Shipyards*, 2–3. Statistics for 1942 come from "Resurvey of Employment," October 5, 1942 (SE Archives); for 1944 statistics, see W. Rhett Harley to Dillard B. Lasseter, October 6, 1944, ibid.

135. See Hartmann, *Home Front and Beyond*, 54; for the January 1942 survey that disclosed that less than one-third of 12,512 defense plants planned to hire women during the following six months and then how this changed to more than 50 percent by the middle of the year, see Trey, "Women in the War Economy," 44; *PTW*, July 31, 1942.

136. *PTW*, October 16, 1942; for navy directives to hire women at the navy yard, see C.W. Fisher to W.A. Allen, February 18, 1942 (NAI).

137. For statistics on women employees at the CSDDC, see "Resurvey of Employment, Charleston," October 5, 1942 (SE Archives); Harley to Lasseter, October 6, 1944 (SE Archives) and "Report of Industrial Safety Re-Survey, CSBDDC," May 26, 28, 1945, Production Division, USMC, Administration / Health and Safety files, Box 521, NAII.

138. The statistics for female workers in October 1942 came from "Resurvey of Employment," October 5, 1942 (SE Archives); note that there are no numbers given in this survey for the American Tobacco Co., but the numbers given for it in October 1944 show that more than 80 percent of its workforce were women, see Harley to Lasseter, October 6, 1944 (SE Archives).

139. Hartmann, *Homefront and Beyond*, 57, 87; Trey, "Women in the War Economy," 45; Milkman, *Gender at Work*, 121.

140. Newman, *Employing Women in Shipyards*, 31–33.

141. For this data, see "1946 Annual Report, SC Department of Labor," in *Reports and Resolutions of South Carolina*, 49. It should be noted that these averages are a rough estimate based on total wages of white males, $1,724,583, and total wages of white females, $39,874.

142. Hartmann, *Homefront and Beyond*, 57–58.

143. Archibald, *Wartime Shipyards*; Anthony II, "Working at the Navy Yard," 597–599; Hartmann, in *Homefront and Beyond*, 63–64, claims that working women initially had

problems when they entered the workplace during the war, but that by the middle of the war, when males realized their necessity and that they could do the job, male resentment declined significantly. The resentment of males at the CNY in the first months of women's employment is suggested by the first anniversary review of their contributions in *PTW*, June 4, 1943.

144. Anthony II, "Working at the Navy Yard," 597–598.

145. Ibid., 597.

146. *CNC*, November 7, 1943.

147. R.N.S. Baker, Captain of NY to Assistant Secretary of Navy, April 6, 1944, General Correspondence, GRDN, Box 80, RG 80, NAI; Hutton interview.

148. Baker to Assistant Secretary, April 6, 1944 (NAI).

149. *PTW*, March 26, 1943. According to this article, more woman crews of this kind were planned so that men could be released for the heavier work of putting the DE sections together.

150. Sneed interview.

151. Archibald, *Wartime Shipyards*, 32–33. Archibald admits that some female employees tried to use their "feminine charms" to avoid or reduce their assigned work.

152. Industrial Survey, Report No. 7, February 21, 1945 (NAII).

153. *PTW*, March 26, 1943.

154. Moore interview; Sneed interview.

155. On the national problem in recruiting enough female workers, see Hartmann, *Homefront and Beyond*, 56; Straub, "Policy Toward Civilian Women," 106–113; for complaints by Charleston labor recruiters, see "Progress Report No. 1," November 25, 1944 (SE Archives).

156. Furnas, "Are Women Doing Their Share," 12–13. Women volunteers in Charleston and domestic duties within the home are examined in more detail in chapter 4.

157. "Resurvey of Employment," October 5, 1942 (SE Archives).

158. Hinds to Ashe, January 20, 1943, WMC, Box 12, Series 11, RG 211, SE Archives; "Progress Report No. 1," November 25, 1944 (SE Archives); see chapter 2 for details of the 1944 recruiting campaign.

159. Glenn E. Brockway, for the Acting Executive Director, Bureau of Placement, WMC, Washington, to Bowman F. Ashe, Regional Director, Atlanta, WMC, January 6, 1943, WMC, Box 12, Series 11, RG 211, SE Archives. Note that this document has been mistakenly dated 1942, but the remaining pages are dated 1943. For a definition of what a Women's Enrollment Campaign meant to the WMC, see "Initial Program for Accelerated Employment of Women, USES, WMC," November 12, 1942, ibid.

160. Mrs. W.R. Slue to Gov. Jeffries, March 7, 1942, with attached reply in the Gov. Richard M. Jeffries Papers, file "leg. Matters", Box 3, SCDAH. It is interesting that in the South Carolina Labor Commissioner's 1945 annual report it was recommended that the legislature pass a minimum wage bill for mercantile and service establishments with a twenty-five-cent-per-hour wage and a maximum work day of eight hours, see "Commissioner of Labor's Annual Report," in *Reports and Resolutions of South Carolina*,

(1946). For data on 1943, see W. Rhett Harley, Director for SC to Dillard B. Lasseter, Regional Director, WMC, October 23, 1943, WMC, Box 19, Series 12, RG 211, SE Archives; for data on 1944, see Harley, to Lasseter, October 6, 1944, (SE Archives).

161. Fox interview.

162. Newman, *Employing Women in Shipyards*, 6–7. The other points included scheduling an eight-hour day and a forty-eight-hour, six-day week with a lunch period of at least thirty minutes and a rest period of ten to fifteen minutes in each four-hour period; providing personnel service, food and medical facilities; and expanding and adapting the safety program for women workers.

163. *PTW*, April 23, 1943, and June 4, 1943. Bureau representatives were sent to private, as well as federal, work facilities throughout the country Hartmann, *Homefront and Beyond*, 60–61.

164. *PTW*, April 23 and June 4, 1943.

165. Passailaigue and Ellis interview; Rollins and Rollins interview.

166. On Smoak, see *Charleston Evening Post* (*CEP*), November 3, 1942; for details on navy yard workers, see *PTW*, October 20, 1944.

167. See chapter 2 for discussion of the intensive labor recruitment campaign for Charleston in 1944; Myers to various Civil Service Boards and Examiners, Fifth Civil Service Region, January 3, 1944, WMC, Box 3, Series 3, RG 211, SE Archives. Note that while the navy yard did train women for skilled positions such as electricians, pipe fitters and machine operators, training appears to have been given largely to women already living in the local area.

168. Preece, "The South Stirs," 350.

169. Myrdal, *American Dilemma*, 1313.

170. Letter to the editor, *CNC*, March 26, 1943.

171. *CNC*, January 9, 1943.

172. For rumors of Labor Day race riots, see *CNC*, September 10, 1942; for bus incident, see Hutton interview.

173. *CNC*, March 21, 1943.

174. *CNC*, March 26, 1943.

175. *CNC*, March 6, 1943.

176. For details about the Charleston Biracial Committee, see *CNC*, August 20, 1943, and Johnson, *Best Practices in Race Relations*, 35, 219.

177. For figures on black workers for 1936, see Rear Admiral H.E. Lackey, USN, Director of Shore Establishments to Congressman T. MacMillan, April 29, 1936, (Office of the Secretary of the Navy, General Correspondence) GRDN, Box 3499, RG 80, NAI; for 1941, see "Statement Concerning Charleston Shipyards," April 8, 1942 (SE Archives).

178. "Resurvey of Employment," October 5, 1942 (SE Archives).

179. Johnstone to Gill, May 11, 1944, (SE Archives). Johnstone observed that the "consensus of opinion among [white] employers [was] if they were to pay the increased rate, the workers would obtain sufficient funds to carry them for the current week within a very few days and would not report to work for the rest of the week." For another

example of this white attitude about black labor, see "Statement Concerning Charleston Shipyards," April 8, 1942 (SE Archives).

180. Perry interview.

181. For reports on low literacy rates in South Carolina before and during the war, see "Annual Report, SC Superintendent of Education," in *Reports and Resolutions of South Carolina* (1940, 1943, 1945).

182. This discrimination in training schools and the reluctance of Southern states to establish black vocational schools is discussed in Reed, *Seedtime*, 175–204; for details on the lack of funds to pay black trainees to go to school, see Dr. Ashe to Bureau of Training, Washington, D.C., June 30, 1943, WMC, File: Georgia, Box 2, Series 18, RG 211, SE Archives; for black vocational training centers in South Carolina, see "Black Workers Training" January 28, 1943, (SE Archives).

183. Harley to B.F. Ashe, September 8, 1943, WMC, File: SC, Box 2, Series 18, Region VII, RG 211, SE Archives.

184. For examples of this, see Hutton and Hutton interview; Boyce interview. For official denial of racism in Charleston shipyards, see "Statement Concerning Charleston Shipyards," April 8, 1942 (SE Archives).

185. This case has several letters between the complainant and the FEPC, all of which are summarized in A. Bruce Hunt, Regional Director, to Will Maslow, Director of Field Operations, September 29, 1944, Final Disposition Report, Records of the President's Committee on Fair Employment Practices FEPC), Box 3, RG 228, SE Archives.

186. Reed, *Seedtime*, 206, 226.

187. For the Nelson case, see his file, beginning with Roy T. Nelson to Witherspoon Dodge, March 16, 1945, FEPC, file: CNY, Box 3, RG 228, SE Archives.

188. W.E. Thomas, Chief, Employee Relation Section, SECP, to Commandant, CNY, April 17, 1944, Box 9, (General Correspondence), GRDN, Division of Shore Establishments and Civilian Personnel (DSECP), RG 80, NAI.

189. November (undated) clipping, John McCray Papers, Military file, Folder 3, SCL.

190. Headquarters, Charleston Ordnance Depot, Public Relations Office, May 26, 1943, ibid.

191. Blum, *V Was for Victory*, 211–212, 220; Burns, *Soldier of Freedom*, 463.

Chapter IV

192. *CNC*, November 29, 1942.

193. "Progress Report No. 1," November 25, 1944, (SE Archives).

194. Passailaigue and Ellis interview. In addition to this interview Mrs. Ellis later supplied further details about her family, on which she based the story "Garnie: Roots, Boots, and Twigs." The author thanks her for supplying a copy to him.

195. Holmes interview.

196. On fuel, rubber and tire rationing during the first months of the war, see Moore, *South Carolina Highway Department*, 162, 164–165; for an account of a failed prewar attempt by

Harold Ickes, the newly appointed oil coordinator for national defense, to ration gasoline, see Perrett, *Days of Sadness, Years of Triumph*, 133–34; Ward, *Produce & Conserve*, 83–84.

197. "Progress Report No. 1," November 25, 1944 (SE Archives).

198. For the best overview of wartime housing in the North Charleston area, see Fick et al., *City of North Charleston*, 36–54; these housing complexes are also discussed briefly, along with some representative photos, in McNeil, *Charleston's Navy Yard*, 106–110. For a detailed description of the dates, funding and construction of these prewar housing developments, see special "Power and Defense Edition," of the *CNC & CEP*, December 1941, p. 10F; hereafter cited as "Power and Defense," original copy on file at the South Carolina State Museum (SCSM).

199. Fick et al., *City of North Charleston*, 45–54; there is some disagreement over the total numbers of housing units built in each subdivision, see chart in text.

200. Ibid., 49.

201. Ibid., 50–54; "Report of Investigation of Proposed FWA Projects," August 4–5, 1943, Box 5, RG 212, SE Archives.

202. Nolan interview.

203. *CNC*, January 19, 1943.

204. Ibid.; for other examples of adaptive reuse for war housing, see *CNC*, February 24, 1943.

205. Tripp interview. It should be pointed out here that naval officers had a more prestigious position within the community than the average war worker. This helped to alleviate some of the stress and privations of wartime life in the city. Tripp acknowledged this in the interview.

206. Hutton and Hutton interview.

207. Nolan interview.

208. The New Yorker's statement is cited in Moore, "No Room, No Rice, No Grits," 27; *CNC*, January 10, 1943.

209. Ham's article, originally published in the *Atlanta Constitution*, was heavily commented upon in *CNC*, February 14, 1943; it is also quoted in Moore, "No Room, No Rice, No Grits," 26. For position of both sides in the USS issue, see letters to the editor in *CNC*, March 19 and March 24, 1943; also see *CEP*, April 2, 1943.

210. *CEP*, April 2 and 10, 1943.

211. *CNC*, March 21, 1943; according to this article, the "city was a museum" with "1,100 buildings aesthetically remarkable enough to be on index cards"; according to Samuel G. Stoney in *This is Charleston*, 118–119, there were 1,380 index cards made for various historic structures in a 1941 building survey.

212. This is quoted from Moore, "No Room, No Rice, No Grits," 27.

213. Rear Admiral Jules James to Assistant Secretary of the Navy, January 14, 1944, Records of the President's Committee for Congested Production Areas (RCCPA), file: "Navy Dept.", Box 5, RG 212, NAII; for rental fees in public housing, see *CNC*, January 17, 1943; on newcomers to Charleston living in cars or shacks and Glassford's scale-back order on rents, see Moore, "No Room, No Rice, No Grits," 24–25 and *CNC*, March 21, 1943.

214. Petition attached to letter, William M. Murray, Liberty Homes Committee, to NHA, December 1, 1943, Papers of Governor Olin D. Johnston, Box 32, SCDAH.

215. Ibid.

216. *CNC* March 21, 1943.

217. For a history of CCPA, see Gill, "Cooperation in Congested Production Areas," 28–33; the sixteen other nationally designated congested production areas included the Puget Sound area in Washington state, Portland-Vancouver, Oregon; Hampton Roads, Virginia; San Diego and San Francisco, California; Portland, Maine; and Newport, Rhode Island. For more details about how the committee worked and the names of other congested areas, see also "Wartime Problems in Congested Areas," remarks delivered by Willard F. Day at the Public Works Congress, October 26, 1943, Central file, Mobile, Subject file on CCPA Operations, 1943–44, Entry 12, Box 1, RG 212, NAII and "Boom Cities Aided," 31–32.

218. J.C. Long to Earl Draper, November 3, 1943, RCCPA, file "Miscellaneous," Box 5, RG212, NAII.

219. For details on this issue, see "Unsanitary Conditions," October 15, and November 3, 1943, (NAII).

220. "U.S. Public Health Service Field Report, n.d." attached to letter, Draper to Gill, November 23, 1943, RCCPA, Box 30, Charleston, RG212, NAII.

221. Boyce and Saunders (phone), November 22, 1943 (NAII). By December the Charleston Housing and Sanitation Department was exploring the possibility of ending further construction of Byrnes Down, see "Unsanitary Conditions" note dated December 15, 1943 (NAII).

222. "Executive Office of the President, CCPA, Charleston, SC Area," March 18, 1944, RCCPA File, Charleston, March 1944, Record of Analysis, Status Reports, 1943–44, Box 1, Entry 18, RG 212, NAII; for the obstacles confronted by the new board in raising funds for the sewer lines, see *CNC*, November 4, 1943.

223. "Unsanitary Conditions," November 3, 1943 (NAII).

224. Ibid.; W.F. Draper to C. Gill, November 23, 1943 (NAII); The annual reports for the South Carolina Department of Public Health show little or no diseases related to sewer contamination, see "Annual Report for the Public Health Department," in *Reports and Resolutions of South Carolina*, (1944, 1945, 1946).

225. "October Diaries," October 6, 1943, RCCPA, Box 4, RG 212, NAII; Charles B. Lawrence Jr. to Nelson Cruikshank, September 12, 1944, File:A, Box 1, Entry 7, ibid.; for report on rat tests, see *CNC*, February 26, 1943.

226. Charles B. Lawrence, Jr. to Nelson Cruikshank, September 12, 1944, ibid.; Banov, *As I Recall*.

227. "Changes in Population," July 23, 1944 (NAII).

228. "Report on Adequacy of Services and Facilities in Charleston, SC area," September 15, 1943, RCCPA, file "Commercial Facilities," Entry 13, Box 4, RG 212, NAII; "October Diaries," entries for October 2 and October 8, (NAII).

229. On student comments on housing, see *The Avery Tiger*, February 1942, on file at Avery Research Center, Charleston. For Negro Community Council, see Johnson, *Best Practices in Race Relations*, 35. *CNC* July 19, 1942.

230. Drago, *Initiative, Paternalism and Race Relations*, 206–207.

231. "Adequacy of Services and Facilities," September 15, 1943 (NAII).

232. *CNC*, February 2, 1943; for a detailed explanation on how this system worked, see Ward, *Produce and Conserve*, 79–103.

233. Ward, *Produce & Conserve*, 86–89; Cohen, *V for Victory*, 78–85.

234. For details on the implementation of food rationing in the Charleston area, see *CNC*, February 3, 1943, and *CEP*, March 22 and 29, 1943. For slightly different numbers on rice shipments to Charleston for 1941–42 and 1942–43, see Lawrence to Harvey F. Price, Chief Management Analysis, OPA, November 1, 1943; Johnstone to Gill, December 9, 1943; and E.P. Grice, Jr. to Lawrence, October 23, 1943, all in RCCPA, file "Food," Box 4, Entry 13, RG 212, NAII; for more details on this incident, see Moore, "No Rooms, No Rice, No Grits," 29–30.

235. D.A. Smith (Secretary to Senator Maybank) to Johnstone, September 10, 1943, RCCPA, file "Congress of the U.S.," Box 4, RG 212, NAII. Interestingly, the next month Maybank wrote Gill at the Washington office of the CCPA asking if something could not be done to increase the rice supply of Upstate Clemson College, where the mess hall was reduced to half the rice needs for one breakfast. He wrote, students from the "lower part of the State…are quite disappointed that the College cannot furnish them this food." It is unknown if the supply was increased, see ibid.

236. Russell H. James to Norman L. Gold, Civilian Food Requirements Division, War Food Administration, March 25, 1944, RCCPA, Box 4, Entry 13, File "Food," RG 212, NAII; Johnstone to Gill, March 25, 1944, ibid.

237. Ibid.

238. James to Gold, March 25, 1944 (NAII); Johnstone to Gill, March 25, 1944, ibid.; "Report from CCPA on Charleston," August 8, 1944, Papers of Governor Olin D. Johnston, file "Federal Housing," Box 32, SCDAH.

239. "October Diaries," October 7, 1943 (NAII); for an investigation of cost of living, see *CNC*, December 7, 1943.

240. Johnstone to Gill, March 25, 1944 (NAII).

241. Hutton and Hutton interview.

242. Teaster interview; Williamson interview.

243. For story about the closing of the candy store, see *CEP*, March 29, 1943; Fox interview.

244. For details on the serious meat shortage, see *CEP*, March 22 and 23, 1943; Passailaigue and Ellis interview; news briefs in the navy yard newspaper occasionally mentioned workers who went hunting on their off days; for examples, see *PTW*, January 7 and 21, 1944.

245. The percentage measured is unclear but it probably means the total number of grocers for Charleston. See "October Diaries," October 8, 1943 (NAII).

246. "Progress Report No. 1," November 25, 1944 (SE Archives).

247. *CNC*, December 6, 1942.

248. "Resurvey of Employment," October 5, 1942 (SE Archives); "Progress Report No. 1," November 25, 1944 (SE Archives); for 1943 passenger numbers, see Fraser, *Charleston! Charleston!*, 388. An alternative to motorized transport was the bicycle, and

until February 1943 the limited ration certificates to purchase bikes were sufficient. The following month the 250-bike quota was exceeded by a small amount, and in April there were 500 applicants, many of whom would have to be turned down. For details, see *CEP*, April 9, 1943.

249. *CNC*, January 8, 1943.

250. Passailaigue and Ellis interview.

251. For Barber's story, see *PTW*, November 5, 1943; for complaints about tire quality and wartime speed limit reductions, see Moore, *South Carolina Highway Department*, 168, 169; for a report on reduced auto registrations in South Carolina, see "SC Highway Annual Report, 1944" in *Reports and Resolutions of South Carolina* (1945).

252. Memo dated September 18, 1942, Jeffries Papers (SCDAH); *CNC*, January 15, 1943.

253. *CNC*, January 19, 1943; for observations on the reduction in tourist visits to area gardens during the war, see *CEP*, April 5, 1943, and for reports on the reduced number of visitors to The Charleston Museum, see "Charleston Museum Scrapbook, 1940–1945," entries for January 2, 1943, and January 4, 1945, The Charleston Museum Archives (CMA).

254. *CNC*, December 6, 1942.

255. For a brief review of the problems of prostitution early in the war, see "Progress Report No. 1," November 25, 1944 (SE Archives); for a comprehensive review of the problems of prostitution in the state and the Charleston area to 1942, see Hudson, "Battle Against Venereal Disease," 104–111; for a brief look at prostitution in Charleston before the war, see Fraser, *Charleston! Charleston!*, 361, 366, 373.

256. Hudson, ibid., 108–109; Fraser, ibid., 390–391.

257. "Progress Report No. 1," November 25, 1944 (SE Archives); on work done to treat wartime VD, see Banov, *As I Recall*, 70–72.

258. "Progress Report No. 1," November 25, 1944 (SE Archives); *CEP*, November 10, 1942 and April 6, 1943.

259. For Duke's remarks, see *CNC*, February 22, 1943; for skepticism about the significance of prostitution on high VD rates, see Hudson, "Battle Against Venereal Disease"; for the prewar VD rates in the state, see Beardsley, *History of Neglect*, 172–173.

260. "Progress Report No. 1," November 25, 1944 (SE Archives).

261. Mrs. B. Enter to Governor Jeffries, March 23, 1942, Jeffries Papers, Box 7, SCDAH; *CNC*, December 12, 1942.

262. "Progress Report No. 1," November 25, 1944 (SE Archives); Johnstone to Gill, September 3, 1943, (NAII); for one person's perspective who "claimed that the one-man police force was sufficient for North Charleston" during the war, see Williamson interview; see also newspaper clipping (probably October 1942), Box 6, Jeffries Papers, SCDAH.

263. *CNC*, December 13, 1942.

264. For story on the Manigault House USO club during the war, see *CNC*, January 3, 1943; on its use as a Red Cross teaching center, see Wyly interview; Fox interview. During the latter interview, Ann Fox showed the author the extant color murals that a sailor painted on the basement walls of the house during the war.

265. *CNC*, November 10, 1943.

266. "October Diaries," October 6, 1943 (NAII).

267. "Adequacy of Services and Facilities," September 15, 1943 (NAII); on cinemas, see "Charleston Area Report, for September 3–15," November 2, 1943, RCCPA, file: "Miscellaneous," Box 5, Entry 13, RG 212 (NAII).

268. "Progress Report No. 1," November 25, 1944 (SE Archives).

269. For navy yard teams, see *CNC*, March 4, 1943; *PTW*, August 21, 1942, October 15, 1943, and October 20, 1944; "Charleston Area," November 5, 1943, File: "Charleston," Box 1, Entry 18, RCCPA, RG 212, NAII.

270. For dates of disbanding Citadel football, see *The Citadel Football Annual, 1948*, copy on file at SCL; for FDR's decision on Major League Baseball, see Ward, *Baseball*, 276–278; for the decision of the South Atlantic League to disband for the remainder of the war, see *CNC*, February 8, 1943.

271. Tuttle, *Daddy's Gone to War*, 69–71.

272. "Progress Report No. 1," November 25, 1944 (SE Archives).

273. *PTW*, October 2, 1942.

274. *CNC*, December 16, 1942; the death of little Willis Washington was reported in *CEP*, April 3, 1943.

275. Both these incidents are reported in *CNC*, January 6, 1943.

276. "Adequacy of Services and Facilities," September 15, 1943 (NAII); "Wartime Changes in Population and Family Characteristics, Charleston: March 1944," July 22, 1944, RCCPA, file: "Census," Box 4, RG 212, NAII.

277. Adequacy of Services and Facilities, September 15, 1943, NA II; Tuttle, *Daddy's Gone to War*, 74–82.

278. For national figures on nursery schools and enrollment, see Tuttle, *Daddy's Gone to War*, 81–82. *PTW*, October 15, 1943; "Progress Report No. 1," November 25, 1944 (SE Archives); for story on the George Legare Homes nursery, see *CNC*, February 26, 1943.

279. "Progress Report No. 1," November 25, 1944 (SE Archives).

280. Ibid.

281. Passailaigue and Ellis interview.

282. "Progress Report No. 1," November 25, 1944 (SE Archives).

283. Ibid.

284. *CNC*, January 15, 1943.

285. Teaster interview; Williamson interview. Note that these gentlemen were in grade school during the war, so their impressions were not as clear as those who were of high-school age. Even so, their memories of that period had deep meaning and they were more positive than some older residents of the period. For comments on the wide geographic origins of Charleston's student population during the war, see *CNC*, January 15, 1943.

286. Williamson interview. There were five distinct values that national educators prescribed each pupil in the nation should learn, ranging from understanding what

America was fighting for through daily practice of democratic ideals to understanding and appreciating others by stressing likenesses as opposed to superficial differences among the republic's citizens. The five values were published in *Education for Victory*, Vol. 1, April 15, 1942, by the FSA Office of Education, and are quoted in Tuttle, *Daddy's Gone to War*, 115–116.

287. *CNC*, March 19, 1943; on the need for South Carolina to assume its share in the Victory Garden campaign, see *CNC*, March 1, 1943

288. For information on the increase in Victory Gardens, see *CNC*, March 1943; for stories on Nafair Victory Gardens, see *CNC*, March 22, 1943.

289. *CEP*, April 8 and May 25, 1943; *CNC*, March 19, 1943.

290. For examples of fears and protests over the lack of sufficient farm labor, see Governor Richard Jeffries to Chesley A. Hayden, July 28, 1942, (telegram), Jeffries Papers, Box 10, SCDAH; Jeffries to Senator B. Maybank, November 9, 1942, Box 6, ibid.; *CEP*, April 5, 1943; Callcott, *Economic and Social Conditions*, 99, 102, 108–110; for volunteer efforts of local business, see *CNC*, February 18, 1943.

291. *CEP*, May 25, 1943.

292. For details on these and other school activities for the war effort, see *CEP*, January 19 and April 7, 1943; *CNC*, January 15, 1943.

293. Nearly every issue of the yard's *PTW* has a story about bond sales, for details on the story related here, see August 21, 1942, February 26, March 12, September 5 and October 1, 1943.

294. *CNC*, March 22, 1943; for classes and instructions on civilian defense and dealing with "unexpected terrorist bombs," see *CNC*, July 23 and November 29, 1942.

295. *CNC*, February 26, 1943.

296. *CNC*, January 9, 15 and 29, 1943.

297. Sneed interview; Teaster interview.

298. For mention of the use of civilian craft to patrol waters around Charleston, see *The State*, December 11, 1991; for the serious threat and destruction of U-boats in 1942 along the U.S. East Coast, see Miller, *War At Sea*, 292–298, 302–306.

Epilogue

299. Passailaigue and Ellis interview.

300. For details of the South Carolina Preparedness for Peace Commission and its many postwar recommendations for the state, see *Address of Hon. Roger C. Peace*, 1–2, 5; for the complete details of the commission's recommendations, see *South Carolina Preparedness for Peace*.

301. *South Carolina Preparedness for Peace*, 5; on the county postwar planning committee, see *CNC*, November 2, 1943; note that county peace commissions were established in forty-two of the state's forty-six counties by the last year of the war, see *South Carolina Preparedness for Peace*.

302. *South Carolina Preparedness for Peace*, xxii; Burns, *Soldier of Freedom*, 362, 465; Bartley, *New South*, 21, 153; Passailaigue and Ellis interview; Holmes interview.

303. For details on the fears of some on the loss of state capital, see *South Carolina Preparedness for Peace*, 8. For a national perspective on the pent-up consumer demand of the nation as the war came to an end, see Tuttle, *Daddy's Gone to War*, 255–256. For the national economic theories and politics of the early postwar era, see Blum, *V was For Victory*, 301, 323–332.

304. For early postwar workforce reductions, see *PTW*, September 15, 1945. On the steadily decreasing workforce numbers after 1945, see "Charleston Naval Shipyard History," 47 and Sass, *Charleston Grows*, 44.

305. Moise, *Ports Authority*, 57–58. Although it would be a year before the army formally transferred the port over to state ownership, the new state Ports Authority recorded its initial business in November 1945 by loading its first cargo ship. The Charleston airport was turned over to the city in 1946 and a new municipal air terminal was completed two years later at a cost of $500,000, see Sass, *Charleston Grows*, 86, 88.

306. Moise, *Ports Authority*, 57–58.

307. For the peak wartime population in Charleston, see Moore, "No Room, No Rice, No Grits," 23; for 1950 numbers, see *Seventeenth Census*, Table 10, 40–32; Nolan interview; Teaster interview.

308. Sass, *Charleston Grows*, 35, 44–147; *CNC*, November 2, 1943. For more specific comparisons of new industries, see "Annual Reports of the SC Labor Department," in *Reports and Resolutions of South Carolina*, (1944, 1945, 1947, 1948). For a lower estimate of new Charleston industries in the early postwar era, see Sass, "Cities of America," 21. Sass also reported that Charleston bank clearances averaged two and half times more than they had for 1939.

309. McNeil, *Charleston's Navy Yard*, 145–146; "Charleston Naval Shipyard History," 54–58.

310. "Charleston Naval Shipyard History," 52–53; The *Charleston Navy News* (*CNN*), May 15, 1947, copy provided by William Boyce; Boyce interview; McNeil, *Charleston's Navy Yard*, 146–147, 152–153, 159–164. It is also likely that the facility's value was considerably enhanced by Congressman Mendel Rivers, who represented the Charleston area for many years (1941–1970) and was a strong champion of the navy base throughout his long tenure, especially during the height of the cold war. See Huntley, "Mendel Rivers."

311. McNeil, *Charleston's Navy Yard*, 145–146; "Charleston Naval Shipyard History," 54–58.

312. "Charleston Naval Shipyard History," 52–53. The near disaster with depth charge igniters was related to the author in an interview with Cross.

313. "Charleston Naval Shipyard History," 73; for a different number in 1949, see Bauer, *Bases*, 93.

314. Huntley, "Mendel Rivers," 31–39. For the best source on the efforts to close the shipyard in 1949, see Bauer, *Bases*, 92–93.

315. Brown interview.

316. *CNN*, October 15, 1945, copy on file at SCL.

317. On Dorothy Brown, see Cupp interview. For a study of women workers in ten national shipyards (unfortunately it did not include the CNY), see *Women Workers in*

Ten Production Areas. See also Allen letter to the author. It is interesting to note that women were still working at the shipyard in 1947, but in clerical and food service jobs. There is no indication that any were still working on the production line. See *CNN*, May 15, 1947.

318. Bendt interview, March 30, 2004.

319. Ibid.

320. Dodds interview.

321. Moore interview.

322. Lester's accusation of discrimination appears in Lester to FDR, January 2, 1945, FEPC, File: CNY, Box 3, RG 228, SE Archives, but the case was not investigated because Lester never replied to an FEPC letter of enquiry nor was a local investigator able to find him at the address he had provided. See Witherspoon Dodge to Clarence Mitchell, January 1945, ibid. and McKay to Dodge, February 9, 1945, ibid.

323. For the problems of discrimination in deep Southern shipyards, see Reed, *Seedtime*, 225–226; ibid., "Black Worker and the Southern Shipyards," 460–461.

324. Perry interview. Before Perry could regain promotion to crane operator, he had to work a year for a private crane operator in his off hours from the Charleston naval shipyard to "gain the necessary experience" for the shipyard managers. Then he had to take his case to the federal authorities in Washington to demonstrate racial discrimination by the facility's management before finally getting promoted to crane operator in 1963.

325. *South Carolina Preparedness for Peace*, 7; Newby, *Black Carolinians*, 297.

326. For more information on Clark, see Brown, *Septima Clark*, 27. For DeCosta-Willis's reflections, see Dent, *Southern Journey*, 131–132. The disunity within the Charleston black community is traced by Dent back to the antebellum era, and today many within the African American community claim this still exists. The author wants to thank Steve Hoffius for making this study known to him.

327. Kluger, *Simple Justice*, 16. For average black and white teachers' salaries and a slightly different perspective than Kluger's, see Newby, *Black Carolinians*, 303–305. For the general retrenchment that African Americans faced throughout the South, see Bartley, *New South*, 12, 28–29.

328. For recollections on the origins of citizenship schools outside Charleston, see Dent, *Southern Journey*, 154–155, 157–158. The citizenship schools flourished in Charleston areas, particularly the Sea Islands, during the late 1950s and early 1960s, see Brown, *Septima Clark*, 43–54.

329. Editorial, *Walterboro Press and Standard,* June 14, 1945, Box 2, File 81, W.W. Smoak Papers (Smoak Papers), SCL.

330. Ibid., June 7, 1945.

331. Editorial, *The Lighthouse*, June 17, 1945, Box 2, File 8, Smoak Papers, SCL.

332. Letter to the editor, *CNC*, July 24, 1945, clipping, File: 81, Box 2, Smoak Papers, SCL.

333. Fraser, *Charleston! Charleston!*, 394–410; In "Genesis of the Modern Movement," 346–347, 368, Hoffman posits that the actual seed for the modern civil rights movement in South Carolina began in the 1930s.

334. For details of the postwar housing problems for blacks and other matters related to welfare, health and recreation, see "Charleston Looks at its Services For Negroes," Charleston Welfare Council/ National Urban League Report, May, 1947, original copy filed at the Waring Historical Library, Medical University of South Carolina, Charleston, SC (Waring). It appears from the document that each family paid the landlord a rent of just above seven dollars per month.

335. Ibid.

336. Ibid.

337. Ibid.

338. Fraser, *Charleston! Charleston!*, 399–400.

339. Sass, *Charleston Grows*, 33, 316. For a brief biography of one of the key individuals who led the preservation fight before the war and its early aftermath, see Bland, "Transcending Expectations," 254. For recollections on the preservation fight against a downtown skyscraper, see Halsey interview. For an examination of the evolving preservation movement and a theory for it in the postwar era, see Hosmer, *Preservation Comes of Age*, 1043–1045. For a brief history of the demise of the famous Charleston Orphan House, see Fraser, *Charleston! Charleston!*, 400–401. Robert Weyeneth does a superb job of examining the evolution of Charleston's preservation movement after World War II, but he does not suggest that it was a way to avoid dealing with the black community's problems. However, the incorporation of black neighborhoods into the historic districts of the city did not begin until the 1970s, see Weyeneth, *Historic Preservation*, xix, 23–40, 110–118.

340. Sass, *Charleston Grows*, 28.

341. For details on Charleston's postwar tourism growth, see Frank, "Economic Impact of Tourism, 6, 36–37, 40–50. For an early postwar look at the renewed growth of Charleston tourism, see Sass, "Cities of America," 21, 72. The increase in hotels and restaurants that has occurred in the historic district over the last two and half decades has accelerated, which the author and many others have witnessed with mixed feelings; see, for example, Halsey interview.

Bibliography

Primary Sources

The primary sources used in this study are separated by the depositories in which they were used. Note that while the naval records used were located in two different places in the National Archives system when reviewed by this author, it may be that since then the records have all been consolidated in the College Park, Maryland, center, designated here as NAII.

Avery Research Center, Charleston, SC
Avery Tiger

The Charleston Museum Archives, Charleston, SC
Charleston Museum Scrapbook, 1940–1945

The Franklin D. Roosevelt Presidential Library, Hyde Park, NY
Presidential Papers

Library of Congress, Washington, DC
National Association for the Advancement of Colored People, Local Reports, Charleston, SC, 1940–1946

National Archives Record Centers
Washington, DC (NAI)
 Records of the Department of the Navy, RG 80
 Division of Shore Establishments and Civilian Personnel
College Park, MD (NAII)
 Records of the Air Adjutant General / Mail and Records Division, RG 18
 Records of the Office of Naval Operations, RG 38

General Correspondence
Records of the President's Committee for Congested Production Areas, RG 212
Records of the President's Committee on Fair Employment Practices, RG 228
General Records of the Department of the Navy, RG 80
Industrial Manpower Section
Division of Shore Establishments and Civilian Personnel
Office of the Secretary of the Navy Section
Records of the United States Maritime Commission, RG 178

Southeastern Regional Center, East Point, GA (SE Archives)
Records of the War Manpower Commission, RG 211
Records of the President's Committee for Congested Production Areas, RG 212
Records of the President's Committee on Fair Employment Practices, RG 228

South Carolina Department of Archives and History, Columbia, SC
Papers of Governor John E. Harley, 1941–1942
Papers of Governor Richard M. Jeffries, 1942–1943
Papers of Governor Olin D. Johnston, 1943–1944
SC Defense Department World War II Scrapbooks

South Caroliniana Library, University of South Carolina, Columbia, SC
Charleston Evening Post, 1942–1945
Charleston News and Courier, 1941–46
Charleston Post and Courier, 1977, 81, 97
Charleston Navy News, 1945
John McCray Papers
Produce to Win, 1942–1945
W.W. Smoak Papers

Waring Historical Library, Medical University of South Carolina, Charleston, SC
"Charleston Looks at Its Services for Negroes." Charleston Welfare Council/ National Urban League Report. May 1947

Oral Interviews and correspondence:

All tapes and transcripts are currently on deposit with the South Carolina State Museum. Except where indicated, all interviews were recorded on cassette tapes.

Allen, Hellen W. Charleston native, CNY inspector in World War II. Letter to the author, July 11, 1996. Charleston, SC.

Anderson, Vivienne. Charleston native. Interview by the author, August 25, 1995, Charleston, SC.

Bendt, William. CNY Personnel Department, 1939–1943, 1946–1978. Interview by the author, December 12, 2003, and March 30, 2004. Charleston, SC.

Boyce, William. CNY design engineer in World War II. Interview by the author, June 27 and August 25, 1995. Charleston, SC.

Brown, Edna. CNY office worker in World War II. Interview by the author, July 19, 1991. Anderson, SC. Transcribed notes.

Clay, Cecil. CNY sheet metal worker in World War II, retired AFL union leader. Interview by the author, February 24, 1998. Santee, SC.

Cross, Eason. Naval officer stationed in Charleston in late stages of World War II. Interview by the author, September 8, 1990. King George County, VA. Transcribed notes.

Cupp, Ruth W. North Charleston resident in World War II. Interview by the author, July 25, 1997. Charleston, SC. Transcribed notes.

Cupp, Ruth. Letter to the author, December 23, 1997.

Dodds, Johnnie. CNY electrician in World War II, former mayor of Mount Pleasant. Interview by the author, July 26, 1996. Mount Pleasant, SC.

Fox, Ann. Charleston resident and former Port of Embarkation office worker in World War II. Interview by the author, February 16, 1996. Charleston, SC. Transcribed notes.

Halsey, William. Charleston artist. Interview by the author, March 21, 1997. Charleston, SC.

Holmes, Dorothea Spitzer. Charleston native, retired nurse. Interview by the author, February 12, 1991, and June 12, 1996. White Rock, SC. Transcribed notes.

Hutton, Sherlock and Eva McCartha. CNY workers in World War II. Interview by the author, June 19, 1991. West Columbia, SC. Transcribed notes.

Moore, John W. CNY machinist in World War II. Interview by the author, March 9, 1995. Summerville, SC.

Nolan, Johnnie. CNY sheet metal worker in World War II, Charleston resident. Interview by Al Hester, March 24, 1997. North Charleston, SC. Transcribed notes.

Ott, Ouida. Charleston resident in 1940s, retired school teacher. Interview by the author, March 11, 1998. Columbia, SC.

Pack, Thomas. CNY shipfitter during World War II. Letter to the author, April 18, 1995. Spartanburg, SC.

Passailaigue, Clifford R. and Delores R. Ellis. Charleston residents in World War II. Interview by the author, March 21, 1995. West Columbia, SC.

Perry, Oliver. CNY crane helper, 1941–43, 1946–78. Interview by the author, April 6, 2003. North Charleston, SC.

Rogers, George C. Charleston native, retired college professor. Interview by the author, May 29, 1997. Columbia, SC.

Rollins, Albert and Evelyn. Charleston natives, CNY workers. Interview by the author, March 15, 1996. Charleston, SC.

Sneed, Robert F. Charleston native, CNY pipe fitter in World War II. Interview by the author, December 6, 1995. Mount Pleasant, SC.

Teaster, Gerald. North Charleston resident in World War II. Interview by the author, April 20, 1995. Summerville, SC.

Tripp, Captain Jack L. USN, retired, stationed at CNY during part of World War II. Interview by the author, April 20, 1995. Charleston, SC.

Williamson, Jack. North Charleston native. Interview by the author, April 20, 1995. North Charleston, SC.

Wyly, Lois Ann J. and Reid, MD. Charleston native and her husband whom she married after World War II. Mrs. Wyly lived in her native city throughout the war years, and her husband returned from military service in 1945 to complete his degree at the College of Charleston. He later received his medical degree at the Medical University of South Carolina. Interview by the author, February 23, 1996. Summerville, SC.

Secondary Sources:

Adams, Leonard P. *Wartime Manpower Mobilization: A Study of World War II Experience in the Buffalo-Niagara Area*. Ithaca, NY: Cornell University Press, 1951.

Address of Hon. Roger C. Peace, Chairman of the Preparedness for Peace Commission. Columbia, SC: State Printing, 1945.

Anthony II, Susan B. "Working at the Navy Yard." *The New Republic*. (May 1, 1944): 597–599.

Archibald, Katherine. *Wartime Shipyards: A Study in Social Disunity*. Berkeley: University of California Press, 1947.

Arnold, Pauline. "Where Will the Postwar Chances Lie." *Independent Women* (October 1944): 303, 318–320.

Banov, Leon. *As I Recall: The Story of the Charleston County Health Department*. Columbia, SC: R.L. Bryan Co., 1970.

Bartley, Numan V. *The New South, 1945–1980: The Story of the South's Modernization*. Baton Rouge: University of Louisiana Press, 1995.

Bauer, K. Jack. *A Maritime History of the United States: The Role of America's Seas and Waterways*. Columbia, SC: University of South Carolina Press, 1988.

———, ed. *U.S. Navy and Marine Corps Bases: Domestic*. Westport, CT: Greenwood Press, 1985.

Beardsley, Edward H. *A History of Neglect: Health Care for Blacks and Mill Workers in the Twentieth-Century South*. Knoxville: University of Tennessee Press, 1987.

Bellows, Barbara. "At Peace with the Past: Charleston, 1900–1950." In *Mirror of Time: Elizabeth O'Neill Verner's Charleston*, ed. Lynn R. Myers. Columbia, SC: University of South Carolina, 1983.

Bland, Sidney R. "Transcending the Expectations of Culture: Susan Pringle Frost, A New South Charleston Woman." In *Developing Dixie: Modernization in Traditional Society*, ed. Winfred B. Moore Jr. et al. Westport, CT: Greenwood Press, 1988.

Blum, John M. *V Was for Victory: Politics and American Culture During World War II*. New York: Harcourt Brace Jovanovich, 1976.

"Boom Cities Aided: Congested Wartime Areas Solve Many Problems with Help of U.S. Agency." *Business Week*. (September 2, 1944): 31–32.

Brown, Cynthia S., ed. *Septima Clark and the Civil Rights Movement: Ready from Within*. Trenton, NJ: Africa World Press, 1996.

Burns, James McGregor. *Roosevelt: The Lion and the Fox*. New York: Harcourt, Brace and Company, 1956.

————. *Roosevelt: The Soldier of Freedom*. New York: Harcourt Brace Jovanovich, Inc., 1970.

Callcott, W.H., ed. *South Carolina: Economic and Social Conditions in 1944*. Columbia, SC: University of South Carolina Press, 1945.

"Charleston Naval Shipyard History, 1901–1958" (unpublished manuscript, 1960).

Coclanis, Peter A. *The Shadow of a Dream*. New York: Oxford University Press, 1989.

Cohen, Stan. *V For Victory: America's Home Front During World War II*. Missoula, MT.: Pictorial Histories Publishing Company, Inc., 1991.

Costello, John. *Virtue Under Fire: How World War II Changed Our Social and Sexual Attitudes*. New York: Little, Brown & Co., 1985.

Daniel, Pete. "Going Among Strangers: Southern Reactions to World War II." *Journal of American History* 77 (December 1990): 886–911.

Dent, Tom. *Southern Journey: A Return to the Civil Rights Movement*. New York: William Morrow and Company, 1997.

Drago, Edmund. *Initiative, Paternalism and Race Relations: Charleston's Avery Normal Institute*. Athens, GA: University of Georgia Press, 1991.

Edgar, Walter. *History of Santee Cooper, 1934–1984*. Columbia, SC: R.L. Bryan Company, 1984.

Fairchild, Louis. *They Called It the War Effort: Oral Histories from World War II, Orange, Texas*. Austin, TX: Eakin Press, 1993.

Fick, Sarah, Robert P. Stockton, Jonathan H. Poston, and John Laurens. *City of North Charleston: Historical and Architectural Survey*. Charleston, SC: Preservation Consultants, Inc., 1995.

Fields, Mamie, and Karen Fields. *Lemon Swamp and Other Places: A Carolina Memoir*. New York: Free Press, 1983.

Fraser, Walter J. *Charleston! Charleston! The History of a Southern City*. Columbia, SC: University of South Carolina Press, 1989.

Furer, Julius A. *Administration of the Navy Department in World War II.* Washington, DC: Government Printing Office, 1959.

Furnas, J.C. "Are Women Doing Their Share in the War?" *Saturday Evening Post*, April 29, 1944, 12–13.

Gannon, Michael. *Operation Drumbeat: The Dramatic True Story of Germany's First U-Boat Attacks Along the American Coast in World War II.* New York: Harper & Row Publishers, 1991.

Gill, Corrington. "Federal-State-City Cooperation in Congested Production Areas." *Public Administration Review* 5 (Winter 1945): 28–33.

Hartmann, Susan. *The Homefront and Beyond: American Women in the 1940s.* Boston: G.K. Hall/ Twayne, 1982.

Harvey, Bruce. "South Carolina Inter-State and West Indian Exposition, Charleston, 1901-1902." *Proceedings of the South Carolina Historical Association* (1988): 85–94.

Heyward, DuBose. "Charleston: Where Mellow Past and Present Meet." *National Geographic* 75 (March 1939): 310–312.

Hoffman, Edwin. "The Genesis of the Modern Movement for Equal Rights in South Carolina." *Journal of Negro History* 44 (1959): 346–369.

Honey, Maureen. *Creating Rosie the Riveter: Class, Gender and Propaganda During World War II.* Amherst, MA: University of Massachusetts Press, 1985.

Hopkins, George W. "From Naval Pauper to Naval Power: The Development of Charleston's Metropolitan-Military Complex." In *The Martial Metropolis: U.S. Cities in War and Peace*, ed. Roger W. Lotchin, 1–34. New York: Praeger, 1984.

Hosmer, Charles B. Jr. *Preservation Comes of Age: From Williamsburg to the National Trust, 1926–1949.* Charlottesville, VA: University of Virginia Press, 1981.

Hudson, Janet. "The Federal Government's Battle Against Venereal Disease During World War II." *Proceedings of the South Carolina Historical Association* (1994): 104–111.

Huff, A.V. Jr. *Greenville: The History of the City and County in the South Carolina Piedmont.* Columbia, SC: University of South Carolina Press, 1995.

Huntley, William. "Mendel Rivers and the Expansion of the Charleston Naval Station." *Proceedings of the South Carolina Historical Association* (1995): 31–39.

Jeffries, John W. *Wartime America: The World War II Home Front*. Chicago: Ivan R. Dee, 1996.

Johnson, Charles S. *Best Practices in Race Relations in the South*. Chapel Hill: University of North Carolina Press, 1946.

Kelley, Robin D.G. "'We Are Not What We Seem,' Rethinking Black Working-Class Opposition in the Jim Crow South." *Journal of American History* 80 (June 1993): 75–112.

Kirk, Robert W. "Getting in the Scrap: The Mobilization of American Children in World War II." *Journal of Popular Culture* 29 (Summer 1995): 223–233.

Kluger, Richard. *Simple Justice: History of* Brown v. Board of Education *and Black America's Struggle for Equality*. New York: Alfred A. Knopf, 1976.

Krammer, Harold. *Nazi Prisoners of War in America*. New York: Stein & Day, 1979; Scarborough House, 1991.

McNeil, Jim. *Charleston's Navy Yard: A Picture History*. Charleston, SC: Naval Civilian Administrators Association, 1985.

Milkman, Ruth. *Gender at Work: The Dynamics of Job Segregation by Sex During World War II*. Chicago: University of Illinois Press, 1987.

Miller, Nathan. *War at Sea: A Naval History of World War II*. New York: Oxford University Press, 1995.

Moise, Ann M., comp. *History of the South Carolina Ports Authority*. Charleston: South Carolina State Ports Authority, 1991.

Molloy, Robert. *Charleston: A Gracious Heritage*. New York: D. Appleton-Century Company, 1947.

Moore, John H. "Nazi Troopers in South Carolina." *South Carolina Historical Magazine* 81 (October 1980): 306–315.

———. "Charleston in World War I: Seeds of Change." *South Carolina Historical Magazine* 86 (January 1985): 1–31.

———. "No Room, No Rice, No Grits: Charleston's Time of Trouble, 1942–1944." *South Atlantic Quarterly* 85 (Winter 1986): 23–31.

———. *The South Carolina Highway Department, 1917–1987*. Columbia: University of South Carolina Press, 1987.

Myrdal, Gunnar. *An American Dilemma: The Negro Problem and Modern Democracy*. New York: Harper & Bros., 1944.

Navy Day Year Book, 1937. Charleston SC: Navy Yard Development Association, 1937.

Navy Day Year Book, 1941. Charleston, SC: Navy Yard Development Association, 1941.

Nelson, Bruce. "Organized Labor and the Struggle for Black Equality in Mobile During World War II." *Journal of American History* 80 (December 1993): 952–988.

Newby, I.A. *Black Carolinians: A History of Blacks in South Carolina from 1895–1968*. Columbia, SC: University of South Carolina Press, 1973.

Newman, Dorothy K. *Employing Women in Shipyards*. Washington, DC: Government Printing Office, 1944.

O'Neill, William L. *A Democracy at War: America's Fight at Home and Abroad in World War II*. New York: Free Press, 1993.

Perrett, Geoffrey. *Days of Sadness, Years of Triumph: The American People, 1939–1945*. New York: Coward, McCann & Geoghegan, 1973.

Preece, Harold. "The South Stirs." *The Crisis* 48 (November 1941): 350.

Reed, Merl E. "FEPC, the Black Worker and the Southern Shipyards." *South Atlantic Quarterly* 74 (Autumn 1973): 446–467.

———. *Seedtime for the Modern Civil Rights Movement: The President's Committee on Fair Employment Practice, 1941–1946*. Baton Rouge: Louisiana State University Press, 1991.

Reports and Resolutions of South Carolina. Columbia, SC: State Printing, 1940, 1943, 1944, 1945, 1946.

Robertson, David. *Sly and Able: A Political Biography of James F. Byrnes*. New York: W.W. Norton & Co., 1994.

Sass, Herbert Ravenel. "The Cities of America: Charleston." *Saturday Evening Post* (February 1947): 21.

————. *Charleston Grows: An Economic, Social, and Cultural Portrait of an Old Community in the New South*. Charleston, SC: Carolina Art Association, 1949.

Seventeenth Census of U.S., South Carolina. United States Census Bureau. Washington, D.C., 1952.

South Carolina Preparedness for Peace Commission: Report to the Governor and Members of the General Assembly. Columbia, SC : State Printing, 1945.

Stoney, Samuel G. *This is Charleston: A Survey of the Architectural Heritage of A Unique American City*. Charleston, SC: Carolina Art Association, 1944. Reprint, 1976.

Thomas, Mary Martha. "The Mobile Homefront during the Second World War." *Gulf Coast Historical Review* 1 (2): 70–71.

————. *Riveting and Rationing in Dixie: Alabama Women and the Second World War*. Tuscaloosa, AL: University of Alabama Press, 1987.

Trey, Joan E. "Women in the War Economy—World War II." *Review of Radical Political Economics* 4 (Summer 1972): 40–57.

Tuttle, William. *"Daddy's Gone to War": The Second World War in the Lives of America's Children*. New York: University of Oxford Press, 1993.

Verner, Elizabeth O'Neill. *Mellowed by Time: A Charleston Notebook*. Charleston, SC: Tradd Street Press, 1941; 1978.

Ward, Barbara M., ed. *Produce & Conserve, Share and Play Square: The Grocer and the Consumer on the Home-Front Battlefield During World War II*. Portsmouth, NH: New England University Press, 1994.

Ward, Geoffrey C., and Ken Burns. *Baseball: An Illustrated History*. New York: Knopf, 1994.

Weatherford, Doris. *American Women and World War II*. New York: Facts On File, 1990.

Weyeneth, Robert R. *Historic Preservation for a Living City: Historic Charleston Foundation, 1947–1997*. Columbia, SC: University of South Carolina Press, 2000.

Women Workers in Ten Production Areas and Their Postwar Plans. (Women's Bureau, U.S. Department of Labor, Bulletin 209, Washington): 1946.

Year Book, City of Charleston, S.C. Charleston, SC, 1925, 1927, 1935, 1942, 1944, 1945.

Dissertations and Theses:

Cann, Marvin Leigh. "Burnet Rhett Maybank and the New Deal In South Carolina, 1931–1941." PhD diss., University of North Carolina, Chapel Hill, 1967.

Frank, Robert Lee. "Economic Impact of Tourism on Charleston." MA thesis, University of South Carolina, 1972.

Hanckel, William H. "The Preservation Movement in Charleston, 1920–1960." MA thesis, University of South Carolina, 1962.

Loftin, Bernadette Kuehn. "A Social History of the Mid-Gulf South (Panama City-Mobile): 1930–1950. PhD diss., University of Southern Mississippi, 1971.

Press, Nancy. "Cultural Myth and Class Structuration: The Downtown Group of Charleston, S.C." PhD diss., Duke University, 1986.

Straub, Eleanor. "U.S. Government Policy Toward Civilian Women During World War II." PhD diss., Emory University, 1973.

Index

C

D

V

W

About the Author

Born in Pittsburgh, Pennsylvania, Fritz Hamer is the chief curator of history at the South Carolina State Museum in Columbia, South Carolina. He has a long-standing interest in the history of World War II and has written many articles and curated several exhibitions on the homefront and the military aspects of this global war. His articles include studies of German POWs in the Palmetto State and the changing roles of women and African Americans in Charleston during the war.

Hamer received his BA in history from Acadia University in Wolfville, Nova Scotia, and his MA and PhD in history at the University of South Carolina. In his spare time he enjoys following the world's greatest sport—soccer—and likes to cycle regularly.